FLORIDA'S UPL

Volume 1 of the Three-Volume Series

Florida's Natural Ecosystems and Native Species

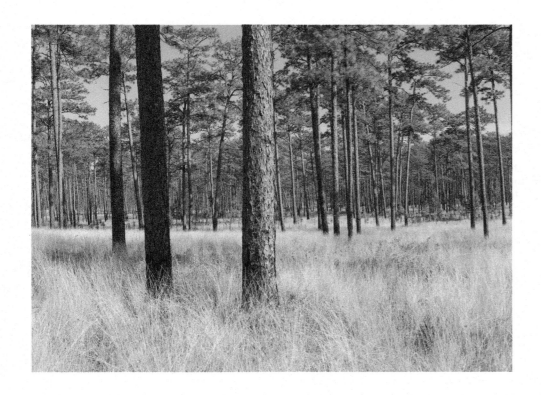

Ellie Whitney, Ph.D.

D. Bruce Means, Ph.D.

illustrated by

Eryk Jadaszewski

PINEAPPLE PRESS, INC.
SARASOTA, FLORIDA

DEDICATIONS

*To the memory of my husband, Jack Yaeger, whose love for wild Florida
I now carry forward.*

——Ellie Whitney

*To all the animals, plants, and ecosystems that have gone extinct
because of mankind, and to those we are now threatening.*

——Bruce Means

Inquiries should be addressed to:
Pineapple Press, Inc.
P.O. Box 3889
Sarasota, Florida 34230

www.pineapplepress.com

Library of Congress Cataloging-in-Publication Data

Whitney, Eleanor Noss.
 Florida's uplands / Ellie Whitney, Ph.D,. D. Bruce Means, Ph.D. ; illustrated by Eryk Jadaszewski.
 pages. cm. — (Florida's natural ecosystems and native species ; volume 1)
Revision of a section of: Priceless Florida / Ellie Whitney, D. Bruce Means, Anne Rudloe. c2004.
 Includes bibliographical references and index.
 ISBN 978-1-56164-685-2 (pbk. : alk. paper)
1. Natural history—Florida. 2. Biotic communities—Florida. I. Means, D. Bruce. II. Whitney, Eleanor Noss. Priceless Florida, III.
 Title.
 QH105.F6W455 2014
 508.759—dc23

 2014005828

First Edition
10 9 8 7 6 5 4 3 2 1

Design by Ellie Whitney
Printed in the United States

CONTENTS

Florida native: Wormvine orchid *(Vanilla barbellata)*. South Florida's warm and humid climate fosters the growth of tropical beauties like this rare orchid.

ACKNOWLEDGMENTS

We are grateful to many people for their contributions of expert knowledge and sound counsel: biologist Wilson Baker, naturalist Giff Beaton, wildlife biologist and writer Susan Cerulean, botanists Andre Clewell and Angus Gholson, botanist and naturalist Roger Hammer, meteorologist John Hope, environmental specialist Rosalyn Kilcollins, environmental educator Jim Lewis, geologists Harley Means and Tom Scott, and paleontologist S. David Webb.

Three editors have contributed importantly to the quality of this book: Patricia L. Johnson, Dana Knighten, and Ken Scott.

Our associcates at Pineapple Press have been wonderfully supportive: June and David Cussen and Shé Hicks.

The photographers who have contributed images to these pages are identified by their initials next to each photo, and their names are shown on page 154. We sincerely thank every one of them for their cooperation.

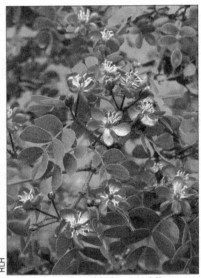

Florida native: Holywood lignum-vitae (*Guajacum sanctum*). This extremely rare flower grows in the Florida Keys.

Title page photograph

Longleaf pine-wiregrass ecosystem, once the most widespread ecosystem in the southeastern United States. This late autumn photo was taken during a rare time when the wiregrass had flowered, in response to a May-June fire. This is one of the only old-growth sites left in the ecosystem's entire range, just over the Leon County, Florida, border in adjacent Thomas County, Georgia.

Photograph by D. Bruce Means

FOREWORD

Priceless Florida was first published in 2004 as a 423-page book that presented all of Florida's upland, wetland, and aquatic ecosystems. Welcomed by a reading public eager to learn about natural Florida, it was widely shared and appreciated among visitors to the state as well as by year-round residents. Victoria Tschinkel, state director of The Nature Conservancy, Florida Chapter, wrote high praise into the Foreword:

> *Priceless Florida is one of the most important books ever crafted about Florida's natural history. . . . The scientific and educational lessons within these pages are simply astounding. Collected within this marvelous book are detailed natural histories of the native species and communities that comprise Florida. . . . Florida's inhabitants, human and other, depend on the state's fragile environment for survival, but the challenges ahead are enormous. Rapid growth drives the need to secure a system of parks, forests, and wildlife management lands. Without a core system of conservation lands to sustain the ecosystem functions and services upon which all life depends, the quality of life for every Floridian will suffer. Humans also need open space for recreation, water supply, rejuvenation of spirit, and reconnection with nature. I have no doubt that the readers of this book will become ardent proponents of this message, and most importantly, will love wild Florida even more.*

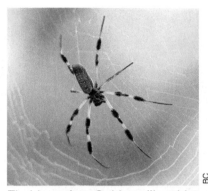

Florida native: Golden silk spider *(Nephila clavipes).* This spider strings up its giant webs all over the southeastern United States. Large and frightening to many people, it has weak mouthparts and is harmless to humans.

It is now time for a second edition—but because the original book was a large volume, we decided to split it into three smaller books: *Florida's Uplands, Florida's Wetlands,* and *Florida's Waters.* These are true derivatives of the earlier book. We have brought forward many of its beautiful photographs and much of the original text, updating it where necessary to keep it current.

It has been a pleasure to revisit Florida's natural ecosystems and to know that they remain, as before, beautiful examples of what nature has wrought in this topographically diverse state. We hope that these books will bring pleasure and useful knowledge to readers today as before.

PREFACE

Florida flame azalea (*Rhodo-dendron austrinum*), from the Apalachicola Bluffs and Ravines

Florida's landscape is much more varied than most people realize, and it supports a surprisingly diverse array of ecosystems—several dozen, in fact. And in each ecosystem, a tremendous number of plant and animal species thrive and interact in interdependent webs of life of which many of us are unaware.

Our goal is to familiarize Floridians with the state's natural ecosystems—first and foremost, because they are so fascinating. They are extraordinarily complex, intricate, ancient, and full of secrets, many of which are still to be revealed to us. The more we learn about them, the greater our pleasure, sense of wonder, and feeling of connectedness. Besides, they are ours, both to enjoy and to protect.

This book is primarily about *natural* ecosystems in healthy ecological condition, as far as scientific studies have revealed. Many books present short descriptions of the natural world and then devote many pages to the damage they have sustained. Those books serve a useful purpose, but in this one, natural ecosystems are given all the available space.

Similarly, *native* species are in the spotlight throughout. They, too, are fascinating, because they are adapted so beautifully to Florida environments. What must an animal do to live all its life in a cave? What does it eat, how does it "see" in the dark? What sorts of animals live in the bark of a tree? What do they do to the tree, and to each other? How in the world do seaoats survive almost continual onslaughts of salt spray, and even thrive on salt? And how are the plants and animals of an ecosystem woven together in the web of life?

Like the ecosystems, Florida's native species, also, are far too little known—and there are so many. This book, in all its photographs and lists, names hundreds of Florida's natives, but those named represent fewer than five percent of the total that are out there. Each is a masterpiece of biological adaptation evolved over eons. As a consequence, it is far beyond the scope of a book of this size to present a complete inventory of the native plants and animals in every Florida ecosystem. Rather, one or more groups of species such as flowering plants, birds, butterflies, or amphibians, are

Florida native: Green anole *(Anolis carolinensis)*. The green anole lives on trunks and in treetops all over the southeastern United States. It is the only anole native to Florida.

singled out for special notice in each chapter. This mode of treatment is as fair as we can make it; even so, many groups have been left out altogether.

Lists of some of the plant and animal species in each ecosystem accompany the text of each chapter. The lists are not intended to provide exhaustive information; other, encyclopedic references do that. Rather, the lists illustrate, in various ways, the specificity with which many plants and animals are adapted to their environments—and even to particular parts of their environments. In steephead ravines, some plants grow near the tops of slopes, some halfway down, and some near the bottom. Some grow better on sunny, south-facing slopes, some on shady slopes that face north.

A reader who simply scans the lists can learn another lesson from them. An immense amount of scholarship has gone into characterizing the ecosystems of Florida, from their physical characteristics to their inhabitants.

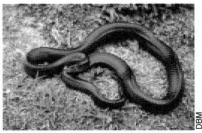

About the names of species, most readers doubtless are more comfortable with common names (such as the "Florida flame azalea,") while other readers prefer the precision of the scientific names (*Rhododendron austrinum*). To accommodate both preferences, all species are identified by their common names in the text, but those depicted in photos are identified both ways, and the Index to Species presents the scientific names for all species mentioned in the book.

Only when one understands something, can one come to love and cherish it. We hope this book leads to greater understanding of natural Florida.

Florida native: Eastern indigo snake *(Drymarchon couperi)*. This large, harmless, almost iridescent snake once ranged widely over the southeastern United States but has become very rare.

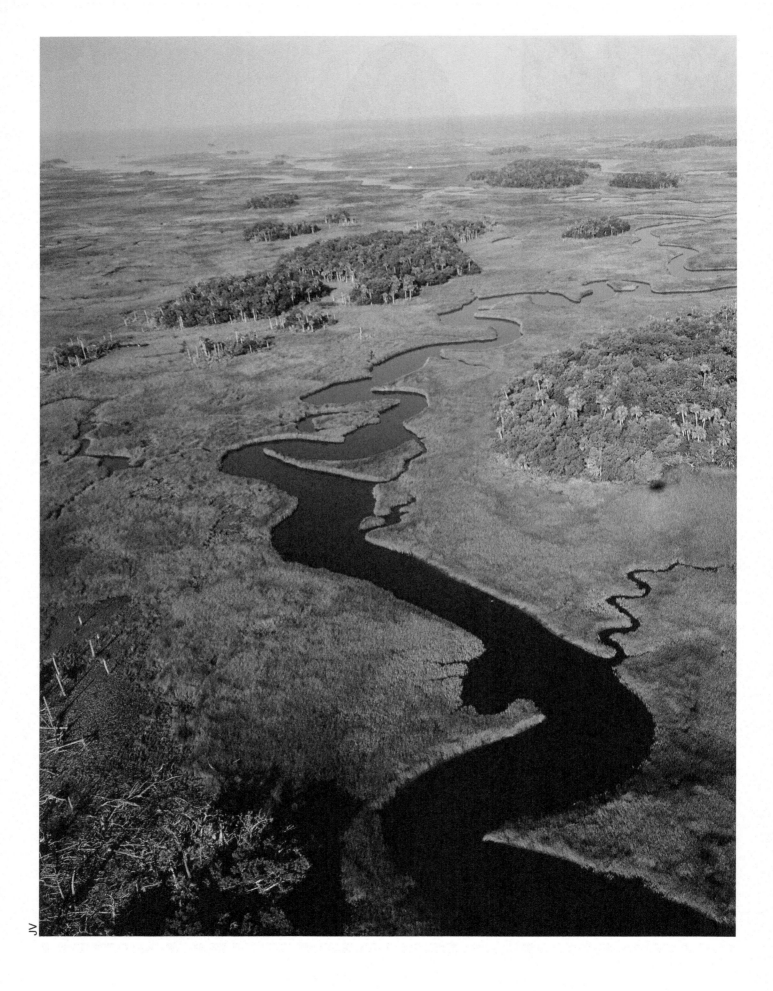

CHAPTER ONE

NATURAL ECOSYSTEMS AND NATIVE SPECIES

Florida's landscape supports upwards of 50,000 square miles of diverse natural areas including forests, flatwoods, prairies, swamps, marshes, and waterways. It has more than 7,700 named lakes greater than 20 acres in area, and countless ponds of up to 20 acres. It has 1,700 rivers and streams, and more than a thousand clear-water springs. It has a 1,300-mile shoreline of beaches, tidal marshes, swamps, and estuaries, and its offshore seafloors hold seagrass beds and coral reefs.

In this series of three volumes, Florida's natural upland, wetland, and aquatic systems are treated separately, but all three share many characteristics. They occur naturally on the landscape in mosaic-like patterns, as shown in the photograph opposite. There are upland areas (such as the pine-palmetto hammocks in the photo), wetland areas (such as the extensive marshes within which the hammocks stand), and aquatic areas (notably the stream that meanders across the landscape and the estuary into which it flows). This book's focus is on the uplands—terraces, plains, and divides between aquatic systems. Uplands are not necessarily high in elevation: many upland regions occur in the coastal lowlands.

All natural areas also support populations of native species of plants, animals, and other living things. (Depending on the classification scheme being used, these others include fungi, bacteria, and others, less well known but important in the functioning of natural communities.) Some of these populations inhabit single areas, some occupy several neighboring areas, some move from one to another with the seasons, and some migrate through at particular times of year. They also offer indispensable environmental services such as purifying water, controlling floods, yielding products of natural and economic value, and maintaining themselves without unnatural inputs of fertilizer or food.

Conditions that define a **natural area, natural ecosystem,** or **natural community**:

It occurs naturally **on the landscape** wherever certain physical conditions occur. It is inhabited by a **distinct assemblage of populations** of living things. It provides habitat for resident populations that are **naturally associated with each other.**

Uplands are areas whose soil is either dry and well-drained, or moist but not saturated with water except after rains.

Living things are grouped into large categories known as **kingdoms**, of which the most familiar are the plant and animal kingdoms. Classification schemes contain five or six kingdoms depending on the criteria used to define them.

OPPOSITE: Natural ecosystems on Florida's landscape. A meandering stream flows to the Gulf of Mexico through several natural ecosystems on the Big Bend coast. Shown are pine-palmetto hammocks (uplands), tidal marshes (wetlands), a stream with several smaller tributaries flowing into it, and at the shore, the stream's estuary (aquatic systems).

Natural and Nonnatural Ecosystems

To place Florida's uplands in context, this chapter first describes natural ecosystems in general and offers definitions of the terms *natural* and *native*. It then goes on to describe the environmental systems that support these ecosystems: the climate, surface materials, and topography.

Natural Ecosystems In 1990, FNAI produced its first *Guide to the Natural Communities of Florida*. This guide identifies 69 natural communities, of which 24 occupy uplands. Each community occupies a particular landscape feature (such as a sandhill or limestone plain) and each consists of populations of native species that have assembled and evolved within it over time.

In 2010, FNAI brought out a revised *Guide*, still with 24 upland communities, but with slightly revised terminology and descriptions. The Appendix shows how FNAI's upland ecosystems are distributed into this book's chapters.

Natural ecosystem: Coastal scrub in St. Lucie County. Dry, sandy soil soaks up rain and returns it to the underground aquifer. Florida beaches and coastal scrubs provide much sought-after recreation for both residents and tourists.

These communities are considered natural because they are relatively undisturbed by human influence and still function largely as they did in pre-Columbian times. However, even before Columbus, the native people who inhabited Florida altered the land somewhat: They cleared some areas, burned them, and planted them, but not to nearly the same extent as the Europeans and African-Americans who succeeded them. *Natural* is therefore an approximate term that represents a range of values.[*]

Altered Ecosystems. Today, many areas are altered from their historically natural state but resemble natural ecosystems in some ways. Examples are farms, orchards, ranches, pine plantations, and parks. Some of these retain some of their original functions. An example is a second-growth pine forest managed for timber production using nature's materials and methods: native pine species and groundcover plants, periodic fires, selective harvesting, and cultivation of uneven-aged stands of trees. Such forests still absorb water into the ground, help to purify air, conserve soil, stabilize land contours, and continue to provide habitat for native species.

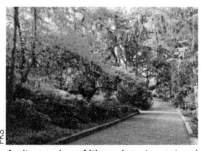

A city garden. Although not a natural ecosystem, a park embodies many of the same values and can be a benign use of the land.

Other alterations are more disruptive and produce areas that are less natural. Examples among forests include commercial plantations of single species such as slash pine or sand pine; forests that spontaneously take over abandoned farm fields; forests that have had major tree populations logged out; and fire-dependent forests that have not been allowed to burn. Yet even these forests can perform many of the environmental services just mentioned.

Artificial Ecosystems. Living systems that are still more unnatural include agricultural fields and lawns, which occupy vast areas of Florida. But perhaps the contrast with natural systems is best illustrated by theme parks, zoos, and aquariums. These establishments are important to Florida's economy. The tourists who flock to them enjoy superb entertainment and some of the highest-quality imitation nature in the world. Some of these places also help teach people to care about parts of the natural world.

[*] Reference notes follow the last chapter

Many a visitor who never before thought about panthers, manatees, or eagles has become a dedicated conservationist after meeting these animals up close and personal in Florida's animal parks.

Beneath the surface, though, artificial displays of nature are but high-maintenance versions of the real thing. Many require heat, air conditioning, piped-in water, mowing, weeding, trash pickup, and artificial light. They cannot tolerate normal local weather conditions, much less weather extremes. If damaged, they can't recover. If the walls are breached, disaster follows—either the alligators eat the flamingos or the flamingos fly away. In short, such systems depend completely on people for their maintenance; we have to fight nature to keep them going. Stop the pumps or cut the power, and the water goes bad. Filth piles up. Plants and animals die.

Ironically, keeping these exhibits going is hard on the natural environment. They produce no resources, they consume them. To meet the demands of these operations, millions of gallons of water are pumped from aquifers, depleting local groundwater reserves. For power, huge quantities of coal, oil, and gas are burned, which pollute the region's air. Tons of human and animal waste must be transported, treated, and dumped somewhere. Truckloads of trash are hauled away to landfills.

Natural ecosystems contrast dramatically with artificial nature exhibits in all of these respects. They cost the environment much less, and contribute far more. They require little maintenance—in fact, none, if their surroundings and the terrain on which they occur have not been altered. No fossil fuels are needed to supply their energy; no pipes or pumps must deliver their water; no trucks must deliver their fertilizer or food. They clean themselves up; they generate no waste materials for processing plants to dispose of because they recycle their own wastes. They run on renewable resources: sunlight, soil, air, water, and the work of living things. And for as long as they run, natural ecosystems produce diverse plants and animals, feed and house them, and enable them to reproduce, as well as rendering many services to the environment and humankind.

How do natural ecosystems manage to do so much with so little? If they owe their success to any single secret, it is that their resident populations are genetically adapted to grow and reproduce in local settings. They have evolved in these or similar environments over hundreds or thousands of generations, and they are equipped to cope with both normal conditions and normal extremes. In short, the resident populations are the native species referred to earlier: they have "local know-how."

Near the extremes to which they are adapted, the living members of natural ecosystems may be stressed, but they rebound at the first opportunity, provided only that invasive exotics are kept out and that repeated injuries don't occur. Often they can even recover after events that people call "natural disasters"—events such as hurricanes, floods, and fires—which may appear to overwhelm them temporarily. Some ecosystems promptly reassemble in the same places where they grew before. Some may recover after floods or fires appear to have wiped them out: For example, lakeside

Seaoats *(Uniola paniculata)*. This native grass is adapted to life on shifting, salt-sprayed sands. It is vitally important in stabilizing coastal dunes.

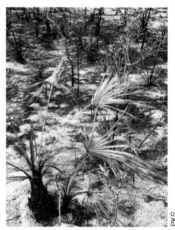

Native to Florida scrub communities, saw palmetto *(Serenoa repens)* may appear to be completely destroyed by fire . .

. . . but begins to recover quickly within a season.

LIST 1-1
Degraded upland areas (examples)

Habitats fragmented by altered land uses

Agricultural fields and orchards

Urban and suburban yards

Fire-dependent forests from which fire has been excluded

Clear-cut forests with their soils chopped up

Areas where solid and toxic waste materials are dumped

Areas that have been invaded by exotic species such as kudzu, punktree or Chinese tallow-tree

Construction sites

Coastal areas where seawalls, groins, and jetties have been constructed

Parking lots, highways, roadside ditches, and road rights-of-way

vegetation regrows after high waters recede. Others may regroup elsewhere as suitable new places become available: For example, a hurricane may completely erase a beach dune with all its vegetation, but the same species of plants will grow again on sand eroded from that dune and deposited on another. In short, natural ecosystems tend to persist, provided that the physical stresses they encounter are within the bounds to which they are adapted.

Degraded Lands. These exist in all settings. Familiar to all are farmed or paved former wild lands and areas that have been overwhelmed by invasive, nonnative species, which occupy millions of acres of land and of course support very few native species. Along coastal shores, especially in bays, the land today is so densely populated that the natural landscape features have largely broken down. Although living communities may still grow there, they are severely impoverished in numbers of native species and may hold none at all. To regain natural function these need more than management; they require restoration (see List 1-1).[1*]

In summary, although few areas are wholly natural any longer, many can be maintained in as near-natural condition as possible. Environmental benefits can be reaped by supporting and mimicking natural processes. Even small plots of land can help, especially if many are added together. In cities and suburbs, people's yards and home gardens can help meet the habitat needs of some native plants, insects, birds, and other animals. Roadside strips can be used to grow native wildflowers.

This book is devoted to those upland ecosystems that are thought to most closely resemble Florida's original ones, but some of their qualities can be recruited for additional uses in today's contexts, and all lands can have some ecological values. There is, however, one facet of natural ecosystems already mentioned, which no other lands and waters can quite match. Natural ecosystems consist of, and support, native species.

NATIVE AND INTRODUCED SPECIES

Natural ecosystems all consist of populations of *native* plants, animals, and other living things. Like *natural*, *native* means that the population is adapted to local conditions, including the presence of other native species, has existed there for a long time, and is contributing services of ecological value. Provided that its environment does not change greatly, a native species population can also perpetuate itself without elaborate management efforts.

In contrast to natives, other species have been introduced into Florida from other parts of the world. Some introduced plants ("exotic" species), for example, are relatively benign in local settings such as parks and gardens, where they are used as ornaments. Either they do not reproduce at all, or they reproduce at a modest rate and are easily kept from spreading into natural areas. But some exotic species tend to multiply out of control, invading the territories of native species and disrupting their webs of relationships. Often arriving without the natural enemies that controlled them in their home territories, they may spread so widely and become so destructive to Florida's

natural ecosystems, that concerned citizens maintain an Exotic Pest Plant Council to identify, monitor, and help state agencies control them.

Some "weeds" are also natives. They may move in readily wherever space becomes available and then grow rapidly. Native weeds appear promptly where erosion occurs, where trees fall, fields are plowed, forests are cut, or land is cleared for roads or construction. However, unlike nonnative plants, native weeds can be important parts of many ecosystems in transition times. The first to move in, they provide habitat and plant food for insects and other small organisms, and they stabilize the soil while slower-growing native plants are getting established. Native weeds are normally somewhat controlled by their own natural enemies and are succeeded by other native plants over time.

The photos on these pages provide examples of native and introduced flowers and weeds that are found in Florida. Animals and other living things fall into the same categories: some are native, some are introduced, and some are invasive. Among animals, one other important category exists: migratory species that pass through, or reside in Florida in certain seasons. Migratory birds come to mind. Some are spring and fall visitors; some are winter residents that fly north in summer to breed; and some breed in Florida during summers and spend winters farther south. Migratory butterflies and dragonflies also cross Florida in big flocks.

Notes on Species. In these times of severe disruptions of natural ecosystems all over the planet, it is important to understand two other things about native species: they did not arrive here overnight; and once extinct, they cannot be replaced. Except under extraordinary circumstances (such as laboratory manipulation), new species arise only by way of the process known as speciation, which in nature is slow. It begins with reproductive isolation. A single population may, for example, be split geographically into two subpopulations that remain separated for long times. Then, over many generations, the separated subpopulations may develop so many genetic differences that they become unable to interbreed. Florida's seven pine species, three of which are shown in Chapter 2, probably evolved that way, long before Florida itself existed.[3]

Long times, perhaps on the order of hundreds of thousands of years, are required to produce new species of slow-growing trees and of animals such as panthers, whose generation times (to sexual maturity of the young) are on the order of several years to a decade or so. In plants and animals that produce one new generation a year, speciation might take 20,000 years—still a long time. In mice, which produce several new generations a year, it takes about 5,000 years. Extremely short times are needed only for bacteria, some of which can produce several generations in a day. In short, immense variation is the rule.

Over the 3.8 billion years or so since life first arose on Earth, hundreds of millions of new species have arisen. Nearly as many have

Invasive exotic pest plant: Chinese tallowtree *(Sapium sebiferum).* This tree invades natural areas, reproduces prolifically, crowds out native trees, and drops litter that is toxic to native amphibians and fish.

A **species** is a distinct group of organisms that reproduces its own kind and is reproductively isolated from other such groups.

Lyreleaf sage *(Salvia lyrata).* This native weed plant grows freely over most of Florida and is especially common on disturbed sites, but readily gives way to other native plants.

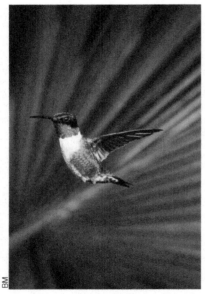

Florida summer resident. Florida native, summers: Ruby-throated hummingbird *(Archilocus colubris).*

also gone extinct. Until recently, however, the rate of production of new species has, on average, slightly exceeded the extinction rate. Thanks to the enormously long spans of time since the origin of life, net species gains over losses now add up to a total, for the world, of millions of species—perhaps even ten million or more, no one knows. About 1.75 million species have been discovered and described. There are at least 8 million, and probably more, species still to be discovered, mostly among invertebrates, plants, and other living things.

Names of Species. Every known species has a scientific as well as a common name. Those featured in this book's photos are given both names in photo captions, but are given just their common names in the text. Every common name has been reviewed and approved by authorities. Thus the bear that is native to Florida is the "Florida black bear." Using the names assigned in this way, all species discussed here are listed in the Index to Species, which precedes the General Index, and the scientific name for each one is also shown. The Reference Notes and Bibliography list the authorities for the naming of species.[4]

A Count of Florida's Native Species. Florida possesses nearly 3,000 native species of trees, shrubs, and other flowering plants. It has more than 100 species of native orchids (compared to Hawaii's two species). Its ferns, numbering some 150 species, are the most diverse in the nation.[5] And besides these, there are many mosses, hornworts, liverworts, and algae. As for the animals, a list of all of Florida's land vertebrates—frogs, snakes, lizards, mice, birds, and all other terrestrial animals with backbones—would number some 700 species. And these are far outnumbered by Florida's invertebrates (animals without backbones such as snails, dragonflies, and earthworms), of which there are about 30,000 species on the land. At least three other whole *kingdoms* of living things are required to accommodate the fungi, bacteria, and others.

Becoming acquainted with Florida's native species is a mind-expanding experience, somewhat like stepping through a small door to discover a multi-story mansion of a thousand rooms. Many a bird watcher is thrilled at first to see a dozen kinds of birds at the backyard feeder, but then goes on to learn that 30 times as many bird species occur in Florida. At the St. Marks Wildlife Refuge alone, nearly 300 species of native birds have been observed. Moreover, birds are only one class of vertebrates, vertebrates are only a small group among animals, and animals are only one of the earth's five or so kingdoms of living things. If one were to try to enumerate all of Florida's species, though, the vertebrates would be a good group to begin with, because they are familiar and closely related to us.

The photographs in this book are intended to give a sense of the diversity of Florida's native upland species. In proportion to the numbers of species in each kingdom, however, animals (especially birds) and plants (especially flowering plants) are over-represented. Florida is noted for the abundance of beautiful, conspicuous examples of both.

Florida's Endemic Species. Native species are of two types. Some are widely distributed; some are limited to small geographical areas. The live oak is an example of the first type. Live oak grows naturally in coastal and near-coastal areas all the way from Virginia, across Florida, and well into Texas. The gopherwood (*Torreya*) tree is an example of the second type: it grows only in north Florida and very nearby in Georgia and is a "near-endemic" species).

Some species are completely restricted to Florida: they are Florida endemics. These include several hundred plant and animal species and several natural communities. Among the endemic plants are about 300 species. Among the endemic invertebrate animals, more than 400 endemic species are known; and among the vertebrates, more than 40 are endemic to Florida. No one knows how many endemic bacteria, protists, and fungi there are.

Florida's native species, and especially its endemic species and communities, are ours to protect or lose. An objective of the volumes of this series is to make their value clear.

Florida's Species Today. Florida's species are among the most endangered in the nation. This is largely due to destruction of their habitats. When the last member of a species' last population dies out, the genetic information necessary to produce new individuals of that species vanishes forever. The total information available for making living things also diminishes. Upon extinction, the information accumulated in a species over hundreds of millions of years is gone for all time.

It still takes approximately 5,000 years or more, to produce a new species, on average, but worldwide species losses today, by current estimates, are mounting to dozens a day. Moreover, the extinction rate is accelerating.

The pace of Florida's species losses matches that of the rest of the world and also is accelerating. However, most of Florida's species have not gone, and need not go, extinct. If the people of Florida know and value local native species sufficiently, they will take what steps they can to protect local ecosystems.

To this point, we have seen that Florida's ecosystems are very diverse and support a wide range of native species. This is so because the ecosystems are tied to a physical landscape which, although reputed to be flat, is not at all monotonous: it is in fact surprisingly diverse.

Adaptation is the key to the success of Florida's native plants and animals. They are adapted to the physical environment: the climate, topography, soils, and waters of Florida, and so they are able to survive the normal extremes in these factors over many millennia. The nonliving components of Florida's ecosystems are the physical context that has molded every species from the time of its arrival to the present.

Florida native, endemic: Ashe Magnolia (*Magnolia ashei*), a north Florida endemic plant. This fascinating plant is a small understory tree that has huge leaves and flowers. It is deciduous, losing its leaves in the fall, unlike most other magnolia species which are evergreen. It grows in beech-magnolia forests along steep river bluff slopes in north Florida.

Support Systems: Climate, Land, and Soils

Florida receives floods of life-sustaining sunlight and experiences mild weather that, for the most part, varies gently in temperature from season to season. Many living things thrive easily in such conditions. Stresses are presented, however, by alternating wet and dry seasons, punctuated by periodic tropical storms and hurricanes. Each species has developed adaptations to cope with the range of conditions it encounters, from hot to cold, sunny to rainy, droughty to flooded, and calm to stormy.

Temperature and Humidity. Because the peninsula is so long, north to south, climatic conditions vary somewhat. Florida lies within the temperate zone, but the climate is subtropical in south Florida and tropical in the Keys. Winter cold fronts often penetrate north Florida, but seldom reach farther south, so north Florida winters have both more varied temperatures and more rain than winters in the rest of the state. This is one of many reasons why the species composition of ecosystems differs between north and south Florida.

The Gulf of Mexico also influences Florida's climate. Elsewhere in the world at Florida's latitude, deserts predominate, with wide variations in temperature and exceedingly dry air. Florida, though, has water on three sides. Warm water moves constantly along Florida's Gulf coast, around the peninsula's southern tip, and along the whole east coast. Proximity to water on three sides produces high humidity and abundant rain. The rain helps to maintain the interior's many lakes and wetlands, and these help to minimize temperature variations.

Although the climate is relatively constant over long periods and the weather is mild on average, day-to-day weather conditions in Florida vary tremendously, ranging in some areas from lows of below freezing on winter nights to highs of 90 degrees Fahrenheit or above on summer days. Snow, sleet, and hail, as well as temperatures above 100, although rare, are not unknown.

Rainfalls and Storms. The quantity of rain that falls on Florida sometimes seems stupendous. Even a single summer shower, if it runs down a slope and collects in a low place, can quickly become several feet deep. A stalled tropical storm can drop more than two feet of rain in just a few days, and nine inches of rain can easily fall on a single location within a single afternoon.[6]

Heavy rainfalls are not the rule, however. Most rain showers bring down an inch or less. Only because they are so frequent do they add up to some four and a half feet a year. If all that rain soaked into the ground, it could easily sustain groundwater levels against current and future demands for eternities to come. Actually, however, about three-fourths of the rain returns to the sky and about one-fourth runs off over land to the sea. Only a little rain soaks into the ground each year. It stays there for a while, and ultimately runs out to sea by way of seepage and through springs.

Although the average rainfall in Florida amounts to about 53 inches in a typical year, areas of the state vary. The western Panhandle receives

Weather is the state of the atmosphere at particular times and places.

Climate is the long-term state of the atmosphere defined by its averages and extremes over time.

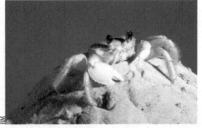

Florida native: Ghost crab (*Ocypode quadrata*). This furtive and fast-moving animal is almost transparent against the sand, with only its eyes betraying its presence. Silhouetted against the sky, however, its features become apparent.

somewhat more rain than does the rest of Florida—60 inches, on average. The east coast receives less—50 inches. And wherever it is measured, the rainfall deviates greatly from the average in many seasons.[7]

Any given area of Florida has, on the average, some 120 rain events a year. Most are showers, but some ten to twelve of these events are storms. On clay-rich, sloping land, raindrops quickly gather in surface indentations, form channels, and run off into streams and rivers. On sandy land, water sinks down and drains away underground. On its way, the water may encounter a somewhat impermeable layer (a hardpan), underlying the sand near the surface; then it accumulates for a while in a shallow aquifer before gradually percolating away.[8]

The most dramatic of Florida's storms cause rivers to surge out of their banks, sweeping their floodplains clean of accumulated litter. At the coast, these storms bring surges that rearrange masses of offshore sand, annihilate beaches, deposit bars, shorten and elongate islands, and shift submarine shoals from place to place. As inconvenient as these events may be for human beings, coastal ecosystems, if not interfered with, continue to adjust as they have for millions of years.

Small rainfalls produce different benefits. they clean leaf surfaces, add to groundwater reserves, and offer relief to Florida's dry-land plants during times of stress. Plants are adapted to withstand dry periods, but do not go altogether dormant. Prolonged droughts can set them back or even kill them.

Rainy and Dry Seasons. Alternating wet and dry seasons have characterized the region's weather patterns for thousands of years. Summers are wet all over the state, throughout June, July, and August (Floridians call August's rainy days the "dog days"). Autumns are dry; in fact, October, November, and December are the driest months of the year. Other months' rainfalls differ between north and south Florida. North Florida has considerable rain in late winter (December to April), and then May turns dry. South Florida has little rain all winter except briefly before cold fronts.

Plant and animal life cycles are adapted to seasonal rainy and dry seasons and even to periodic fires—which, under natural conditions, were frequently ignited by lightning. As a result of their long evolution under these conditions, the pine and scrub communities that top Florida's clay and sand hills actually depend on frequent burning for their renewal. Lower on steep slopes are hardwood hammocks that are dominated by fire-sensitive plants.

Dry conditions combined with lightning make fires especially likely, and lightning strikes are frequent events in Florida, generating more strikes per square mile of the state's land surface than anywhere else in the country. In Tallahassee alone, 40 lightning strikes hit each square mile every year.

Most lightning storms occur in summer, that is, in the months from May through August, and since May is dry, that is the month in which fires

Florida native: Laurel oak *(Quercus hemisphaerica)*, photographed in an old-growth stand in Wakulla Springs State Park. This is a tall canopy tree, growing as it normally does in its native habitat. On a city street or in a suburban yard in full sunlight, it would grow dense and round.

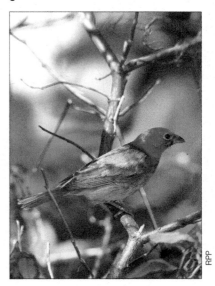

Florida migrant: Painted bunting *(Passerina ciris)*. This bird ranges across the southern United States and Mexico. Its breeding (summer) range includes parts of northeast Florida and the Panhandle and its winter grounds include parts of south Florida.

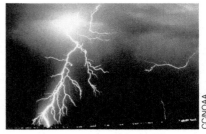

Lightning. Fires ignited by lightning strikes are an important force shaping many Florida ecosystems.

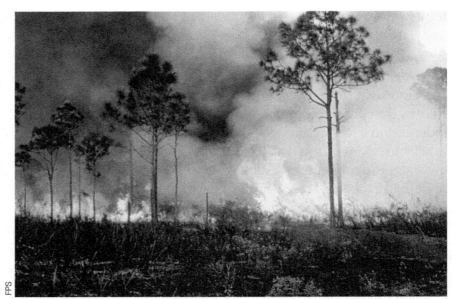

Fire burning through pine flatwoods in Jonathan Dickinson State Park, Martin County. Fire is the agent of natural regeneration in these ecosystems.

most easily ignite. Accordingly, Florida's fire-loving plants are especially well adapted to May fires. In natural, fire-adapted ecosystems, fires started by lightning kill fire-sensitive plants, leaving fire-resistant plants in possession of the territory. May fires stimulate these plants to flower, and by the time their seeds drop, the ground is bare and nutrients released by fire are available as fertilizer.[9]

Tropical Storms and Hurricanes. Windstorms are another force affecting Florida's ecosystems, and all species populations must have ways of surviving them. Tropical storms produce winds of more than 40 miles per hour and hurricanes are the most extreme of tropical storms, having winds greater than 70 miles per hour. A hurricane may produce rain and sometimes dangerously high water over an area hundreds of miles across, while its wind gusts may reach speeds of 200 miles per hour and spawn tornadoes. Looking at just the *center-line* paths of all the tropical storms and hurricanes that struck Florida during the last century, one can hardly see the state's outline beneath the mass of tracks. See Figure 1-1.

The winds of tropical storms and hurricanes pull weak limbs from trees, break brittle trees off midway up their trunks, and topple strong trees, exposing their roots. The result is a massive overhaul of forests. Bare earth lies exposed for new seedlings to take root. Sunlight floods formerly shaded ground, permitting seedlings to grow. Seeds that fall on the tops of broken-off stumps and start growing there are perched high above the next flood where they can grow without rotting. The tipped-up roots of fallen trees expose crevices in which many animals can make homes. The opportunities for new life to take hold following a storm are a major means of forest regeneration—not all at once, as forestry practice so often plans it, but piecemeal, summer after summer, now here, now there.

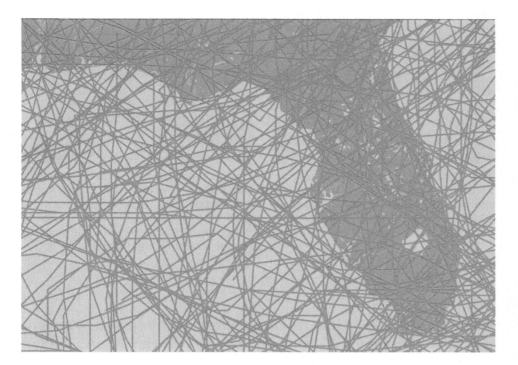

FIGURE 1–1

Tropical Storms and Hurricanes Striking Florida in 100 Years

Source: National Oceanographic and Atmospheric Administration.

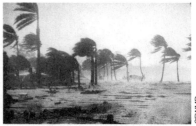

Natural force: Hurricane winds. Several tropical storms and hurricanes strike Florida every summer, and native species populations must be equipped to withstand or recover from them.

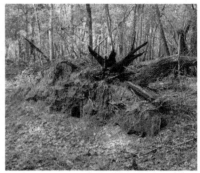

After a storm. The toppling of a tree makes a varied surface of bare, soft earth available for new seeds to spring up on. The mass of upraised roots and earth, known as a tip-up mound, may persist for many decades and is an important feature of forest ecosystems.

In summary, Florida's living things are adapted to temperatures, sunlight exposures, rains, droughts, fires, winds, and even storms as they have occurred through past millennia. Native ecosystems are also adapted to variations over time, such as wet and dry spells of several years.

Florida's Surface Materials. Besides the climate and weather, the surface materials of which Florida is made profoundly influence the character of its ecosystems. That there are deeply cut ravines and high banks in one area, flat plains and broad lakes in another, and caves and sinkholes and springs in still others, is due to the diversity of the sediments of the southeastern U.S. Coastal Plain. This region, within which all of Florida lies, has well-defined physical boundaries. The innermost boundary is the base of the Piedmont, which flanks the southern Appalachian mountains. The outermost boundary is the coastline. Figure 1-2 depicts the southeastern U.S. Coastal Plain.

Three physical characteristics distinguish Florida (and indeed the whole southeastern U.S. Coastal Plain) from the regions to the north. First, *marine* sediments (limestone and dolomite) lie in thick layers all over Florida, at or below the surface. These calcium-containing sediments were deposited during earlier times when Florida lay under the sea and they profoundly influence the region's topography. Second, the whole Coastal Plain is deeply layered with *clastic* sediments (clay,

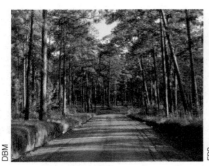

Clay. Exposed on a road cut through a high pine grassland, this clay has given the highlands of north Florida the name *Red Hills*. This is Pine Tree Boulevard, just north of the Florida-Georgia line in Thomas County.

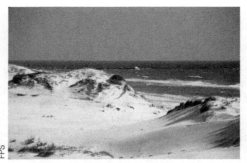

Sand. Composed of particles of a larger size than clay, sand is the predominant material of Florida's beaches, sandhills, and coastal lowlands. This beach is in Deer Lake State Park in Walton County.

Limestone outcrops in the Waccasassa Bay State Preserve, Levy County. Accumulated on the seafloor mostly from the skeletons, shells, and bones of marine creatures, limestone gives evidence of Florida's submarine history.

silt, sand, and gravel). These sediments have been transported by streams and rivers from the Appalachian Mountains over the past 65 million years and generally lie on top of the marine sediments. Third, a layer of *organic* soil lies on or is mixed into the surface sediments. This layer may be nearly imperceptible on high, dry sandhills, but is inches to tens of feet thick beneath all kinds of wetlands and water bodies from small, shallow ponds and seepage slopes to large swamps and lakes.

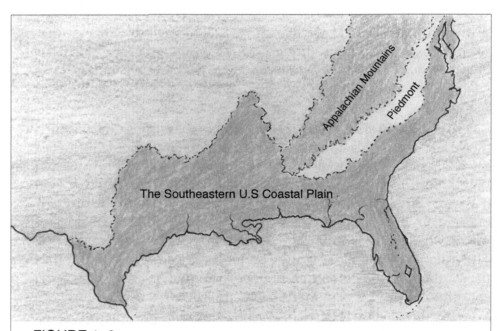

FIGURE 1–2

The Southeastern U.S. Coastal Plain

The southeastern U.S. Coastal Plain is the apron of loose sediments that spreads from the foot of the Piedmont to the shoreline.

Source: Brouillet and Whetstone 1993, Ch 1.

Soils are the foundation material of most of Florida's living communities and are mixtures of these three basic types of sediments. Plants are adapted differently to grow on different kinds of soils. Well-drained soils challenge plants to obtain and retain water. Water-saturated soils exclude air with its life-giving oxygen, so that plant roots have to be specially adapted to obtain oxygen, which they need for growth and metabolism. Moisture and drainage characteristics of soils are so important that ecosystems are often classed by them. For example, xeric, mesic, and hydric hammocks consist of trees growing on soils that are, respectively, dry and well drained, moist, or often waterlogged.

Depending on what they are composed of—limestone, clay, silt, sand, gravel, peat, muck, or mixtures of these—Florida's soils may be fine or coarse, acid or alkaline, fast-draining or water-holding. Altogether, some 300 different types of soil occur in Florida, contributing much to the diversity of the state's ecosystems.[10]

Contours of the Land. The land's topographic features, or contours, are profoundly influenced by the materials of which the land is made, and help determine what sorts of ecosystems will form in each area. Where there are clay-rich sediments, rain erodes gullies and stream valleys form. Where there are broad plains of sand, water soaks in instead of running off. Where limestone lies in thick layers just below the surface of the ground, rain water percolates down through cracks and fissures and spreads through horizontal bedding planes between layers, dissolving the limestone and creating sinks, springs, and caves. In various combinations, these factors apply to all regions of Florida. Clay-rich areas of the state are divided into many stream valleys with hardly any lakes; areas with deep sand are dotted with numerous lakes and ponds and have few streams. Limestone-dominated areas have many caves, sinks, and springs.

This chapter has laid the groundwork, literally, for appreciating Florida's living communities. Additional details will be added in the chapters to come, which now turn to the natural upland ecosystems themselves.

Soil is the particulate material lying on top of the land, which is capable of supporting plant life. Soil includes **sediments**—namely clays, sands, and organics; living things, including microscopic organisms and earthworms; and air and water.

Soils may be characterized by their moisture contents:

Xeric soils are dry and well drained.

Mesic soils are usually moist.

Hydric soils are wet and waterlogged.

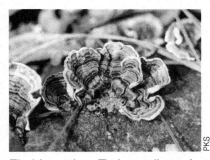

Florida native: Turkey-tail mushroom (*Trametes versicolor*). This fungus is widespread across the world, and like its fellow fungi, it digests dead wood.

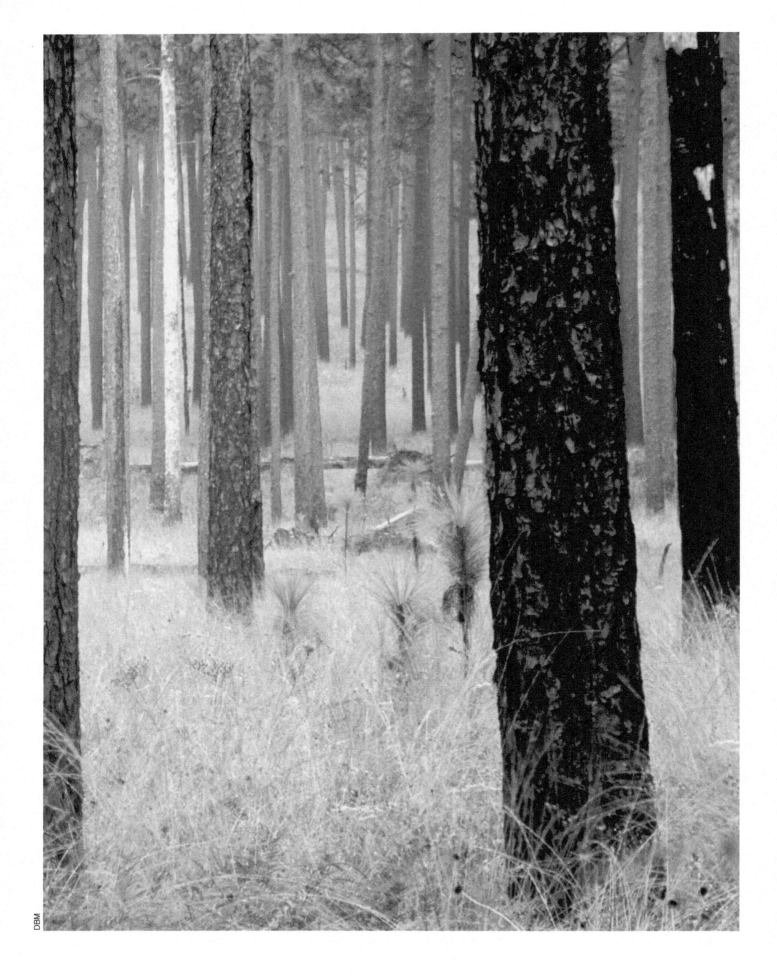

CHAPTER TWO

HIGH PINE GRASSLANDS

Five hundred years ago, north and central Florida looked altogether different from today. A vast, continuous pine grassland covered nearly all the high ground and spread across the flatwoods almost to the coast. The pine trees were giants, widely spaced, and the ground was carpeted with a sea of grasses. Other plants were numerous and diverse, but pines and grasses dominated the scene. Pine grasslands like this had covered more than 20 million acres in Florida on and off for millions of years.[1]

Today, the vast and mighty pine forests that cloaked most of Florida for so many millennia are almost completely gone—logged out during the late nineteenth and twentieth centuries at a rate faster than the tropics are being logged today. Today, hardly anyone knows what they looked like. To today's Floridian, the word *forest* conjures up an abandoned farmers' field thick with newly growing trees, or a pulp farm, or a logged-over forest remnant. These are not natural, self-maintaining forest ecosystems, but the products of human interference with nature. The few remnants of the original ecosystem are mostly of second growth, but they are still prized for their extraordinary diversity and complexity. Figure 2–1 shows the change in extent of the original pine forests from pre-Columbian times to today.

ANCIENT PINELANDS

Natural high pine grasslands are so few and far between today that most people don't know what they look like—or, seeing them, don't recognize their significance. An authentic old-growth pine grassland is shown in the photo, opposite. It is strikingly different from the commercial pine plantations that have overtaken most of its territory today. The canopy is open. The biggest pines are more than 100 feet tall, straight, and spaced well apart. If allowed to grow to their natural age, upwards of 500 years, they will be three or four feet across at breast height. The original, pristine longleaf pine community had millions of monster trees.[2]

Florida's natural pine grasslands have an open canopy of pines and a floor of wiregrass or other grasses. Based on the tree cover, they are called *forests*, but from the groundcover, they are **pine grasslands** or **pine savannas**.

Other terms referring to Florida's high pine grasslands described in this chapter are **upland pine** (on clayhills) and **sandhill** (on sandhills). Florida's low pine grasslands, flatwoods and prairies, are described in Chapter 3. The pinelands of extreme south Florida are **pine rocklands**, and are treated in Chapter 7.

Florida native: Lady lupine (*Lupinus villosus*). This plant is widespread in the dry soils of longleaf pine sandhills.

OPPOSITE: Longleaf pine *(Pinus palustris)* in a high pine grassland. They were open, grassy lands where lightning struck frequently, starting fires that swept across them nearly every year. The small shrubs and trees died back, opening the way for grasses and wildflowers.

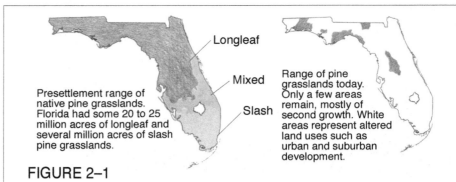

Presettlement range of native pine grasslands. Florida had some 20 to 25 million acres of longleaf and several million acres of slash pine grasslands.

Longleaf

Mixed

Slash

Range of pine grasslands today. Only a few areas remain, mostly of second growth. White areas represent altered land uses such as urban and suburban development.

FIGURE 2–1

Native Pine Grasslands Yesterday and Today

Originally, native pines and grasses occupied most of the southeastern U.S. Coastal Plain, spreading in an almost unbroken expanse all the way from eastern Texas to Virginia, an area 85 to 90 million acres in extent. Shown here is the presettlement range of longleaf and slash pine grasslands in Florida, compared with the range today.

Other pine species occupied small areas. Sand pine topped coastal dunes and strands, barrier islands, and areas transitional between longleaf pine savanahs and wetlands. And recent studies have shown that shortleaf pine naturally occupied special upland soild types.

Hardwood trees dominated other areas, where forest fires occurred infrequently such as along river valley bottoms, in deep ravines, on steep slopes, and in low, swampy depressions. Strands and circles of cypress also outlined some streams and ponds. Pine grasslands occupied most of the rest of the landscape. Vaster than the Everglades, pine uplands were old, well organized, diverse, and Florida's most important natural ecosystem.

Sources: Drawings adapted from Platt 1999, 24 (adapted with the permission of Cambridge University Press) and Myers 1990, 175. Information from Anon. 1991 (Longleaf pine communities vanishing); Derr 1989, 110–114; Means 1994 (Longleaf pine forests); Carr et al 2009a, Carr et al 2009b.

The **overstory**, or **canopy**, of a forest consists of its tallest trees.

The **understory**, or **midstory**, consists of trees and palms that grow below the canopy.

The **groundcover** consists of grasses, other herbs, and shrubs that grow beneath the trees, the lowest layer of greenery.

A tip-up mound in a pine grassland.

In addition, old-growth longleaf pine grasslands have longleaf trees of all ages, evidence that the forest is naturally replacing itself. There are baby pines with a specially fire-adapted morphology called "grass stage." Also there are all sizes of thick-stemmed saplings that look like broomsticks, each with a tuft of long needles at the top and few or no branches for 5 or 6 feet up. And there are maturing trees of 20, 60, 110, and even 120 feet in height. Biologists believe that the dearth of low branches is an adaptation to quickly raise the tender growing tips out of reach of fire. Lower limbs are naturally "pruned" in older trees, and the branches have bursts of needles only at their tips, so they readily admit light through to the ground. One can see for great distances among the tree trunks across the grassy floor.

Dead standing trees—"snags"—are present, too, and some trees are blown down by wind with their roots upraised as tremendous, tangled tip-up mounds. Some dead trees lie full-length on the ground in the last stages of decay. Huge pine cones, 8 to 12 inches long, are scattered on the ground, dropped by the pines or by fox squirrels. Pine straw litter hangs from the branches and lies strewn on the grasses.

One has to wonder how such a place could ever come to be. Why is this forest so open? Sunlight is plentiful, yet no other trees are growing in the spaces between the pines. Is that because the grasses are too thick? And where did these thick bunch grasses come from, anyway? You don't see grasses like these in today's younger forests; rather, you see a thick tangle of hardwoods mixed with pines, shrubs, and vines. But in the few old-growth pine grasslands of today, open space is the rule. Why? Read on and discover how fire shapes this ecosystem.

FIRE IN PINE GRASSLANDS

It is a dry, breezy May afternoon. Embers are smoldering inside an old pine tree that was struck by lightning in a storm a day or so ago. Now the ground is dry, and when an ember falls to the ground, flames spring up in the pine straw at the foot of the tree and begin to spread rapidly through the wiregrass. A sudden gust of wind makes the fire flare up in a crackling, five-foot-high wall for a few minutes, but then the breeze changes direction and the fire's leading edge creeps along with flames only a foot high, leaving behind black ashes that quickly cool.

The line of fire sweeps steadily across the ground surface. A red-tailed hawk eases from tree to tree working the fire line, swooping down to catch grasshoppers and mice, which are moving about to avoid the flames. Finally, in the waning evening light, the fire moves over a rise out of sight.

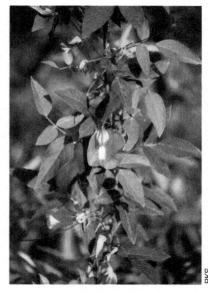

Florida native: Spurred butterfly pea (*Centrosema virginianum*). Butterfly pea grows naturally in many Florida ecosystems, inclu ding pine grasslands.

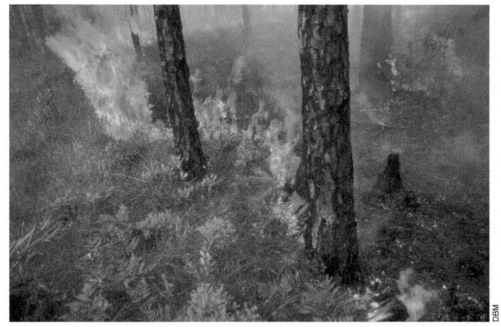

Fire in groundcover in the Apalachicola National Forest, Liberty County. Not much litter has accumulated on the ground since the last fire, and there is little midstory growth, so the fire burns at a low temperature and moves across the surface without significantly damaging the pines. In presettlement times, surface fires worked their way around ponds and the heads of streams and could progress freely for hundreds of miles across Florida, Georgia, and southern Alabama.

Land managers recognize different kinds of fires on the land. Described here is a **surface fire**, or **ground fire**, one that burns through litter and undergrowth. Longleaf pine communities typically experience ground fires.

A **crown fire** is one that burns through the tops of trees. Such fires occur in sand pine scrub as described in Chapter 5.

The term *ground fire* is sometimes used to mean a **peat fire**, one which burns deep into accumulated peat in the ground. Peat fires may occur in peaty wetlands during severe droughts.

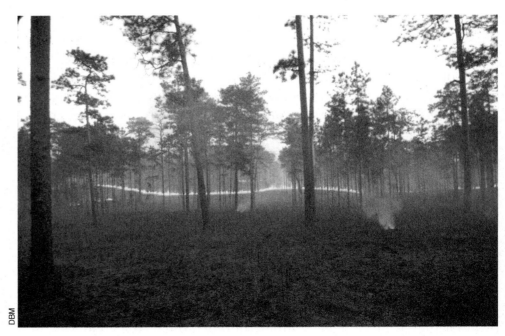

Slow ground fire in virgin groundcover. At night, it is easy to see that the fire is burning mildly but steadily.

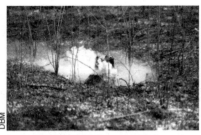

Longleaf pine stump still burning after recent fire. When it finally burns out, this stump will leave a deep, branched hole in the ground that will serve as habitat for many native animals.

All nonwoody flowering plants, both grasses and broad-leafed types, are **herbs**.

Grasses are herbs with narrow blades and distinctive flowers that identify them as members of the family Poaceae.

Forbs are all of the herbs other than grasses.

Some forbs that have narrow blades and look like grasses (sedges, lilies, palms, and others) are called **grasslikes**.

In the morning, the ground is covered with black ash. Only a few wisps of white smoke still rise from dead snags and large fallen branches on the ground. Several days later, the old tree that was smoldering earlier has burned down to a hard, resinous snag, the "fatwood" or "lighterwood" cortex of the tree. Impregnated with resins that protect the wood from rot, this snag will burn and reburn for decades.

The scaly pine bark is black to several feet above the ground. Some of the pine needles are scorched, but many trees still have healthy green needles and all are still alive. The wiregrass clumps are circles of black stubble, the other herbs seem to have been vaporized completely, and the running-oak stems are brittle and break off easily, but beneath the soil, the roots of all these plants are already resprouting. Only trees that are not adapted to survive summer fires, namely hardwoods such as southern magnolia and American beech, are completely killed. Those trees are absent from this ecosystem. If they start to invade, they are eliminated by the next fire that will come a few years hence.

A close look reveals that the community has burned unevenly. The high, dry ground is totally scorched. Lower, damper spots are less intensely burned, and unburned patches are common. Different plants will dominate these areas, adding to the ecosystem's diversity.

In September, a return visit reveals an astonishing scene. The grassy floor is alight with vibrant, new life. The wiregrass carpet has put up millions of slender, haylike, golden flowering stalks, waist-high, and soft to the touch. Myriad wildflowers, earlier unseen, are blooming: pink, lavender, purple, red, blue, and yellow. Insects are hopping, buzzing, and crawling everywhere, making a feast of juicy young plants, and cross-pollinating the

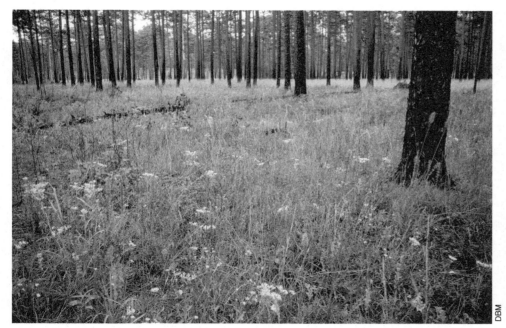

High pine grassland with groundcover flowers in bloom. This forest burned in June and different flowers bloomed every month thereafter. These are October blooms in the Wade Longleaf Forest in Thomas County, Georgia.

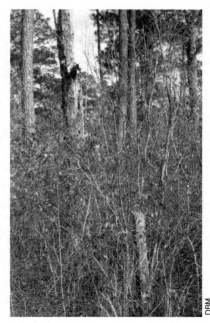

Unnatural system: Pine grassland deprived of fire. This forest was kept from burning for twelve years, enabling water oak, laurel oak, and sweetgum to encroach on the pines. Ironically, the forest is now dangerously fire-prone, because flammable pine litter has piled up. Native animals are not well adapted to living in an unburned pine forest, and many cannot survive in this environment.

flowers as they move about. Small birds, lizards, and frogs are pursuing the insects. As predicted, the plants are unevenly distributed: there are patches of legumes here, goldenrod there, berry bushes elsewhere. Fire creates a mosaic, and because in different years fires come at different times, even the patches differ somewhat from one year to the next.

The reason the forest floor is so open is now clear: fires keep the woody plants down. Prior to European settlement, fires swept the surface nearly every summer. That may seem improbably frequent, but a single summer day may see a hundred fires start up naturally in Florida thunderstorms. For millions of summers in the past, lightning-set fires swept unimpeded across the pinelands of the Coastal Plain.[3]

It was only after people came on the scene that this steady state began to change. When the early Native Americans began to practice agriculture, they cleared some fields to plant crops, hindering fire's spread, but they compensated by setting fires intentionally so that they could see their enemies, control mosquitoes, create spaces for recreation, or hunt game. Later, the Europeans cleared more land for fields, pastures, roads, and towns. They, too, burned patches of pine grasslands to maintain them, but fires no longer swept freely across most of the land.

Today, roads, agriculture, and developments block or suppress the spread of fires. Freed from control by fires, shrubs, scrub oaks, and other hardwoods quickly grow into a dense subcanopy that shades out the groundcover and young pines. Finally, the pine grassland gives way to a tall, dark, broad-leafed hardwood forest that will not burn again, because hardwood litter resists burning. Today's hardwood forests are far more extensive than they were in presettlement times.[4]

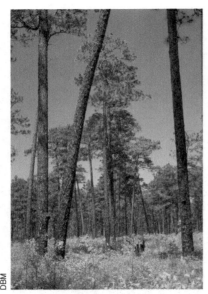

Natural ecosystem: A longleaf pine–turkey oak community. Turkey oak (*Quercus laevis*) is kept low to the ground by frequent fires.

Fires in pine grasslands not only suppress hardwoods, they also help the community's plants to reproduce. Fire stimulates grasses and some forbs to flower and release their seeds. Fire also exposes patches of bare soil, which permit new seeds to take root, and the sunlight that floods the ground after a fire fosters the growth of new seedlings. Without fire, bare sun-drenched soil is hard to come by, because the groundcover and pine litter are so dense. Bare ground is available only on an occasional tip-up mound, or where a gopher tortoise or pocket gopher has dug a burrow. Fires also turn accumulated litter to a residue of ash, which contains the phosphorus, nitrogen, and other nutrients that newly growing plants need. Rains wash the ash fertilizer into the soil just as new seedlings are starting to grow. And fires preferentially burn trees that are already weakened by infection and have started to rot. Elimination of these trees helps to control disease agents.[5]

Because fires sweep the terrain frequently, they also keep dry litter to a minimum. This prevents major, hot, pine tree–killing wildfires. The animals benefit, too. Young plants that arise after fires make tender and especially nutritious food for newborn grazing animals. Open spaces permit fruitful hunting for hawks and ease the gathering of seeds by quail and other seed eaters.

The season of burn is important. It might seem that fires at any time of year would do equally well, but fires in winter are usually not effective at killing hardwood trees. In winter, the plants' nutrient reserves are stored down in the roots, where fires cannot destroy them. If young hardwoods are exposed to a winter fire, even if it burns them to the ground, they can resprout from their roots the next spring.

The fires that maintain the ecosystem best are those that occur in the season when lightning storms are most common in Florida—that is, early in the growing season, from April to July. Summer fires stress hardwoods more effectively, both because they are hotter and because they burn the plants' stems and leaves while the nutrients are in them. Also, most grasses and some forbs only flower and produce seeds in response to early, growing-season fire. If forest managers burn the forest in winter, although they may clear out the groundcover just as well, they will induce fewer plants to flower and release their seeds.

In short, historically, the natural fire cycle was governed by consistent summer lightning storms. Today these have to be simulated by intentionally set fires known as controlled, or prescribed, burns.

All of the ecosystem's plants exhibit adaptations that make them tolerant of fire. The longleaf pine itself is a paragon of fire adaptedness. It has been evolving for millions of years in a fire-dominated realm, and today it is by far the most robust and fire resistant of Florida's pines. Not only that; it actively promotes the igniting and spreading of fires, thus perpetuating the conditions that favor its dominance of the landscape.

Longleaf Pine, Fire Starter

Figure 2–2 shows that longleaf is superbly adapted to a fire-frequent environment. One secret of its success: it can withstand fire as a seedling. Slash pine and other pines can, when mature, withstand fire better than most hardwoods but, at least in north Florida, they cannot out-compete longleaf.

While maintaining superb defenses against fire, the longleaf pine also tolerates soil infertility better than hardwood trees do, and this favors its supremacy on the infertile, sandy soils of the Coastal Plain. Hardwood trees grow better on fertile soil. Another contrast: the needles, twigs, and bark dropped by longleaf pines are highly flammable, whereas hardwood leaves resist fire. Even after they have fallen and turned brown, hardwood leaves, having no flammable resin, tend to hold moisture and refuse to burn.

Longleaf also holds onto the land tenaciously enough to withstand hurricane-force winds. Its taproot plunges deep into the ground to reach a steady water source and at first is as stout as the pine tree's trunk. The taproot puts out lateral roots, and from these, secondary taproots. Fine feeder roots from all of these branch prolifically beneath the ground surface. This stupendous anchoring system is more effective, even in sand, than that of any other tree. At maturity, the root system's wide-ranging penetration of the underground space enables the tree to stand firm against storms and collect water and nutrients from a circle some 60 feet or more in diameter.

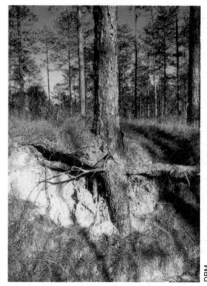

Longleaf pine taproot. Shown partially exposed here, the longleaf taproot penetrates far below the ground.

Associated with the root system are several species of underground fungi that extend the tree's nutrient-gathering system severalfold more. Webs of fungal hairs intertwine with, and even penetrate, the roots and deliver minerals to them. Some root-associated fungi contain bacteria which capture nitrogen from the air and bind it into usable compounds. Other fungi produce hormones that stimulate tree growth. You can easily detect such fungi in an old, undisturbed ecosystem. Gently lift the mat of litter around the base of a tree. See how it is knit together by a web of nearly invisible threads. This is a fungal network that links the litter to the soil.

> Root-associated beneficial fungi are known as **mycorrhizae** (my-co-RIZE-ee).

Thanks to its land-grabbing root system, longleaf competes fiercely with other trees, even its own seedlings, for water and nutrients. If growing too close together, young longleaf pines cannot survive for long. In an undisturbed old-growth tract, each mature tree releases hundreds of thousands of seeds during its lifetime, but very few (perhaps only one or none) grow to maturity and reproduce. Ironically, where patches of bare soil become available, young longleaf pines may begin to grow in clusters, but competition eventually thins them out.

The longleaf's open spacing produces further advantages. Because the tops are not in contact with each other, they cannot carry crown fires. Even in a single tree, the branches are so irregularly spaced that fire cannot jump from branch to branch. And the trees' open spacing also admits abundant sun, which favors the growth of groundcover plants. Given such favorable conditions, the wiregrass that naturally accompanies these trees on undisturbed sites overlaps in a continuous sea of fine fuel that guarantees the spread of fire across the ground (see next section).

> Trees that yield huge crops of seeds at intervals of several years are said to be **masting**. Hardwoods such as beech and oak trees exhibit this pattern of seed production and the term **mast** refers to their nuts and acorns. In the case of longleaf pine, the mast consists of cones and pine nuts.

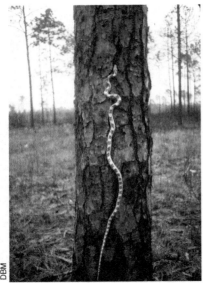

Florida native: Gray rat snake (*Pantherophis spiloides*). Rat snakes readily climb trees to feed on baby squirrels, baby birds, and bird eggs. This one is climbing a longleaf pine.

To retain dominance, the trees have to produce immense numbers of seeds. Numerous animals eat longleaf seeds, typically devouring 99 percent of them or more every season. About every seven years, however, a stand of longleaf turns out vastly more seeds than the average population of seed eaters can consume in a year. The intervening years of less abundant seed production then keep seed-eater populations at low levels.

What more could the trees possibly do to perpetuate conditions that would favor their own survival? They could actively promote the igniting and spreading of fire—and they do. Dead, standing snag trees are lighting rods. When struck, their resinous heartwood may smolder for days following a rain and then drop sparks to ignite the groundcover when it has dried out. Also, longleaf pine needles are more flammable than those of any other pine native to the southeastern United States. The burning pine straw ignites the groundcover and the fire spreads. Thus longleaf pines both invite fire and help it to spread.

The more old trees there are and the longer the time that has passed since the last fire, the more likely fires become. Long intervals between fires, which might permit hardwood trees to invade, are thus made highly unlikely.

Finally, the tree's own life cycle favors its renewal. Seed drop is in fall, after the summer lightning season. No other pines release seeds in this season, so longleaf seeds have free access to whatever bare soil is available. The seeds then germinate in winter, supplied with fresh ash fertilizer, and have a fire-free season in which to start growing.

Thanks to all these adaptations, longleaf pines, once established, tend to perpetuate themselves naturally. Foresters may choose not to plant longleaf because other pines produce more wood at first, but recent studies show that after the first two decades, longleaf catches up and thereafter produces more, and higher-quality, wood than other pines. In short, longleaf is the tree best adapted to grow in Florida's pine grasslands.

WIREGRASS, FIRE SPREADER

The natural groundcover in a pine grassland consists primarily of huge fountains of bunch grasses—in north Florida mostly wiregrass; in south Florida other grasses. The grass plants are ankle-high and nearly a yard across. They feel springy underfoot, but one can easily turn an ankle on the hidden center of a clump under the long, wiry leaves.

Nestled among the grasses are dozens of other low-growing plants such as running oak, saw palmetto, bracken fern, and numerous flowering forbs. These support a food web that consists of a vast variety of small insects, insect eaters, and their predators. But the grass is obviously dominant and is the most important plant. It is an indicator species signifying that the whole, integrated community is likely to be present. Without wiregrass, many of the other species of groundcover plants will be missing, too, and a stand of pine will be just a tree farm, poor in species. The natural

Florida native: Wiregrass (*Aristida stricta*). Wiregrass is one of several native, flammable grasses that spread fire in Florida's pine grasslands.

FIGURE 2–2

Longleaf Pine *(Pinus palustris)* Adaptations to Fire

SEEDLING

FIRE SURVIVORS

SAPLING

The longleaf pine seedling hugs the ground while the stem and bark grow thick. Only a bushy spray of needles is exposed above the ground for the first two to ten years. The needles are thick, more than 12 inches long, and moist. Silver scales on the growth bud help reflect the heat of fire.

While it hugs the ground, the tree is said to be in its "grass stage." During the grass stage, it puts down a deep taproot and stores energy and nutrients in it. The taproot grows well below the fire zone and never burns.

If a fire comes through while the tree is in the grass stage, the long, moist needles give off steam. This keeps the growth bud at a temperature no higher than the boiling point of water. The needle tips may be scorched, but the growth bud is protected. Only in extremely hot, dry, windy conditions can fire kill young longleaf pines.

Now that it has a stout taproot with a good store of water, energy, and nutrients, the sapling wastes no energy making side branches, but shoots up fast, rising above the fire zone within two years. The first year, it grows 1 foot, the next year, 2 feet more. After three more years of growth, it is 5 to 6 feet tall. This is the tree's so-called "broom stage."

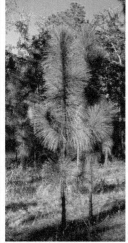

YOUNG TREE

The young tree has a sturdy trunk and thick, corky bark. It grows lateral branches only after the growth bud at its top is above the zone in which a mild surface fire can damage it.

The mature tree's bark is scaly, and when it burns, the scales flake off, and carry heat away. The trunk can resist brief, intense heat, even that of an acetylene torch.

MATURE TREE (not shown): Mature at 40, longleaf pine then can go on to live for 300 or 500 years or longer. It dies, usually, due to lightning strike followed by insect attack.

Sources: Croker and Boyer 1975; Wahlenberg 1946; Muir 1916; Myers 1990; Clewell 1981/1996, 104–107.

Slash Pine *(Pinus elliottii)*

Slash pine growing in south Florida has a grass stage and exhibits other similarities to longleaf pine. It tolerates fire well.

In north Florida, however, slash pine has no two- to ten-year-long grass stage. At 1 year, it is already 6 inches tall, with a spindly stem, paper-thin bark, and needles all along the stem. Even a mild grass fire will kill this seedling.

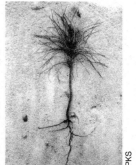

SEEDLING

As a sapling, the northern slash pine has a slender trunk with thin bark and needle-laden branches close to the ground. It is readily killed by fires, even mild surface fires.

MATURE TREE (not shown): Slash pine matures at 40, and dies at 100 or 150 years, typically; earlier in bay swamps and probably much earlier in flatwoods.

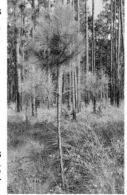

SAPLING

An **indicator species** is one whose presence in an area signifies that a whole suite of other species is present along with it. It is a sign of an intact ecosystem.

groundcover produces the seeds, flowers, fruits, and leaves on which the community's tiny animal members feast, these animals become food for other animals, and in turn for the whole community. High plant diversity supports still greater animal diversity.

The sea of grass that carpets a pine grassland withstands and promotes fire just as the trees do. Like the pines, the grasses of pine grasslands deal well with infertile soil and competition; they have become adapted to these conditions over millions of years. The roots are safely buried under the soil and escape the heat of ground fires. The plants are remarkably evenly spaced across much of the terrain, forming a continuous mat, almost a grid, of overlapping plants. Their blades, as they reach full length, die and turn brown, but stay in place. They readily catch fire from burning pine needles and neighboring clumps of grass. Once ignited, the dry grasses alone carry fire for long distances among widely spaced pines.

The grasses of pine grasslands, like longleaf pine, require fire to thrive. They flower and drop their seeds, just as the pines do, in fall after a fire in the lightning season. Grasses love sunlight. Wiregrass produces more than 20 times more seed under an open canopy than in the shade. Without summer fire, wiregrass makes few seeds and fails to grow, even if the nearby earth is exposed by plowing. After a fire in mid-April to mid-July, however, the grass seeds colonize the exposed soil and guarantee the dominance of this tenacious and amazing grass over all other species.

That wiregrass survives at all in environments where people have prevented summer fires is a tribute to the tenacity of its roots. In a natural, old-growth pine grassland, individual wiregrass plants may live and keep growing for several hundred years. In an unburned forest, as woody shrubs and hardwoods invade, wiregrass plants may persist for a long time, but they gradually shrink and die in the shade.

Wiregrass plants compete aggressively with other grasses and forbs wherever fire is frequent and sunlight abundant. The roots of a healthy old clump of wiregrass form a dense, shallow underground mat up to 18 inches in diameter that captures nearly all available water and nutrients. Above the ground, the blades are arranged somewhat like a funnel, so that they channel rain water down to the center of their own root system, leaving their competitors dry. After growing upward, the long grass blades fall over and lay several inches of thick wiry growth in a three- to four-foot circle on top of other plants, hogging the sun and pitilessly shading out everything underneath. Other plants' seeds often can't find a way to the ground, or if they do, can't germinate in the shade.

LIST 2–1
Groundcover plants of the longleaf community (examples)

Arrowfeather threeawn*
Big threeawn*
Bush goldenrod
Croton
Dogfennel and several relatives*
Dwarf huckleberry*
Flaxleaf aster*
Florida calamint
Florida dropseed*
Florida greeneyes
Gayfeather*
Goat's rue and several relatives*
Honeycombhead
Lespedeza, several species*
Milkpea, several species*
Mohr's threeawn*
Partridge pea

(continued on next page)

OTHER GROUNDCOVER PLANTS

Despite the dominance of bunch grasses, other plants do grow successfully among them—thanks to fires at the right time of year. Growing-season fires burn back the grasses, eliminate the dense pine litter, and allow seeds to reach bare soil in fall, before the grasses can recover. Many of the grassland's groundcover plants require summer fires, too, to stimulate them to flower (see List 2–1). After fires, perennial plants also regrow from their roots and rise high enough to get above the grass. Bracken fern springs up, blueberry and dwarf huckleberry bushes bloom, greenbrier vines and gallberry shrubs resprout.

Fires bring out legumes, too—herbs such as milkpea and lespedeza, whose root-associated bacteria can capture free nitrogen from the soil and incorporate it into their own tissues. They return nitrogen to the food web just after fires have freed much of the nitrogen from earlier plants and plant litter. After fires, legumes increase tenfold in small patches and become an important food for wildlife. Later they are shaded out, and when they die and decompose, they leave nitrogen in the soil where other plant roots can absorb it.

Between one fire and the next, the running oaks, which have been burnt back to the ground, grow new shoots a foot or two tall. Knee-high running oak stems in a pine community may outnumber the pines, and their extensive root systems may be hundreds of years old, but the stems always stay low to the ground. One often sees hundreds of running oak stems in a dense green patch. These are all the same plant, which are connected by their root system. Their ability to come back again and again from their roots is a successful adaptation to a fire-frequent environment. Turkey oaks also are clones of stems growing from an underground network of roots. Normally, the stems are kept low to the ground by fires, but in the absence of fire, the stems can become small, scraggly trees that can live for 50 to 60 years or so. They can quickly regrow after fires by drawing on the pool of energy stored in their extensive root system. If frequently burned, both running oak and turkey oak shoots yield acorns after only two years.[6]

The scrub oaks (turkey, blackjack, bluejack, sand post-oak) that grow scattered among longleaf pines on certain soils also respond adaptively to fire. Their stems are all shoots from networks of interconnected roots. The shoots can become small, scraggly trees if left unburned, but if burned frequently, the shoots produce acorns on second-year growth when only knee high.

Florida native: Pine bark borer (*Tyloserina nodosa*). The beetle breeds in the bark of dead and dying pines and deposits its eggs there. Once hatched, the larvae feed in the bark and destroy the larvae of other bark beetles.

Florida native: Black carpenter ant (*Camponotus pennsylvanicus*). These ants have excavated tunnels beneath the bark of the tree and are tending a herd of aphids there.

Florida native: An arboreal ant (*Crematogaster ashmeadi*). This ant spends its entire life in longleaf pine trees and is a major food item for the red-cockaded woodpecker.

Insects that Live on and in Longleaf Pine

On just a single pine tree, these insects eat the needles:

- The caterpillar of the pine devil moth

- An inchworm, the caterpillar of another moth

- The pine webworm, which hides inside a nest made of caterpillar droppings, clips off needles, and pulls them in to eat

- Two species of leaf beetles

- Pine scale insects, which suck sap out of the needles

- Woolly pine scales, which live under a layer of fleecy white wax and eat needles

- Tortoise scales, which suck sap from growing shoots

- Sawflies, several species in two genera, which lay their eggs inside pine needles, form pupae under the bark or in the soil beneath the tree, and emerge as flying adults in a cycle that turns over four or five times a year in Florida.

These insects eat other parts of the tree:

- Pine tip moth caterpillars, which eat growing tips

- Another moth caterpillar, which eats male catkins and young female cones

- The deodar weevil, which attacks twigs and stems, living in small holes in shoots or chambers in the sapwood

- Reproduction weevils, which feed on pine seedlings and produce larvae that tunnel through the inner bark leaving loose reddish-orange fluff behind

- Mole crickets and May-June beetle grubs, which eat the roots

- Wood-boring beetles of several genera, and other beetles that prey on them

- Carpenter and harvester ants, which forage on the tree and rear herds of aphids there. The aphids suck up fluids from the tree and the ants then "milk" the aphids

- An arboreal ant, which conducts its entire life cycle in galleries under the bark left behind by wood-boring beetles. These ants never touch the ground. The queens colonize new trees by flying to them.

Sources: Minno and Minno 1993; Hahn and Tschinkel 1997.

WEBS OF RELATIONSHIPS

Pines, grasses, and groundcover plants form the basis of a well-integrated, complex ecosystem, whose intricate interactions have evolved over countless generations. Every member is connected in myriad ways with many others. Consider a single old-growth pine: a dozen or so species of fungi are connected to its roots. Other species of fungi may grow on the litter around its base, others on the bark, and still others in the heartwood. The tree may support a hundred different plants: algae, mosses, ferns, and vines.

A single tree also houses hundreds of species of insects and other small invertebrates, which eat the needles, bore in the bark and under it, lay eggs along the needles, and feed on the pollen: ants, beetles, caterpillars, flies, and more. In one high pine community, researchers fogged just two longleaf pines with insecticide and collected 50 species of arthropods.[7] A few of the insects associated with longleaf pine are named and described in Background Box 2–1, opposite.

Thanks to the many insects, insect eaters can thrive. Foremost among them are other insects and spiders, but many larger creatures eat insects too, including sapsuckers, other woodpeckers, nuthatches, bluebirds, kestrels, wood ducks, flying squirrels, frogs, salamanders, lizards, snakes, skunks, moles, shrews, foxes, opossums, and bears. In fact, that is why all those hungry insects don't eat the tree up altogether: their many predators eat them first. On a pine plantation where the top priority is timber production, managers may deem it necessary to kill insects with pesticides, but in a natural old-growth pine community, numerous biological controls are acting. The birds alone are so important in controlling insect populations that they have been called "the keepers of forest health."[8] A single woodpecker eats several times its weight of insects in a day, and all trees are monitored.

Still other animals prey on the insect eaters. Among them are raccoons, hawks, shrikes, owls, indigo snakes, rat snakes, pine snakes, gray foxes, weasels, bobcats, and (in the past) panthers and wolves.

After woodpeckers drill holes in search of their prey, other birds and squirrels follow to eat from, or live in, the holes; then snakes climb the tree to go after the nesting young. Other snakes, lizards, salamanders, toads, and frogs hide and hunt other prey among the roots.

The tree serves the ecosystem in still more ways. The pine straw prevents erosion, preserves soil moisture, protects small plants, spreads fires, and slowly releases nutrients. Tip-up mounds expose bare soil, otherwise rare except after fires, on which seedlings can take root. Downed snags and rotted stumps provide moist shade, food, support for fungi, and habitats for mice, voles, toads, and other ground animals. And even after the tree itself has burned or rotted away, it benefits other community members. Its ash is the ideal fertilizer for the next generation of trees. The deep, branched holes that remain after the roots have burned make superb tunnel systems in the ground. At least ten species of animals use these stump holes, and the

Florida natives: Lichens on tree bark.

A **lichen** (LIKE-un) is an organism in which an alga and a fungus cooperate so closely that neither can survive without the other. The alga, which can capture the sun's energy, makes sugars that the fungus can use. The fungus dissolves mineral nutrients from the substrate into fluid that the alga can take up, and provides some protection from drying.

Coevolution is the process by which two or more species develop genetically determined adaptations to each other. A familiar example is that of flowers that have evolved scents and color patterns that attract certain insects and insects whose anatomy fits the flowers and ensures pollination.

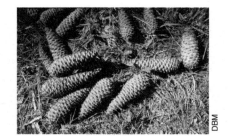

Longleaf pine cones.

Florida native: Fox squirrel (*Sciurus niger*).

LIST 2–2
Menus for the fox squirrel

Spring
Pine buds
Ripening pine cones from this year and last
Pine flowers
Mushrooms and other fungi
Florida maple seeds/fruits (H)
Insects

Early summer
Pine seeds (if numerous)
Mushrooms and fungi
Berries and fruits if available

Later summer
Pine seeds
Mushrooms and other fungi
Holly, bay, and greenbrier berries and grapes
Persimmon fruits

Fall
Acorns
Nuts from pignut hickory, pecan, chinquapin oak (H)
Seeds and fruits of cypress, sweetgum, tupelo, and tuliptree (S)
Pond pine cones
Mushrooms and other fungi

Winter
Mast, whatever is left
Older cones, seeds, fruits
Fungi

Note: Foods labeled (H) are from nearby hardwood forests, foods labeled (S) are from nearby swamps.

Source: Adapted from Weigl and coauthors 1989.

eastern diamondback rattlesnake is known to prefer them 60 to 1 over gopher tortoise burrows (which themselves are first-class accommodations).[9]

Besides providing habitats, the pine, its attached plants, and the plants of the groundcover produce food for many plant eaters. The fare includes flowers, leaves, stems, seeds, nuts, berries, acorns, bark, tubers, and rhizomes. These nourish insects, quail, squirrels, rabbits, deer, gopher tortoises, pocket gophers, cotton rats, mice, and numerous others. Even beaver and rabbits eat parts of the pines, and deer eat lichens that grow on the bark.

Clearly the resident populations of Florida's ancient pine grasslands exhibit many adaptations not only to the land's character and to fire but to each other. They have evolved side by side for so many generations that innate interdependencies have arisen—evidence of coevolution. All members benefit from the stability these relationships confer on them. The next three sections describe the webs surrounding a squirrel, a woodpecker, and a tortoise.

THE FOX SQUIRREL

The sight of this large, beautiful squirrel running across the ground with its long, dark, flowing tail rippling behind it like a small puff of smoke is almost diagnostic for old-growth high pine. When you see a fox squirrel, look around. You will usually see many other features of the classic environment.

The fox squirrel, the longleaf pine, and some of the underground fungi associated with the pine are knit together in a three-way relationship that suggests they have been coevolving for a long time. The squirrel derives food from both fungi and pine cones and helps to propagate both by spreading their spores and seeds. The fungi and the pine also interact, with the fungi taking sugar from the pine's roots, and the pine deriving soil minerals from the fungi.

Many aspects of this relationship illustrate why the natural, old-growth pine forest best serves its resident species. For example, green longleaf pine cones are a key support for the squirrel at the end of the hungry winter season, when other foods are in short supply. Green cones are produced reliably only by old-growth pines. It also happens that green cones are so tough that the fox squirrel is the only squirrel that can tear them apart to get at the seeds while they are still viable. In the process, the squirrel scatters a few seeds, and they have a chance to germinate. Months later, the cones will finally open and fall to the ground, but by then beetles have already eaten most of the seeds and those that remain are no longer viable. The squirrel's early attack on the cones helps propagate the pines.

The sound of a squirrel feasting on a green longleaf pine cone is arresting. The animal ravenously tears it apart like a demolition expert on deadline, and shredded parts fly everywhere. After the feast, you can tell it was a fox, not a gray, squirrel that was at work because the cone has been torn apart and chewed to the core. The squirrel's size and strength help it to protect its food, too. A longleaf pine cone is heavy, but if a predator

is near, a fox squirrel can carry the cone up a tree to the end of a branch, and eat it there. The squirrel can also run fast and far over ground where the trees are spaced well apart.[10]

The squirrel also eats fungi—both mushrooms and the fungi that produce their fruiting bodies underground. In the process, the squirrel ingests millions of fungal spores. Later, as it roams far and wide, the squirrel excretes the spores, undigested, in its droppings—most often where it spends most of its time—near the base of a longleaf pine. When a pine seed sprouts and becomes a tree seedling, the fungal hairs are already present in the soil to intertwine with it and form the close association that will benefit both throughout their lives. The three-way relationship described here holds true for eight or more whole genera of underground fungi.[11]

In late spring, summer and fall, high pine provides a cornucopia of nourishing foods within easy reach: pine seeds, low-growing acorns, and the nuts, buds, and bulbs of other native plants. The squirrel's population size varies with the availability of these foods, which are most abundant in regularly burned pine grasslands. Different foods nourish the squirrel in each season, as shown by an eight-year study whose results are summarized in List 2–2. Take away a plant species and a food will go missing—possibly an important food. This accounts for the rarity of fox squirrels except in old-growth pine.[12]

The squirrel also requires a nearby closed-canopy forest where it can breed and raise its young, and where the branches are close enough to permit safe travel from tree to tree. The squirrel builds a platform nest of sticks in the oaks, pines, or cypresses of hardwood hammocks, but returns to the nearby pine grassland to forage for food where it can move about on open ground without fear of unseen predators. The natural landscape provides an ideal arrangement: hardwood hammocks and cypress stands embedded in a pineland matrix.

Each fox squirrel has a home range of up to 50 acres, though some 13 to 60 squirrels can share a square mile of good habitat. (There are 640 acres in a square mile.)

Squirrels native to Florida today include the flying, gray, and fox squirrels, and the fox squirrels are the strongest and fastest. The fox squirrel is represented by some nine different subspecies, each occupying a different cluster of pine habitats.

THE RED-COCKADED WOODPECKER

The red-cockaded woodpecker's worth to its natural ecosystem far exceeds its own presence. It is an indicator species, in that its presence signifies a native community. It is adapted by tens of thousands of years of evolution to court, breed, nest, forage, and raise and defend its young in surroundings that offer numerous insects and an open, fire-pruned understory in which to hunt them. It is also a keystone species, in that its activities enable many other animals to thrive.

A **keystone species** is one that many other species depend on, so that its loss spells the loss of many others.

Florida native: Red-cockaded woodpecker (*Picoides borealis*). Belying the description that its name implies, the red-cockaded woodpecker is a black and white bird, with an almost undetectable spot of red above each eye, in males only.

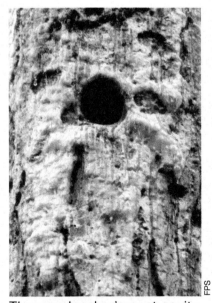

The woodpecker's nest cavity. The bird defends its home by pecking small wells around the entrance, so that sticky resin will drip down the trunk all around it. The resin deters invasion, particularly by tree-climbing rat snakes that live in the same territory. For as long as a bird uses a cavity, it keeps freshening these injuries on the tree.

Heart rot in pine.

Heart rot is the softening of a pine tree's resinous heartwood, caused by an in-dwelling fungus. Not all pines have it, but those that do make the excavation of a tree-hole nest cavity easier for the red-cockaded woodpecker.

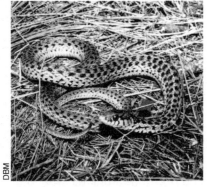
Florida native: Common garter snake (*Thamnophis sirtalis*). This snake uses high pine grasslands and many other ecosystems as its habitat.

The bird's requirement for a nesting site is exacting: it is the only woodpecker in Florida that drills its cavity in a living, native pine. No other woodpecker can excavate a nest cavity in a tough, living tree, and even the red-cockaded finds the task hard to do. The pine must have heart rot to make it soft enough to drill, and that means it has to be an old pine. As a result, the woodpecker is found only on sites with trees older than about seventy years.[13]

The bird meets the challenges of its difficult life by forming clans. Each breeding pair produces its eggs in the spring, and non-breeding family members stay nearby throughout the summer to help find food for the hatchlings. The pair drives away the female clan members in the fall, but may keep the males around for several years to help feed, house, and defend successive families. Clan members cooperate in drilling several cavities at a time. It may take from half a year to several years to complete any one cavity—one bird's roosting site. Not every bird rates a cavity; some roost in scars or crotches already available in trees.

Insects and other small invertebrates are the woodpeckers' food of choice: they eat a varied diet of spiders, ants, roaches, centipedes, and insect eggs, helping to control populations of these creatures. Lightning-struck pines make for especially bountiful dining, because they are infested first by beetles and later by ants that move into the beetles' abandoned burrows. (The ants are the arboreal species shown and described on page 44.) At times, up to 80 percent of the birds' diet consists of these ants, which they easily find under the bark of dead pine branches. If need be, the birds can also eat blueberries, cherries, wax myrtle berries, and other fruits.[14]

The red-cockaded woodpecker requires a large foraging area. Ideally, a single clan will be surrounded by at least 125 undisturbed acres of mature, live trees nine inches or more in diameter at breast height. If the site is of lower quality, a clan may need several hundred or even a thousand acres. The presence of several thriving clans of red-cockaded woodpeckers in a given area suggests that the habitat must be somewhat similar to that in which the species and its co-inhabitants evolved.

Red-cockaded woodpeckers once were common. Now they are rare, because their habitat, the pine grassland, has so greatly dwindled in area. Isolated colonies tend to die out because females, once they have left their original clans, fail to find mates nearby. The largest known population of red-cockaded woodpeckers living anywhere in the world consists of several hundred clans in Florida's Apalachicola National Forest.[15]

If a red-cockaded woodpecker's cavity comes available, many animals compete to move into it. Among would-be tenants are snakes, several types of bees, the broad-headed skink, and eleven kinds of birds, including the red-bellied woodpecker, the pileated woodpecker, the red-headed woodpecker, the great crested flycatcher, the American kestrel, and even the wood duck, which may nest hundreds of yards from water. Mammals use the cavity, too, among them the flying squirrel.

To this point, the strands in the pine grassland's web of relationships

Florida native: Gopher tortoise (*Gopherus polyphemus*). The gopher tortoise's ancestors have been present in North America for at least 55 million years and have produced 22 different species of land tortoise. Four species remain today, and the gopher tortoise is the only one remaining east of the Mississippi River.

Vulnerable to predation by bears, wolves, coyotes, and big cats, the tortoise digs burrows in which to hide. It is well adapted to this endeavor. The burrow's entrance is always on high, dry ground, but the tortoise digs down to just above the water table and so achieves a comfortable humidity and temperature. Except during heavy rains, the burrow is dry all the way to the bottom. Like people, tortoises can inherit homes from their forebears from several generations back. Some live in burrows known to be several decades old.

The tortoise burrow. The modest, tortoise-sized entrance offers no clue that the burrow descends well below the surface of the ground. Burrow lengths vary from three to 52 feet.

Tortoises may be either right-handed or left-handed. Those that have a stronger left front leg will dig a burrow that curves to the left, and vice versa.

Source: Ashton and Ashton 2004.

have all been attached directly to the pines. But there are other webs, and one involves a ground animal, the gopher tortoise.

THE GOPHER TORTOISE

The gopher tortoise is an ungainly, slow-moving, bland-looking creature, but like the red-cockaded woodpecker, it is a key member of the pine-grass-land ecosystem. For one thing, now that bison and wild horses no longer graze the groundcover, the gopher tortoise is the community's most significant native grazing animal. For another, the tortoise's burrow serves as a sort of community safe house. A northern bobwhite chased through the woods by a cooper's hawk can fly directly into a tortoise burrow and hide until the hawk has gone away. A rabbit may dash into a burrow to escape a fox. A Bachman's sparrow may flit down a burrow to hide from a hawk when the groundcover has recently been shorn by fire.

Gopher tortoises typically live at a maximum population density of only three animals per acre, each maintaining about eight to ten burrows. The burrows are pivotal to other animals' survival on that acre. Only one mature gopher tortoise lives in a burrow, but members of some 300 to 400 other species may reside there, too, finding needed shelter from sun, fire, and

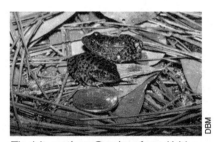

Florida native: Gopher frog (*Lithobates capito*). This frog is named for the gopher tortoise, whose burrow it frequently uses as its home.

Florida native: Florida mouse (*Podomys floridanus*). A gopher tortoise burrow makes a secure home for this little rodent that lives in side passages it digs for itself.

Florida native: Six-lined race-runner (*Aspidoscelis sexlineata*). This speedy reptile thrives in xeric habitats.

LIST 2–3
Amphibians and reptiles native to Florida's high pine grasslands (examples)

Amphibians
Barking treefrog
Gopher frog
Narrowmouth toad
Oak toad
Ornate chorus frog
Pine woods treefrog
Spadefoot toad
Striped newt
Tiger salamander

Reptiles
Coachwhip
Corn snake
Eastern diamondback
 rattlesnake
Eastern fence lizard
Eastern glass lizard
Eastern indigo snake
Eastern pine snake
Gopher tortoise
Gray rat snake
Ground skink
Mole skink (endemic)
Short-tailed snake
Six-lined racerunner
Southeastern crowned
 snake
Southeastern five-lined
 skink
Southern black racer
Southern hognose snake

extremes of heat and cold. For at least three or four species of vertebrates and for many arthropods, the presence of the gopher tortoise may today spell the difference between survival and extinction. Three dozen species live there the year around, including the gopher frog, the Florida mouse, the gopher cricket, and the threatened, nonvenomous, and beautiful indigo snake (which locals may call the gopher snake). Other permanent residents include blind and colorless beetles and flies that are adapted to life in the dark and cannot survive in the outside world. Visitors may include many kinds of salamanders, rattlesnakes (which don't bother the tortoises), pine snakes, skunks, opossums, armadillos, burrowing owls, lizards, frogs, toads, and many invertebrates. North America's largest tick lives on the tortoise and can use no other host. It takes a long span of years for such an exclusive relationship to evolve. The tick may not be a charming creature, but it does testify to the antiquity of *Gopherus polyphemus* as a species.

For plants, too, the tortoise's burrow digging offers mounds of bare soil in the sun—and in the absence of fire, these, together with tip-up mounds, are the main sites on which new pine seedlings can start their lives. For all these reasons, the presence of a stable and thriving tortoise population in its natural habitat signifies a healthy natural community and its absence indicates ecological decline. Where gopher tortoises today make their homes on grassy road shoulders or in the backyards of houses in subdivisions, they may survive for a time, but most of the animals that occur with them in natural sites will be missing.

Summer fires are as vital to the gopher tortoise as to the other members of the high pine ecosystem. The tortoise mates during April and May, and several weeks later the female lays about six eggs in a sunny place, usually in the sandy mound in front of her burrow. Nine years out of ten, the clutch is destroyed by predators such as armadillos, raccoons, foxes, skunks, and snakes, but now and then the eggs survive for the whole 80 to 90 days until they hatch. They hatch in August when, under natural conditions, summer fires have already burned across the landscape and new plant shoots are just coming up. The tortoise hatchlings are only about two inches long, and they struggle through groundcover and debris looking for their first food. They need to find young, tender, and abundant grasses and forbs right at ground level where they can reach out with their short necks and nibble the leaves. Dense, thigh-high groundcover is an impenetrable jungle to a hatchling tortoise. A pleasing sight after a summer burn is the tiny burrow made by a baby gopher tortoise.

Tortoises move to find grassy areas. They tend to disappear from areas that remain unburned, where shade and litter have built up. Their numbers increase in areas recently burned.

Once past the vulnerable hatchling stage, gopher tortoises are large enough to deter predation and too tough-shelled to eat. Thereafter they have few enemies other than people and dogs, and are thought to live for 50 years or more. They are slow to reproduce: they become sexually mature at about 18 to 25 years and only then can pass on their special

traits to the next generation of tortoises. Their slow reproduction rate, like their dependence on a habitat that is shrinking, makes them vulnerable to extinction, and today they are protected throughout their range.

From the gopher tortoise's point of view, three wishes must be granted to secure happiness: well-drained, sandy or loamy soil in which to dig a burrow; abundant low-growing tender plant life for food; and open, sunny areas in which to bury nests of new eggs. Fire-maintained high pine communities fill the bill.

OTHER RESIDENT ANIMALS AND VISITORS

Beneath the litter layer, on and in the soil, are many other microhabitats. Earthworms, beetles, cicada larvae, millipedes, moles, ants, and others keep turning the soil, returning nutrients to the surface and freeing them for reuse. And besides the gopher tortoise, several dozen species of amphibians and reptiles are found within the range of longleaf pine, and several are endemic. Examples are listed in List 2–3.[16]

Some birds spend their whole lives in Florida's pine grasslands. The red-cockaded woodpecker has already been mentioned. Northern bobwhites nest on the ground; wiregrass lends protection as they scurry along the ground with their chicks following behind them in single file. The American kestrel and the brown-headed nuthatch, too, require old-growth longleaf or a close facsimile for their habitat: they are absolutely dependent on its open spaces in which to hunt their prey. List 2–4 itemizes birds that breed, raise broods, or spend winters in north Florida longleaf pine communities. There are many more.

Winter birds are especially numerous. They fly south to use the pinelands as a winter haven, then return north for the summer to breed. Their numbers are higher in longleaf pine than in any other kind of Florida forest because forage is so abundant in natural, old-growth pine grasslands.

Communities 70 years old and older are especially rich in bird life. Stop in an old longleaf pine community in winter, get out of the car, and stand still. At first, the treetops seem devoid of life. But wait until the ripples you've created die down, and suddenly birds are sprinkled all over the trees, flitting from branch to branch, chipping and chirping, picking at the bark and pine cones, finding a feast of seeds and insects that earth-bound humans would never know was there. Others rustle about in the groundcover, eating tidbits from the grasses and shrubs, and pulling worms and grubs from among the roots.

Other migratory birds stop in on Florida's pine grasslands as they fly through in spring, on their way to breeding grounds farther north, and again in fall on their way to wintering grounds in South America. Like other birds, these migrants seek out old-growth sites, which best meet their needs for food and shelter. Florida's few remaining natural high pine communities, especially the old ones, are vital to many of the birds of eastern North America.[17]

LIST 2–4
Birds that use north Florida pine grasslands

American crow
American robin
Bachman's sparrow
Barred owl
Blue grosbeak
Blue jay
Blue-headed vireo
Brown thrasher
Brown-headed nuthatch
Carolina chickadee
Carolina wren
Chipping sparrow
Common grackle
Common yellowthroat
Downy woodpecker
Eastern bluebird
Eastern kingbird
Eastern meadowlark
Eastern towhee
Eastern wood-pewee
Fish crow
Great crested flycatcher
Great horned owl
Hairy woodpecker
House wren
Loggerhead shrike
Mourning dove
Northern bobwhite
Northern flicker
Palm warbler
Pileated woodpecker
Pine warbler
Red-bellied woodpecker
Red-breasted nuthatch
Red-cockaded woodpecker
Red-headed woodpecker
Red-winged blackbird
Ruby-crowned kinglet
Summer tanager
Swamp sparrow
Tufted titmouse
White-breasted nuthatch
Wood duck
Yellow-bellied sapsucker

Note: Some of these birds breed in the forest in summer, some spend winters there, and some do both.

Sources: Engstrom 1982, Repenning and Labisky 1985.

Florida native: Northern bobwhite (*Colinus virginianus*). The bobwhite's ideal habitat includes both open, bare ground on which to scratch up seeds, and thick tufts of wiregrass or the like in which to nest and hide. Longleaf pine communities managed naturally with summer fires best meet its needs.

Source: Bailey 1998. Need of summer burns from Tall Timbers staff 1996.

Florida native, endemic: Mock pennyroyal (*Stachydeoma graveolens*). Mock pennyroyal grows on sandhills, in flatwoods, and around pond margins.

Bird expert Roger Tory Peterson remarked that the variety and abundance of bird life in an environment is an index of its health. By that index, Florida's high pine grasslands are healthy indeed. Moreover, because natural high pine communities support migratory birds, their integrity supports the bird life of other ecosystems elsewhere.

VALUES OF HIGH PINE COMMUNITIES

Originally, Florida's ancient pine grasslands were valued for their timber. The loss of nearly all of them was due almost entirely to logging. The once mighty trees became masts for tall sailing vessels and the timbers for lodges, mansions, and dwellings all over the continent and in Europe. The ecosystem's lumber brought substantial profits to the South, but today, other values are recognized as perhaps even greater than the timber's market value. Viewed simply as masses of living plants, pine grasslands, like all terrestrial ecosystems, help regulate local and global environmental conditions. They capture carbon dioxide and store carbon in their tissues, helping to prevent global warming. They take up water from below the ground and release it into the air, contributing to regional rainfall. They absorb heat, moderating the climate. They keep soils porous and able to absorb water and prevent runoff. They immobilize or detoxify pollutants that would otherwise taint surface waters. They serve as a conduit for massive flows of materials (carbon, oxygen, nitrogen, phosphorus, and others) through natural cycles from earth and water to air and back again. Thanks to these services, some economists now agree with ecologists that "forests are worth more standing than logged."[18]

In addition to these values, which are common to all forests, the natural pine grassland is truly ancient. Pine savannas have existed on the Coastal Plain for more than 20 million years, the species that grow in them are superbly well adapted to the landscape, and many are endemic. Fossil records show that many species have been present in this ecosystem, essentially unchanged, for at least two million years, and their close interdependencies suggest that they have been evolving together for even longer. When species are lost from this interdependent system, all other species are affected and many populations die out.[19]

High pine savannas help to introduce fire into other communities nearby. Fires start up most frequently in high pine, and then sometimes spread into neighboring communities, which require fires at longer intervals to maintain them. Sand pine scrub sometimes ignites from high pine. Pond pines that grow in wet depressions in pineland grasslands depend on the heat from fires in the surrounding pine community to open their cones. Herb bogs are wet and often nearly treeless, so they are not prone to lightning-struck fires, but fires spreading into them from nearby high pine communities permit them to regenerate. At long intervals, fires from high pine burn into red-cedar groves and sand pine stands and promote their reproduction. If pine grasslands decline, other communities decline in concert, and if the grasslands are restored, neighboring communities

may recover as well. The whole, interlocked system of high pine, sand pine scrub, lowland pine, bogs, and adjacent wetlands is a single, fire-dependent system.

Beyond all of that, the pine grassland, in its natural state, is very species diverse, with some 50 to 250 species of plants per acre. One researcher has identified more than 50 herb species within just a few square meters. And the mix of groundcover plants is not the same in north Florida as in south Florida, Virginia, or Texas. Florida's pinelands also are a refuge for dozens of plant species that are endangered or threatened throughout their ranges.[20]

Finally, some people find spiritual inspiration when they visit places such as this. They hold that old-growth communities have a "transcendent aesthetic and religious value in the inner landscapes of natives and newcomers alike" and that "their majesty inspires comparison with . . . great cathedrals."[21] Perhaps we have some innate way of sensing intricacy, stability, and harmony. Perhaps something deep in us knows and needs these qualities.

Florida native, endemic: Florida beargrass (*Nolina atopocarpa*). This delicate plant, found only in Florida's pine grasslands, has become very rare. Its flowering stem is visible against the longleaf pine trunk in the background.

MAINTAINING HIGH PINE

It is a relatively new and welcome idea that forest ecosystems can be managed for values such as biodiversity instead of, or together with, timber extraction. In the case of high pine communities, management can center on maintaining a few species such as the red-cockaded woodpecker. Because the red-cockaded woodpecker's requirements are so exacting, they practically define the mature, healthy Florida pine grassland. If caretakers manage the ecosystem to provide optimal habitat for the birds, this benefits the whole community. Red-cockaded woodpecker habitat contains old trees, well spaced, that are suitable for cavities, and younger trees that will become good cavity trees later. It is frequently burned in summer and has few or no hardwood trees in the understory. It has many different plants bearing flowers and fruits at different times of year; it has healthy insect and other invertebrate populations—in short, it provides an environment in which all of the community's inhabitants can thrive and perpetuate themselves.[22]

Timbering is not incompatible with such management, provided that the groundcover is maintained relatively undisturbed and that different patches are selectively logged every year, leaving mature and variously aged trees for natural regeneration and later harvest.[23] What cause to celebrate, that this magnificent ancient ecosystem, after dwindling to a fraction of its former range, may still be there for our children and grandchildren to enjoy and learn from.

* * *

Fire exerts its influence on ecosystems all across the highlands, upland plains, and coastal lowlands, and even into wetlands such as bogs and marshes. The next chapter is devoted to the high pine grasslands' major neighboring communities—the flatwoods and prairies that surround them, which extend nearly all the way to the coast.

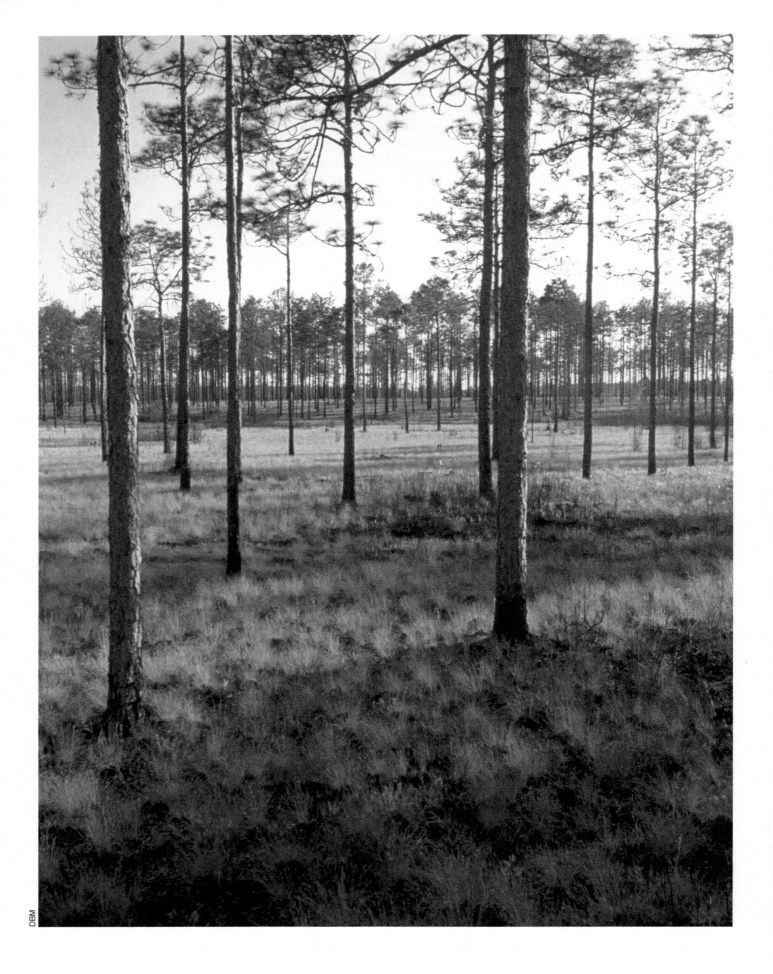

CHAPTER THREE

FLATWOODS AND PRAIRIES

Come down off the rolling sand and clay hills, now, and view the expanses of flat lands that skirt them. These, too, are part of Florida's pine grasslands—in fact, they are the larger part. They occupy the whole, broad band of sand and marl plains that once lay underwater off Florida's shores—that is, the coastal lowlands. In the past, they were the most extensive grasslands in the southeastern United States and covered about 50 percent of Florida. Today, although the underlying level terrain is still there, it is largely developed. The natural systems have all but disappeared.[1]

These communities go by many names: flatwoods, savannas, prairies, grasslands, plains—but because they are all level in topography, some being treed and some treeless, it is suggested that as a group they be described as flatwoods and prairies. Some are predominantly dry, some moist, some wet, and at the wet end of the moisture gradient, some support wetlands, as described in Volume 2 of this series, *Florida's Wetlands.*

Despite their various names, there is no mistaking flatwoods and prairies visually, as is clear in Figure 3–1. They have widely scattered trees, or no trees. They may have some shrubs, notably saw palmetto and gallberry, but under natural conditions, most shrubs are inconspicuous or absent. They have a diverse groundcover of grasses and forbs, including legumes. What defines them all is their flat expanses across which you can see long distances.

From their level appearance, it is easy to picture how these flat lands formed. During the past two million years, after the seas had receded from Florida's higher lands, ocean waters moved onto and off the lowlands many times and spread sand all across them. All of them have these features in common: fine sandy soils that are poor in nutrients, low flat topography, low rates of runoff, and water tables that are close to the ground surface. All are slightly to strongly acidic. (An exception is marl prairies, which are treated in Volume 2.)

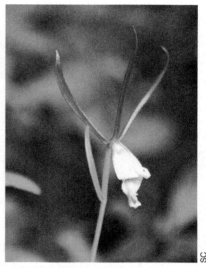

Florida native: Rosebud orchid (*Pogonia divaricata*). This orchid grows naturally in Florida flatwoods and bogs.

The **flatwoods** and **prairies** are the predominant natural communities of the coastal lowlands. They are level in topography with a continuous carpet of grasses (often wiregrass or its close relatives) and herbs. The flats called flatwoods have scattered trees; those called prairies are treeless or nearly so.

OPPOSITE: Longleaf flatwoods in April after winter burn. Pine flatwoods were popularly called "pine barrens" in earlier times, but in truth they are far from barren. It is now known that there may be more than 100 species of plants, and many more species of insects and other small animals, in an acre.

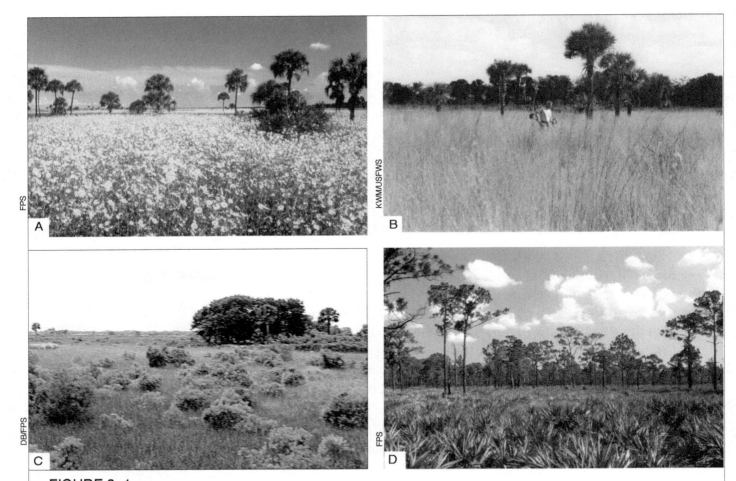

FIGURE 3–1

Various Flatwoods and Prairie Communities

A = A central Florida pine grassland abloom with wildflowers
B = A cabbage palm–wiregrass prairie near Kissimmee
C = A shrubby grassland in Kissimmee Prairie
D = A longleaf pine–saw palmetto flatwoods in the Panhandle

In north Florida, the trees on natural flatwoods are mostly longleaf pines except at low-elevation borders, where slash may hold a strip. In south Florida the pines are more often slash pines. Midway down the peninsula the two are mixed. Pond pine often grows in depressions. South Florida flatwoods have cabbage palms and some hardwoods as well as pines.

Flatwoods appear monotonous at first sight. Who would guess that they support vast numbers of fascinating plants and animals? One reason is that they are connected to many other kinds of communities. Taken all together, these communities provide many different combinations of habitats that meet animals' needs for food, shelter, nesting, and nursery grounds.

THE FLATWOODS-PRAIRIE MATRIX

Flatwoods and prairie communities form a matrix within which other systems lie. High pine grasslands stand on rises within them. Lower areas hold hardwood hammocks, marshes, swamps, ponds, and streams (all of

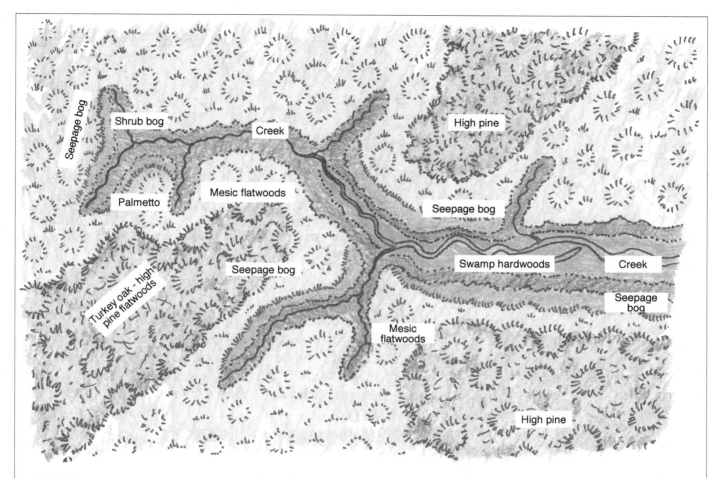

FIGURE 3–2

An Aerial View of Flatwoods

A typical flatwoods (or prairie) may contain many ecosystems. Here, a Panhandle flatwoods is shown in which high ground holds high pine grasslands. Low ground holds various kinds of forests, swamps, and bogs. A creek collects in a low area and will flow into a river, farther downstream.

Source: Clewell 1971, appendix.

these are treated in later chapters). Many animals conduct their lives using several different communities within such a mosaic. Figure 3–2 shows a flatwoods matrix within which other communities are embedded.

FIRE AND RAIN ON THE FLATWOODS AND PRAIRIES

Fire, water, and lack of water all influence what grows on the flatwoods and prairies. Under natural conditions, fires frequently clear away shrubs, favoring an open, grassy aspect. Rains are seasonal, and the land receives them differently than in high pine grasslands. In high pine, rain runs off or sinks into the soil relatively quickly, but in flatwoods and prairies, soils

Florida native: Pawpaw (an *Asimina* species). Many pawpaw species grow in pine flatwoods throughout Florida.

LIST 3–1
Shrubs in flatwoods and prairie communities (examples)

Coastalplain staggerbush
Dwarf huckleberry
Dwarf live oak
Fetterbush
Gallberry
Running oak
Sand live oak
Saw palmetto
Shiny blueberry
Tarflower
Wax myrtle
Wicky

Sources: Adapted from Abrahamson and Hartnett 1990, Stout and Marion 1993.

Three Florida natives: At left, narrowleaf blue-eyed grass (*Sisyrinchium angustifolium*). Center, tuberous grasspink (*Calopogon tuberosus*). At right, white birds-in-a-nest (*Macbridea alba*), an endemic species.

drain poorly and rains leave behind standing water. During rainy seasons, flatwoods and prairies remain soggy for weeks at a stretch, which for many plants would make survival difficult. Another stress, drought, alternates with rainy seasons and sometimes lasts for several years. To live and reproduce in flatwoods and prairies, plants have to be adapted to standing in water, to seasonal droughts, to decades-long droughts—and even to fires. Remarkably, many native plants possess all of these adaptations. Plant diversity in flatwoods and prairies is high.

Before people altered the landscape, fires swept across the broad expanses of the flatwoods as often as in high pine communities. Fires were ignited similarly by lightning, sweeping across the landscape for miles and often for weeks at a time, burning out at the edges of bogs and swamps, but in times of drought, all the way to the borders of water bodies. A mid-April to mid-July fire in Florida's flatwoods is shown on page 10.

Endemic: Leavenworth's tickseed (*Coreopsis leavenworthii*). The several plants in the genus *Coreopsis* bloom all year in moist to wet flatwoods and marl prairies as well as in disturbed areas. Collectively, they are Florida's "state wildflower."

Native: Chapman's rhododendron (*Rhododendron minus* var. *chapmanii*). This rare plant grows in Panhandle flatwoods and prairies.

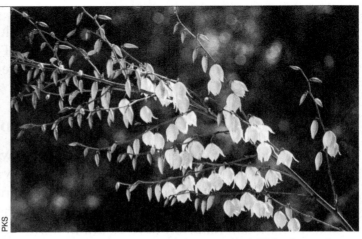

Native: Adam's needle (*Yucca filamentosa*). This showy flower blooms in spring in the drier parts of the flatwoods.

Flatwoods and Prairie Vegetation

Trees are sparse, spindly, and stunted in the flatwoods and prairies; sometimes there is only one slender tree per acre. Conditions are unfavorable for trees. The sandy soil is underlain by a water-retardant hardpan that tends to keep the soil waterlogged. That, and the soil's infertility, usually stunt the trees to well below 100 feet in height. Speculation has it that because the trees are more slender than in the sandhills and clayhills, they are more vulnerable to fire and require longer times to recover from scorch. The completely treeless prairies of central and southeastern Florida were once thought to be logged-over flatwoods, but they may in fact have been treeless all along, due to frequent fires.[2]

If shrubs get a foothold in flatwoods, frequent fires keep them low to the ground. Where shrubs are numerous or large, fire has been excluded for unnaturally long periods; shrubby flatwoods are probably the result of fire exclusion for ten to 25 years or more. Once present, though, shrubs can survive repeated fires: their root crowns and taproots store water and nutrients underground, and they can draw on these stores to regrow after their tops are burned.[3] List 3–1 names the main shrubs of flatwoods and prairies.

The grasses and forbs of flatwoods and prairies are mostly fire-loving plants, and as in high pine grasslands, many flourish best only if burned during summer every few years. They respond to fire by rapidly regrowing from their roots and by flowering and releasing seeds. Many, being highly flammable themselves, also help spread fires.

Hardly anyone, casually viewing a natural flatwoods or prairie, would guess that there were upwards of 100 species of groundcover plants on an acre. Only a few are apparent at any one time; they become conspicuous only when they bloom, and many don't bloom unless the groundcover has been recently burned. After a burn, though, the floral variety is astounding. Many of the groundcover plants are widespread across the southeastern United States, but a few are endemic and rare.[4] Endemic species are named in List 3–2.

Flatwoods and Prairie Animals

What kinds of animals might make use of a flatwoods or prairie? It seems an unlikely place for animals of any kind. Birds can't roost where there are few or no trees. Large animals such as deer, bear, bobcats, and foxes don't spend much time there, because they need cover. But simple looks deceive. The great variety of plants make food for many kinds of animals including a multitude of tiny insects and other invertebrates and small vertebrates that eat them. On a tiny scale, the animal life is rich and varied, especially when legumes and other forbs are flowering in response to burns.

Invertebrates. The buzz of insects in a flatwoods or prairie bespeaks a horde of tiny things that live in, and eat, all parts of the plants, and serve

> A **hardpan** is a layer of water-impermeable substances below the surface of the soil. It consists of accumulated organic materials and aluminum and iron compounds that have leached down from the sediments above it.

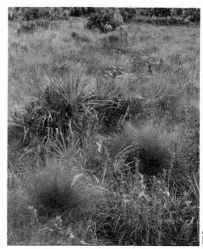

Florida native: Hairawn muhly (*Muhlenbergia capillaris*). This fire-loving grass, with its reddish seedheads, grows in flatwoods and coastal swales all over the eastern and southern United States. Here, it is growing in Caladesi Island State Park in Pinellas County.

> **LIST 3–2**
> **Endemic herbs in flatwoods and prairies (examples)**
>
> Cutthroatgrass*
> Fallflowering ixia
> Mock pennyroyal
> Rugel's false pawpaw
> Scareweed
> Yellow milkwort
>
> *Note:* *Cutthroatgrass requires seepage water and "cutthroat seeps" are wetlands.
>
> *Source:* Adapted from FICUS 2002.

Florida native: Apalachicola gruntworm of the flatwoods (*Diplocardia mississippiensis*).

Florida natives: Walking stick (a member of the order Phasmatodea, left) and Eastern lubber (*Romalea microptera,* right). These insects and hundreds of others occur naturally in multitudes in Florida flatwoods and prairies. The lubber grasshopper is a young specimen. Adults are black with yellow markings and red on their wings.

the plants by cross-pollinating them. Attention to detail in the grasses may reveal many grasshoppers, beetles, and other small insects. Spiders are numerous: many species live on the ground and many others in foliage. Inspection of saw palmettos may disclose other beetles, walking sticks, and paper wasps. Scrutiny of the soil might well reward the searcher with any of four species of ants, while at least two species of termites are busy disposing of fallen litter. A centipede and a millipede are also active in Florida flatwoods. Unseen, hundreds of other invertebrates are also present.[5]

To appreciate how many animals there may be in a flatwoods or prairie, consider just the earthworms. In his classic earthworm study, Charles Darwin estimated 50,000 earthworms per acre in English soils. Florida's soils probably support ten times fewer worms than this, but even 5,000 earthworms can do an impressive amount of work. Earthworms ingest the soil grains, digest bacteria and other microbes from them, and then excrete the grains as small, crumbly deposits called castings. Each earthworm excretes about a teaspoon or so of earth on the soil's surface each day, so that an acre of worms turns a prodigious ten to twenty tons of soil a year.

Processed by earthworms, flatwoods and prairie soils stay loose and inviting for plants to grow in. During droughts, earthworms, seeking moist soil, dig deeper. Then plant roots find the moisture they need by growing downward within the pores that the worms have left behind. Live worms serve as the dinner of choice for many slightly larger animals. Dead ones serve as food for decomposer organisms and then as nitrogen-rich plant fertilizer. Earthworms do more work, and of more different kinds, than any plow can do, but they burn no fossil fuel and leave behind no pollution.[6]

The earthworms of Florida's flatwoods and prairies are, by worm standards, stupendous in size. They are also numerous. A collector can gather a thousand in a day just by vibrating a stake in the ground (called "grunting" for worms). The vibrations drive the worms to the surface.

On learning to "grunt" for worms, one writer reported, "I bore down, surprising myself as I suddenly produced just the resonant worm-tingling grunt I was after . . . and pale legions of annelids magically began to emerge from their tunnels. I had become a pied piper of worms. The finest bait in

Florida native: Flatwoods salamander (*Ambystoma cingulatum*, left) and its larva (right). This salamander lays its eggs in depressions at the bases of clumps of wiregrass in October just before the winter rains fill them with water. The larvae then hatch and grow in the water. They metamorphose to adults in April or May, as the dry season begins.

Salamanders are safest from predation in ponds that dry up every year. The dwarf and mole salamanders also breed in puddles and ponds in the flatwoods and prairies.

Florida native: Ornate chorus frog (*Pseudacris ornata*).

the entire South—the finest, some say, in the whole of the planet—was surfacing all around me."[7]

Hundreds of other invertebrates dwell in the flatwoods and prairies, each species in almost unimaginably large numbers and performing equally important tasks. A lot more goes on than people see.

Amphibians and Reptiles. Consider what an amphibian (say, a salamander) is up against when living on a Florida flatwoods or prairie that may be altogether dry for long times, and then soggy wet for equally long times. Salamanders easily meet the challenges of the alternating flatwoods seasons: they spend their early lives in the water and their later lives on land, takng refuge underground. Many species of frogs also spend their lives in flatwoods. Like salamanders, they breed in ponds and puddles and their tadpoles mature there; then, as adults, they live on higher ground or in nearby trees. These small animals make attractive prey for garter, eastern ribbon, and hognose snakes, as well as for visiting birds. Two species of turtles are also common—the mud turtle and box turtle.

Birds. Some birds nest in the flatwoods, while others nest in adjacent swamps and hammocks and then fly into the flatwoods to forage. Migratory birds use the flatwoods as refueling places. Open, largely treeless expanses invite insect-eating birds to skim low over the grasses and pick out morsels among them. By day, the eastern meadowlark and red-winged blackbird hunt this way, and by night, the common nighthawk does the same. These smaller birds become prey for the American kestrel, the white-tailed kite, and the short-tailed hawk, which are often seen soaring high over the land. More rarely, over Florida's central dry prairies, the peregrine falcon, the grasshopper sparrow, and the bald eagle may be seen. List 3—3 presents a partial list of birds often seen in Florida's pine flatwoods.

Three species of large birds nest in prairies: a crane, an owl, and a vulturelike hawk. In spring, the Florida sandhill crane executes its thrilling, ages-old mating dance on central Florida's prairies; then it nests in embedded marshes. The burrowing owl makes its home in the abandoned burrows of gopher tortoises and other digging animals on central Florida's

LIST 3–3
Birds seen in Florida's pine flatwoods (examples)

Bachman's sparrow
Bald eagle
Black vulture
Brown-headed nuthatch
Carolina wren
Chuck-will's widow
Common yellowthroat
Eastern towhee
Henslow's sparrow
Northern bobwhite
Northern cardinal
Pine warbler
Red-bellied woodpecker
Red-cockaded woodpecker
Red-shouldered hawk
Red-tailed hawk
Turkey vulture
Wild turkey
Yellow-throated warbler

Source: Adapted from Stout and Marion 1993.

Florida native: Burrowing owl (*Athene cunicularia*). Close by its burrow, this engaging small creature bobs, cackles, preens its mate, and periodically leaps up to hover 20 feet above the ground. It has a rich vocabulary of some 13 different calls, one of which mimics the rattlesnake's rattle and scares potential predators away. Florida populations are non-migratory and most pairs mate for life.

Source: Haug and coauthors 1993.

Florida native: Crested caracara (*Caracara cheriway*). Unlike vultures, this scavenger spends most of its time on the ground.

Florida native: Florida sandhill crane (*Grus canadensis pratensis*). One of Florida's largest native birds, the crane uses a mosaic of habitats in the Okefenokee Swamp, in basin wetlands such as Paynes Prairie near Gainesville, and in parts of the Kissimmee Prairie north of Lake Okeechobee. These ecosystems offer both shallow ponds, in which the crane builds large conspicuous nests, and expanses of dry prairie where it forages.

Each pair mates for life and produces one to two young per year. The courtship ritual is a famous, dramatic mating display.

Source: Stys 1997.

prairies. The crested caracara, a scavenger, nests and forages in cabbage palm flatwoods.

Wild turkeys illustrate especially dramatically how well adapted native species can be to their natural environments. Wild turkeys have inhabited the flatwoods and prairies for millions of years. Observer Joe Hutto spent a season living and roaming with a flock of wild turkeys and reports that their instinctive behaviors are molded to give them every advantage under natural conditions. They notice everything that relates to their survival and take appropriate action, and by the same token, they ignore things that are unimportant (to turkeys). They run from large predators and fend off small ones. They recognize venomous snakes, warn each other, and steer clear of them, but waste no energy being alarmed by harmless snakes. They alert each other to danger, stick together in a flock, call in straying members, and find nourishing foods in every season.

Turkeys find the many foods they need all year in the flatwoods. In spring, young turkeys eat spiders and green grasshoppers; in summer, they turn to ripe blackberries and, later, blueberries. By fall, when fully grown, they eat fox grapes, lizards, and frogs together with earthworms and dozens of kinds of insects. (List 3—4 shows what their fall menu might consist of.) Hutto sees in wild turkeys "a remarkable preexisting genetic understanding of the various aspects of their environment . . . it seems they are born ancient."[8]

The wild turkey uses every part of the flatwoods mosaic—not just the

Wild turkey (*Meleagris gallopavo*). Turkeys use all parts of the the terrain—pine flatwoods, hardwood hammocks, thickets, ponds, and streams. In earlier times, they roamed freely all over Florida, but today only the more cautious ones remain and produce equally cautious young.

hardwood hammocks or the flats, but all parts, including open prairies or flatwoods, hammocks, marshes, swamps, ponds, and streams. The turkey nests in thickets on dry ground burned a year earlier. As the young mature, they begin to roost in the trees. Turkeys stroll in bands through flatwoods and hardwood hammocks in search of food, seek cover and rest in thickets, and quench their thirst in streams and ponds.[9]

Mammals. Several species of small mammals are numerous in flatwoods and prairies, among them the cotton rat, the cotton mouse, the harvest mouse, the least shrew, and the short-tailed shrew. The rodents thrive on the living salad provided by the diverse groundcover plants. They use all parts: roots, stems, leaves, flowers, and seeds. The shrews eat the

Florida native: Hispid cotton rat (*Sigmodon hispidus*). For its rapid reproduction rate, this little animal might well be called "the mother of all mothers."

Florida native: Cotton mouse (*Peromyscus gossypinus*). This is another prolific and important prey animal for predators of flatwoods and prairies.

Florida native: American bison (*Bison bison*), restored to Paynes Prairie, Alachua County.

multitude of insects that swarm among the plants. In turn, these small animals are a favorite food of larger mammals, snakes, and birds of prey.

That small mammals can withstand the constant pressure of such heavy predation is a tribute to the rapidity with which they multiply. Take the hispid cotton rat, for example: it has been called "the ultimate baby machine." In theory, a single newborn female cotton rat can produce more than 150,000 descendants within a year of her own birth. The cotton rat's gestation period is a brief four weeks; the newborns number up to a dozen (averaging seven) at each birth; they are weaned and independent within a week; and the mother can immediately become pregnant again. Such rapid reproduction rates enable rats and mice to serve as the community's main converters of plant to animal protein. All of the local carnivores can stuff themselves with rats and thrive. Clearly, although a flatwoods or prairie may not look like much, it is a highly productive ecosystem.[10]

Mammals that visit Florida's flatwoods and prairies from nearby include the raccoon, opossum, cottontail rabbit, gray fox, bobcat, white-tailed deer, Florida black bear, and even Florida panther. The fox squirrel is occasionally seen.

Prior to 11,000 years ago, a species of bison (*Bison antiquus*) also roamed central Florida's flatwoods and prairies and played an important role as the ecosystem's major grazing animal. It maintained shortgrass prairie plants by cutting them, which stimulated their growth. Bison also served as a dispersal agent for plants because their thick fur readily picked up barbed and sticky seeds. Their hooves conditioned the sod to ease rain infiltration, and their wallows caught water in rainy times and served as small reservoirs in dry times. Their extinction in Florida, together with the

demise of many other large animals, may have been caused by overpredation by early human hunters.

After the original bison died out, another species, the American bison (*Bison bison*) migrated in from the Great Plains. These bison penetrated as far south as Hillsborough County, but they, too, were overhunted, this time by European and African settlers. The last of these bison was shot in 1875. As a conservation measure, small herds of plains bison have been reintroduced to several locales in Florida.

Florida native: White peacock (*Anartia jatrophae*).

VALUES AND MAINTENANCE OF FLATWOODS AND PRAIRIE COMMUNITIES

Not many of Florida's original flatwoods and prairie ecosystems remain in natural condition. A few notable communities that remain are listed in List 3–5.

Because natural flatwoods and prairies are so much reduced in area, those that remain are especially important ecologically. The ecosystems that naturally occur on the lowlands have been present and evolving for millions of years. They are part of a landscape mosaic, linked to other communities at both higher and lower elevations adjacent to them, and the whole array hosts enormous diversity of both plants and animals.

Fire links these neighboring communities together. Fires at intervals of from one to three years are indispensable in maintaining flatwoods and prairie plant communities, and once ignited in one community, fire can spread into the others. Animals, too, link Florida's flatwoods and prairies to neighboring communities. The fox squirrel breeds and nests in hardwood forests but forages in pine grasslands. Many frogs and salamanders require ponds in which to reproduce and nearby higher, drier land for their adult lives. The Florida sandhill crane nests in marshes and forages in prairies. The wild turkey uses all parts of flatwoods and prairie mosaics. For these animals and many others, the integrity of the landscape is important. The few natural communities still found in Florida today deserve preservation.

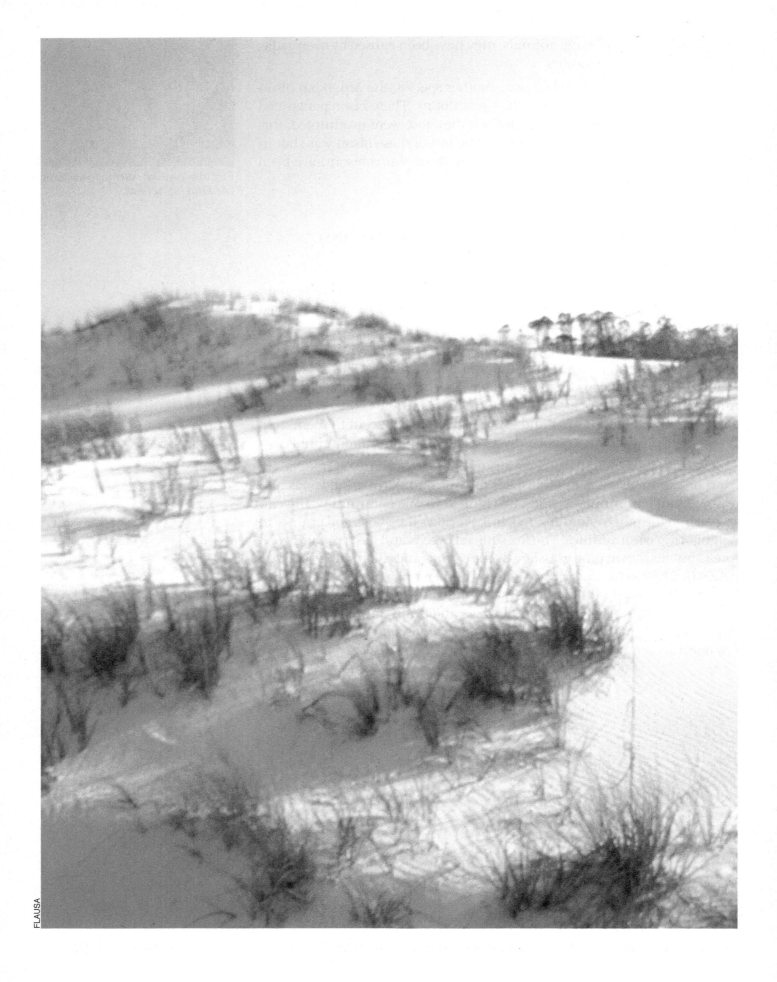

CHAPTER FOUR

BEACH-DUNE SYSTEMS

Walk along an unspoiled beach anywhere in the world and you will enjoy the same familiar features. The waves roll in from offshore, the dunes are clad in their characteristic gnarled vegetation, and behind the dunes lie interdune fields and maritime hammocks dotted with ponds and marshes and rich with plant life and birds. All natural high-energy coastlines have these features, for all have been formed by the same forces—wind and waves, working on the same materials—sand and shells. Chapter 2 described how, along these shores, restless winds, waves, tides, currents, and storms constantly move sand from place to place. This chapter enlarges on that theme of constant change, because change places demands on every plant and animal in beach-dune systems.

Florida native: Gulf fritillary (*Agraulis vanillae*). This butterfly occurs all along the eastern seaboard. Individuals from farther north fly south to the Gulf coast in winter.

SHIFTING COASTAL SANDS

Coastal landforms are very dynamic, compared with others. Most of the beaches, dunes, and barrier islands that fringe the world's continents have been formed just recently, in geological terms—they are no more than about 6,000 years old. All of Florida's barrier islands, large and small, have come into being in just these past six millennia. The early Native Americans were here long before the present-day beaches were; the ocean was 200 to 300 feet lower when they first came. Florida's beaches at that time were anywhere from a few to 200 miles farther out than the present coast, and barrier islands long since drowned lay offshore beyond them.

Today, those long-ago beaches and barrier islands lie deep under water off our present shores. Divers report that they are still decked with ridges, dunes, and even the drowned remains of ancient inland forests. Still, the shoreline looks the same, because new beaches and barrier islands have formed where the coast lies now—not everywhere, but wherever winds and waves carry enough energy to create these formations. Between the stretches of high-energy shores are coastal marshes and swamps, the subjects of the next chapters.

Beaches are long, usually narrow, strips of sand and shells heaved up by wave action along the shore.

Dunes are mounds of sand piled up by wind.

Barrier beaches face open water along seashores.

Barrier islands are long, narrow islands parallel to the coast. Each barrier island has a barrier beach on its ocean side.

High-energy shores have beaches and fields of dunes.

Low-energy shores have wetlands, notably salt marshes and mangrove swamps.

OPPOSITE: Dunes on Navarre Beach in Okaloosa County.

The **coastal uplands** along Florida's shores consist of beaches, dunes, berms, flat lands, dry swales, and mounds that are composed mostly of sands, shells, and marls.

Florida native: Joewood (*Jacquinia keyensis*). This extremely rare plant grows, in Florida, only in coastal hammocks in Lee, Miami-Dade, and Monroe counties.

A **beach ridge** is an elongated pile of sand pushed up in the water offshore from a beach by unusually strong winds and high tides.

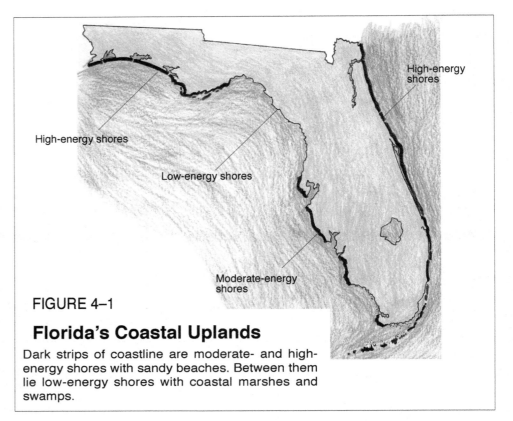

FIGURE 4–1

Florida's Coastal Uplands

Dark strips of coastline are moderate- and high-energy shores with sandy beaches. Between them lie low-energy shores with coastal marshes and swamps.

Why are there sandy beaches along some stretches and coastal wetlands along others? The waves coming onshore make the difference: they are highest and most energetic where the land slopes steeply into the ocean, and they are barely perceptible where the land and offshore seafloor are flat. Figure 4–1 shows the locations of Florida's coastal uplands, where vigorous wind and wave action rearrange coastal sands a little every day, and massively over years and during storms. Beaches may grow outward by the addition of sand, they may be eroded away, or their sand may migrate along the shore, depending on which ways the winds, waves, and currents are moving.

Broadening of Beaches. A beach grows outward in a giant step when a major storm piles up a ridge of sand just offshore and sand fills in the space between. A major storm has unusually large waves that scour huge quantities of sand from the ocean floor and then, on reaching shallow water, slow down and drop the sand in a great heap parallel to the shore. As the storm retreats, it leaves the ridge of sand above water, adding substantial area to the beach.

Once laid down, a beach ridge may remain in place for decades or even centuries until another major storm moves its sand again. For as long as it is present, the ridge protects the land behind it from erosion. Other ridges may form seaward of the first, and as the swales between beach ridges fill in with sand, the ridges seem to be moving inland. In reality, though, the shoreline is moving farther out to sea.

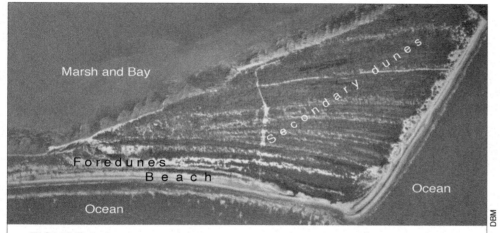

Marsh and Bay

Secondary dunes

Foredunes
Beach

Ocean

Ocean

DBM

The first row of dunes facing the ocean is called the **fore-dunes** (or **barrier dunes**). Those behind them are the older, **secondary dunes**.

FIGURE 4–2

Island Building

Saint Vincent Island, Franklin County. The island is now being eroded as sea level rises and storms intensify, but its beach ridges still reflect the way its beaches and dune fields were built in the past. In past centuries, each beach ridge was first shoved up in front of the island by a major storm. Between storms, wind-blown sand filled the space behind the ridge, in effect adding it to the island.

It is beach ridges that, over the past 6,000 years, have served as the foundation for Florida's present barrier islands and coastal beaches. Ridges that now are part of barrier islands show up in aerial photographs as parallel stripes, easy to see because the ridgetop vegetation differs from that in the swales. Figure 4–2 provides an example.

Once the water has laid down a beach ridge, the wind piles sand on top of it, forming dunes. The process of dune building occurs in small bits daily, mostly as the tide is falling (see Figure 4–3). Grains of sand dry in the wind and are blown up the beach until they strike an obstacle such as a rooted plant, most often seaoats. The sand grains fall and pile up around the oat, the oat responds by growing upward, and an oat-decorated dune forms. Sand dunes are a feature of all of Florida's high-energy shores.

The higher a dune grows, the stronger the wind must be to lift sand to its top. Winds coming in off the Gulf of Mexico are strong enough to pile sand 30 feet high, and winds along the Atlantic coast are even stronger. And unlike beach ridges, dunes can march landward over time. Sand is constantly blown over the windward side of each dune and falls on the leeward side, so that the dune gradually moves inland. New dunes form in front of the old ones as the winds keep blowing.

Beach Erosion. While some storms add to coastal sands, others drag whole beaches back into the ocean or shove them into bays. The direction of transport depends on the direction and strength of the waves and winds. Today, several factors combined are rapidly eating away at many of Florida's beaches. The sea level is rising and major storms are becom-

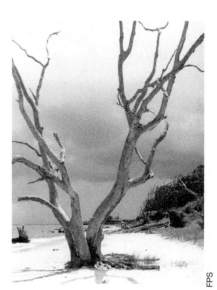

FPS

Tree skeleton on a beach. The beach has been eroding, due to a rising sea level. Encroaching salt water has killed the roots and the dead tree remains standing.

First, sand is left behind by retreating waves.

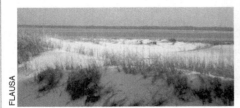

Next, the wind blows the grains of sand up the beach and they pile up around obstacles such as seaoats.

FIGURE 4–3

Dune Building and Maintenance

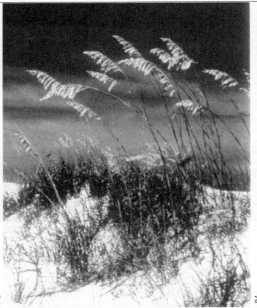

Then the seaoats grow taller, the newly buried parts of their stems become roots, the roots grow longer, and more sand piles up around them, building a dune. Fort Clinch State Park, Nassau County.

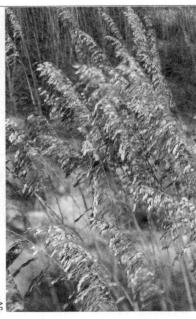

In all seasons, seaoats hold dune sand in place. These were photographed in fall in Caladesi Island State Park, Pinellas County.

ing more frequent. Homes and hotels are built on dunes with "erosion-prevention" structures but ironically, these promote beach erosion. They prevent deposition of added sand and they cause waves to rebound with extra force and carry more sand away.

Longshore Movement of Sand. Sand moves underwater, not only onto and off the coast, but along it, transported by the longshore current (called longshore drift). The longshore current drags sand from one place to another with varying effects. Sand continuously moves from one beach to the next, or from one barrier island to the next, so that, in effect, the beaches and barrier islands are parts of a river of sand. Sand from the end of a barrier island may shift into the space between that island and the next, filling in a pass. Sand may be added to the end of a spit, making it longer; or eroded from the heel of an island, making it shorter. Over time, barrier islands can actually move along the shoreline (see Figure 4–4).

Storms combined with longshore drift can wreak dramatic effects on coastal sands. A storm may cut a channel across the neck of a spit, isolating its tip—now, the barrier spit has become a barrier island. Another storm may cut through a barrier island, creating a new pass, and later, the pass may be filled in again. Successive storms may carry sand from island to island, so that the islands "march" along the shore. If a stretch of the coastline seems calm and still, that is only an illusion like the split-second photo of a diver in mid-dive. The next second, every part of that scene will be somewhere else.

Sources of Sand. In times past, rivers delivered sand to the coast,

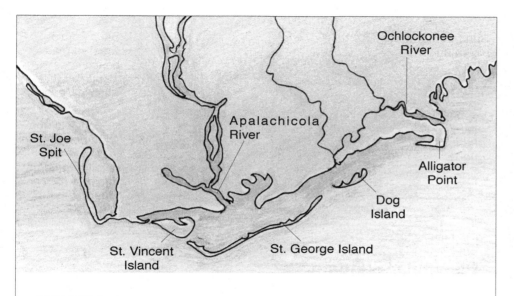

FIGURE 4–4

Longshore Movement of Sand (Examples)

Sand delivered earlier by rivers is now moving along the shore with longshore drift. The two spits and three islands shown here are constantly losing sand from their eastern ends and adding it at their western ends, in effect migrating westward along the shore. As a result, pioneer plants constantly have new opportunities to take hold and grow.

Florida native: Coastal sandbur (*Cenchrus spinifex*). This thorny-seeded plant grows along both coasts of Florida. It sticks painfully to people's feet, dogs' paws, and whatever other animals brush by, and then is often carried long distances before it is dropped or picked off. By this means, it achieves wide dispersal.

which was then picked up by water or wind and distributed onto beaches, dunes, bars, and other formations. Today, sand that is flowing down rivers settles out along the way, trapped by dozens of dams. Very little river-borne sand reaches the coast. When "new" sand seems to be deposited along the coast today, it comes not from the interior but from near or far coastal formations or from the ocean floor.[1]

Still, beaches, dunes, berms, swales, flats, interior sandhills—all are made of sand deposited by water or wind. Most sand formations are more or less sorted—that is, some are made of fine grains of sand only, some of coarse sand and shells. The famous, powdery, "sugar sand" on today's Panhandle beaches and dunes is made of very fine quartz grains that were deposited by rivers on their deltas some two to five million years ago. When exposed at low tides, they are blown inland and dropped on the Panhandle's beautiful beaches and dunes. Wind picks up only the small particles and leaves heavy ones behind, so dune sand is especially powdery and light. The sand grains are of uniform size and air occupies the spaces among them, so they stay loose. Wind-formed dunes tend to blow around, and plants find no firm foothold there unless, like seaoats, they can produce masses of tangled roots that stabilize the sand.

Figure 4–5 shows the contrast between the Panhandle's fine, powdery sand and the "sand" on the southern and Atlantic-side beaches, which is coarse and is made of both shells and sand deposited by water. It is unsorted: its grains are of all sizes. The smaller grains fill the spaces among

Florida native: Cockspur pricklypear (*Opuntia pusilla*). This cactus, a desert plant, grows well in sand that drains rapidly after rains. Here, it is growing within a few feet of the sea and just one foot above sea level.

Sand from a wind-blown dune . . .

. . . consists of tiny grains of quartz.

Sand from a water-formed beach ridge along Florida's Atlantic Coast

. . consists of a high percentage of shells and shell fragments mixed with quartz grains.

FIGURE 4–5

Dissimilar Sands

The source and nature of the sand help determine what will grow on a site, even centuries later.

A beach has two zones: the foreshore and the backshore.

The **foreshore** is the zone that is wet by each high tide.

The **backshore** is the sand, normally dry, above the high-tide line. The backshore is wet only by rains and flooded only by storm and hurricane surges.

Burial by sand. From the moment they sprout, dune plants face an avalanche of sand that seems intent on burying them. This Florida native, beach morning-glory (*Ipomoea imperati*), is hanging on by its roots and growing as fast as it can.

the larger grains and as the shell material dissolves, a carbonate adhesive leaches out that tends to cement the grains together. Bars and beach ridges, because they were formed by moving water, are more cohesive than are dunes: they hold water better and make a more stable base for plant roots.

The differences among sands from different sources persist for centuries and are still seen in sandhills that now stand in Florida's interior, miles from the sea. When wandering on a sandhill, pick up a handful of its sand and speculate on its origin. Is it fine and powdery? Then it must have been a dune. Is it coarse and unsorted? Then it must have been a beach ridge, sand bar, or spit. Depending on its origin, it supports somewhat different plants and animals to this day.

PLANTS OF COASTAL UPLANDS

Because coastal landforms shift rapidly from place to place, individual plant communities are short-lived. Coastal plants survive and produce new generations thanks to their gift for being able to relocate with shifting sands, and in that sense, they are stable and long-lived.

No rooted plants grow on the foreshore, because twice-daily inundation by vigorous saltwater waves is too great a stress to withstand. The first rooted plants take hold on the backshore—the familiar plants beachgoers see at the foot of the dunes. Not everyone realizes, however, that the plants may have been the first to arrive; the dunes may have begun to grow after.

Dune Vegetation. Plants that help to hold the sand in primary dunes are remarkable for their mastery of a challenging, even threatening, set of conditions. Consider what plants have to put up with to grow on a primary dune. Five major factors limit life there. First, the wind is constantly shifting the sand around the roots, which makes it hard to maintain a foothold.

Second, continual bombardment by wind-blown sand abrades plant tissues and threatens to bury all obstacles. Third, rain drains away through the coarse, porous sand almost as fast as it falls, but plants growing in sand need freshwater often. No matter how high on a dune they are, their roots still must reach to the freshwater layer that lies just above sea level. Fourth, offshore winds blow salt spray onto the dunes; then, when rains follow, the salt is washed away. Plants have to cope with both extremes. Finally, coastal sands are exposed to extremes of temperature, with summer midday readings commonly above 100 degrees F. And unlike humans, who can duck into the shade when the sun is high, plants have to stand in place and endure the scorching heat.

Most seeds that land among these hazards find it impossible to grow. Only a very few are sufficiently adapted to withstand such hostile forces. They are members of an elite group: true beach pioneer plants. The quintessential beach pioneer is seaoats. To grow vigorously, seaoats actually require the constant accumulation of sand because it stimulates their buried stems to convert to roots and proliferate.

Seaoats also thrive on the repeated doses of sea salts that ocean spray delivers. Their stems and seed heads become sticky with salt, but a thick, waxy coating protects their internal tissues from injury. When rains come,

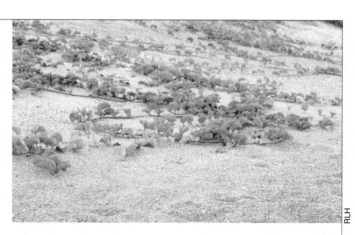

LEFT: Beach peanut (*Okenia hypogaea*). This plant, after growing its fruit, pushes it down into the sand, where it will escape being blown away by the wind. Thus it can produce a new plant the next year in the same place. If a storm wave washes the fruit out of the sand, it floats to the uppermost reach of the wave and germinates in the sand there, so it is just out of reach of the highest likely water line.

RIGHT: Coastal searocket (*Cakile lanceolata*) has a two-stage fruit that doubles its chances of survival. The bottom half stays attached to the parent plant and is buried with it by drifting sand at the end of the growing season. The top half breaks free and floats on the water to drift ashore elsewhere and colonize a new site.

ABOVE and RIGHT: Railroad vine (*Ipomoea pes-caprae*). The railroad vine produces its longest runners at right angles to the shore. No matter how much sand either piles up or blows away in a season, some nodes will be located in just the right places to grow the next year.

FIGURE 4–6

Beach Pioneer Plants

the salts wash down to the roots and nourish the plant. Thus seaoats catch their own fertilizer. In this way, seaoats and other foredune plants acquire as many nutrients as do typical inland plants from all other sources.[2]

Seaoats also grow best in company with a root-associated fungus, just as longleaf pines do. This association, useful to both the seaoats and the fungus, bespeaks the long time during which the two have been coevolving.

Without seaoats, Florida's primary dunes would blow away, leading to rapid erosion of the coastline. With seaoats, dunes keep growing higher. So important are seaoats to dune stability that the law protects them and prosecutes those who pick seaoats.

Other pioneer plants (shown in Figure 4–6) also colonize primary dunes: beach morning-glory, railroad vine, evening primrose, coastal sandbur, tread softly, several tough grasses, and others. All of them exhibit special adaptations to beach life. All, like seaoats, have long, tough, branching rootstocks that bind dunes together. All have tough, waxy leaves that withstand abrasion and resist water loss. All can also cope with hot sun and desiccating wind in dry sand that holds rain water only for an instant. All can quickly colonize new areas and hang on as the sand shifts about. Many produce seeds that can sprout and shoot up even if they are buried under two to four inches of sand. Other beach plants exhibit other special adaptations.[3]

Many of these remarkable plants, like seaoats, not only can survive in, but are dependent on, shifting sands for their growth and reproductive success. If the substrate is stabilized, as when new dunes rise seaward of the old ones, these plants not only fail to thrive, but age and die as other plants, better adapted to stable soils, succeed them. They are also extremely sensitive to mechanical disturbance and die quickly if run over or trampled.

Interdune Vegetation. The lee slopes of dunes and the swales between them provide sanctuary for a different array of plants, which tolerate salt spray and wind less well. Plants in low areas face less stress from winds and sand abrasion, but more from periodic inundation by sea water washing between the foredunes at extreme high tides and storms. (Coastal grasslands may also be called overwash plains.) With the stress of inundation comes an advantage, though, in that seaweeds often wash in and pile up in interdune areas. The seaweeds act as a natural mulch, providing shade and moisture in which seeds can start up.

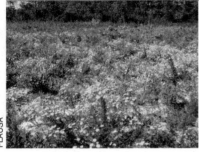

An interdune swale on the northwest Florida coast.

Narrowleaf yellowtops (*Flaveria linearis*), a native coastal plant.

Firewheel (*Gaillardia pulchella*), also native in some areas.

FLORIDA'S UPLANDS

Behind the primary dunes and interdune fields are older dunes. Ongoing buffeting by rainfall and wind, and wear from plant and animal action, have rounded them off and smoothed them out. As a result, they may be lower than the foremost barrier dunes and are somewhat protected from salt spray, winds, and storm surges.

On slopes and in hollows are grasslands, shrub communities, and hammocks of various kinds. Different stretches of the coast have somewhat different characteristic plants, many of which are found nowhere else. Ecologists identify 22 species of plants endemic to Florida's coast and seven others that spill over the state's boundaries just a little. Endemics are especially numerous along the Panhandle, which has for millennia been isolated from other coastal uplands by extensive coastal marshes.[4]

Older dunes support still more kinds of trees, shrubs, and herbs, and these, too, tend to be somewhat different in each sector of Florida. Scrub zones among older dunes on the east coast are often dominated by wax myrtle; those along the central Atlantic coast, by saw palmetto; those of the south Florida coast, by a dwarfed form of seagrape; and those of the Panhandle, by woody goldenrod and rosemaries. There are other patterns, and there is much overlap, but one thing is clear: plants have to be specially adapted to thrive in coastal uplands. It is not surprising that plants from the interior seldom, if ever, last for any time, even if they manage to get started at the coast.

The oaks, pines, and other trees of dunes near the coast take on distinctive shapes, because they are pruned and flattened by salt spray. The salt kills those growth buds that are facing ocean winds—only those growing back toward the land can grow and elongate. Hence all the branches are angled upwards and away from the sea. When their main growing tips succumb to the ravages of sun, salt, and wind, individual trees shunt their growth into inordinately large lateral branches, so that they become flat-topped, gnarled, and twisted.

Just as seaoats at the edge of a beach enable dunes to begin growing at first, so do older, larger plants such as trees help form secondary dunes. Oaks first start up from acorns that roll onto the flat land between dunes, often helped in getting started by a mulch of seaweed blown or washed in during storms. As they grow, they obstruct wind-blown sand flying off the foredune top. The oaks grow both upward and laterally, barely escaping burial; and the more branches they grow, the more sand falls around them (see Figure 4–7A). Their original roots are soon buried so deeply that they are deprived of oxygen, but as burial proceeds, the trunks and branches sprout additional roots. These new roots capture oxygen, keep the tree alive, and help to hold the dune in place. Finally, a full-sized dune surrounds the entire tree, except for the very tips of its wide-reaching branches (Figure 4–7B).

Such a dune is only temporary, though. Sooner or later, extra-powerful winds will blow the sand away from around the tree. The roots along the trunk will then be visible, as well as the long, leafless branches that have

Pruning by salt spray. This is the top of a sand live oak (*Quercus geminata*). Dead twigs stick up above the main branches, killed by salt spray blowing in from the sea (from the right). A dense, flat, protective canopy forms beneath them, and below it, the lower parts of the tree are healthy and well formed.

The **oak scrub** that grows on sand dunes most often includes a trio of oaks: Chapman oak, myrtle oak, and sand live oak.

A. Dune begins to engulf an oak. A great pile of wind-blown sand is moving up the beach and into this coastal hammock and completely burying the trees.

B. Dune completely surrounds an oak. This dune has advanced further and has dropped sand all around an oak tree. The tree has responded by elongating its branches shoreward, keeping their tips just ahead of the dune. The oak's scraggly seaward branches are beginning to be exposed again.

C. Dune leaves oak behind. The sand that surrounded this oak is blowing further onshore, leaving some of the oak's branches exposed again. While buried, they kept growing shoreward, barely keeping ahead of the advancing sand. Now they are greatly distorted but still alive. Later still, the whole tree will be exposed and will survive.

FIGURE 4–7

Dune Migration, Oak Survival

Shown are photos of three different dunes, each at a different stage of blowing past an oak tree.

A **coastal berm** is a beach ridge pushed up by storm waves parallel to a low-energy shore. It is usually surrounded by salt-marsh or mangrove wetlands, and supports a plant community of cactuslike plants, shrubs, and trees.

A **maritime hammock** is a stand of mixed hardwoods lying inland from coastal scrub and pine on an old dune that has been stable for a long time. Maritime hammocks may also form within coastal marshes on stable patches of high land.

A **shell mound** community is a closed-canopy hardwood hammock growing on an elevated mound of shells and bones discarded by Native Americans who lived there for a while.

foliage only at the tips (see Figure 4–7C). Meanwhile, other whole trees behind this one are being buried by the advancing sand. It takes about a century for a dune to advance upon a tree, completely engulf it, and then move on, leaving it bare again.

Several hundred yards inland from the beach, behind the older dunes, may be still more interdune fields, or flats. Low areas hold freshwater ponds full of waterlilies and surrounded by marsh plants including sawgrass and umbrella sedge. Slash pines often grow on the flats as well. Near the shore, slash pines are stunted and twisted, but on interior interdune flats, they may form a well-developed, unbroken forest. Slash pines can tolerate both salt and freshwater. In fact, they can root in wet sand and can grow where they must stand in shallow water for some time after rains. They succumb only to long-standing or permanent water.

On still older dune ridges, on both mainland and barrier-island shores, oak scrub often grows, a community of oaks together with slash pine or sand pine. Finally, on higher land farther inland, where the sand is better drained and salt spray never penetrates, longleaf pines first appear.

Interior pine-oak scrubs become stable communities. Protection from the sea is constant, litter accumulates, the canopy provides shade and curbs temperature variations, and moisture persists. Basins within these forests may hold permanent freshwater ponds and lakes, which afford rich harvests of fish for birds, other animals, and people. In past times, Native Americans were attracted to these areas, and wherever they habitually ate, they discarded so many bones, oyster shells, conchs, whelks, and other shellfish that they significantly enriched the sandy soil with calcium. Middens, as

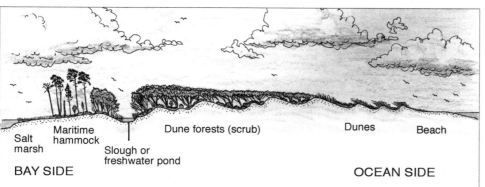

Salt marsh Maritime hammock Slough or freshwater pond Dune forests (scrub) Dunes Beach

BAY SIDE OCEAN SIDE

FIGURE 4–8

Profile of a Barrier Island

On a walk across the classic barrier island from seaside to bayside, it might be possible to observe the profile depicted here. A transect from front to back (right to left, or ocean to bay) crosses the beach foreshore, and then the backshore zone between the high-tide mark and the dunes. Next is the dune face where sand first piles up around seaoats bordering the beach.

A descent from the dune's crest reveals scrub oaks on the back side of the foredune. Older, more stable backdunes lie behind the foredunes, but high winds and overwashing seas can change the entire landscape, wiping it free of all dunes and vegetation. Interdune flats lie between the lines of dunes and may support prairies, scrubs, marshes, or even maritime hammocks depending on the depth of the sands above the water table.

Finally, beyond the flats is the sheltered back shoreline of the island which supports a stretch of salt marsh or mangrove swamp. The island itself partially encloses an estuary or sound that lies between it and the mainland.

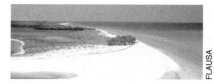

A barrier island (Caladesi Island) offshore from Pinellas County. The seaward side (right) is composed of sandy beaches and dunes. The landward side is carpeted with mangrove swamps and a salt marsh.

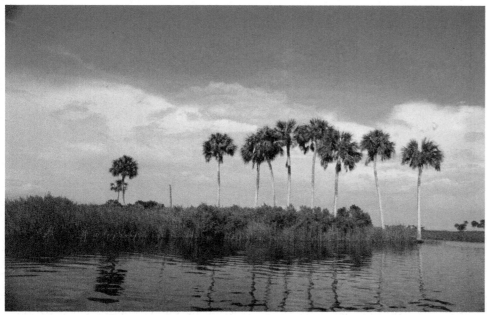

A coastal berm. Surrounded by calm water along a low-energy shore, this isolated ridge of land in the Suwannee River estuary supports a plant community in which cabbage palms stand tall.

the large accumulations are called, can be many feet high and a half a football field long. In time, richly varied hammocks grew, dominated by live oak, cabbage palm, red bay, and southern magnolia together with pignut hickory, red cedar, and wild olive.

Remnants of ancient beach communities also occur in interior Florida. Chapter 5 describes the Florida scrub on the central Florida ridge many miles from the coast, where there are old forests that consist of scrub oaks with or without pines. In the Panhandle, too, inland from the coast, a few ancient sand deposits still have a few coastal species. They, too, were once barrier islands or coastal beach-dune ecosystems.

Nature seldom matches the descriptions of it that appear in books, including this one; it is always more varied and complex. In reality, any one of the zones described here may be absent, atypical, or over-represented. Still, progressing inland, a visitor would see that certain sets of plants occupy the dunes, and others the interdune flats.

Barrier Island Plants. On their ocean sides, barrier islands face the sea with wind-built sandy beaches and dunes. In contrast, their back sides are low-energy shores, sheltered by their foredunes from sea breezes that are blowing salt spray. The array of plant communities one encounters on crossing a barrier island is depicted in Figure 4-8.

Other Plant Communities. Two variations on beach-dune-scrub theme are coastal berms and cactus barrens. Coastal berms are first pushed up offshore as beach ridges along low-energy coastlines, then stabilized by vegetation. Along the Panhandle, berms are enclosed within salt marsh communities; along south Florida they lie in mangrove swamps.

Berms are composed of materials that are less well sorted than in dunes. They have coarser components, including shells and other debris, and they hold

Seawrack. Hundreds of miles of Florida beaches are littered with this material, an accumulation of seagrasses, algae, and animal remains delivered by rivers and tides from interior and coastal marshes and swamps and seagrass beds.

Florida native: Sanderling (*Calidris alba*). This bird spends summers in the Arctic and winters along Florida's coasts. It takes its nourishment from seawrack, which provides important food for many shorebirds and other animals.

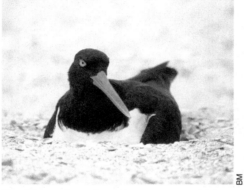

Florida native: Black skimmer (*Rynchops niger*). The bird's nest consists of nothing but a scrape in the bare sand.

Florida native: American oystercatcher (*Haematopus palliatus*). This big bird once nested all along Florida's coast, but today is seen in only a few restricted locales.

BIRDS THAT NEST ON BEACHES

more moisture. On these sites various communities of spiny cactuslike plants, shrubs, and trees may grow. List 4—1 displays some representative species.

A cactus barren community is a flat expanse of limestone with cracks and solution holes in which marl and organic debris are lodged. This is a rare community found only along rocky coastlines in the Florida Keys. Frequently sprayed and splashed by salt water, alternating with freshwater rinsings by rain, a rock barren supports a scattered assortment of plants that can withstand these alternations, intense sun, high winds, and storms (see List 4—2).

ANIMALS OF COASTAL UPLANDS

Many animals that people never see inhabit beach-dune systems. Few visitors would guess that hundreds of species of animals are members of coastal upland communities.

On the Beach. The beach food web is based on a scraggly line of sea-wrack along the high-tide line, where uprooted seagrasses and the remains of jellyfish, shellfish, fish, and others lie baking in the sun. The piled-up weeds are alive with a swarm of tiny animals: jumping beach hoppers, sandhoppers, other amphipods, insects, and their larvae, all feeding on the weeds and on stranded animal remains. Picking off these frantic creatures in turn are crabs and other animals, which scuttle to safety in their burrows when approached. Shorebirds forage among the weeds, catching insects and other prey. That line of weedy, smelly debris, which sunbathers avoid, is a prime feeding place for animals. Without seawrack, the beach would be much less lively.

Birds use the beach in many ways. Shorebirds seek food there, and migratory birds stop to rest before continuing their travels. Local birds settle on the sand between fishing forays, and bird couples meet and court

LIST 4–2
Plants of Keys cactus barren*

Barbed-wire cactus
Buttonwood
Catclaw blackbead
Coral panicum
Dwarf bindweed
Erect pricklypear
False sisal
Florida Keys indigo
Green sprangletop
Gumbo limbo
Royal flatsedge
Skyblue clustervine
Spanish stopper
Three-spined pricklypear
Yucatan flymallow

Note: *This community was earlier known as Coastal rock barren.

Source: Guide 2010, 109-110.

LIST 4–3
Birds that nest on Florida beaches

Thirteen species of birds nest on the ground on Florida beaches between April and August:

On bare sand:
Black skimmer
Brown noddy
Least tern
Royal tern
Sandwich tern
Snowy plover
Sooty tern

Among grasses and herbs:
American oystercatcher
Willet
Wilson's plover

In dense grass or bushes:
Caspian tern
Gull-billed tern
Laughing gull

Source: Johnson and Barbour 1990.

At left: Perdido Key beach mouse (*Peromyscus polionotus trisyllepsis*). Center: Santa Rosa beach mouse (*Peromyscus polionotus leucocephalus*). At right: Choctawhatchee beach mouse (*Peromyscus polionotus allophrys*). Note that these mice are lighter in color than the cotton mouse shown in Chapter 7 (page 118) which is also a *Peromyscus* species. They are also different from each other, and are considered to be three distinct subspecies. Grains in the photos are seaoats, a major food item for beach mice.

FIGURE 4–9

Native Beach Mice (*Peromyscus polionotus* subspecies)

Different subspecies live on different beach stretches or on different barrier islands.

each other. Some thirteen bird species even nest on beaches, if human disturbance is far enough away (see List 4–3). The snowy plover places her eggs in a shallow scrape of sand at the base of a dune, but abandons them if intruders approach. Terns form large colonies and defend their nests against marauding gulls, people, and dogs by flying up in a huge, shrieking mob to scare them away. American oystercatchers nest among backshore grasses and herbs and forage on mollusk reefs offshore.

At night, long after sunbathers have packed up and left the beach, many more animals appear. Tiny sand hoppers emerge from the seawrack and scour the surrounding sand for specks of food. Rove beetles come out to prey on them, and ghost crabs (aptly named) creep warily out of their burrows to prey on the hoppers and the beetles. On spring and summer nights, giant sea turtles may drag their bodies, heavy with eggs, out of the waves and up the beach to dig their nests above the high-tide line. From behind the dunes come other visitors: mice, rabbits, raccoons, skunks, foxes, bobcats, and white-tailed deer. Next morning, their tracks remain as clues to their diverse activities (see List 4–3).

Among the Dunes. Plant communities among the secondary dunes offer food and shelter in abundance. The plants' seeds and berries are nourishing foods, and the trees and shrubs offer shade, a boon to animals who need to escape the punishing sun, and shelter from predatory seabirds, roving bobcats, raccoons, and others. Dune animals seldom come out by day. They are mostly nocturnal, but a search readily reveals their tracks and their burrows.

Many reptiles live in coastal uplands, notably several kinds of snakes, skinks, other lizards, and the gopher tortoise. Some exhibit remarkable adaptations to intense, desiccating heat and sun such as "swimming" in sand. The six-lined racerunner, which can tolerate daytime conditions, stands on hot sand with two legs elevated: one hind leg, and the opposite

LIST 4–4
Animals of coastal uplands (examples)

Beach-Dune, Coastal Berm, and Coastal Grassland
American kestrel
Beach mouse
Eastern hognose snake
Ghost crab
Hispid cotton rat
Raccoon
Red-winged blackbird
Savannah sparrow
Six-lined racerunner
Southern toad
Spotted skunk

Coastal Scrub
Beach mouse
Coachwhip
Eastern diamondback
 rattlesnake
Gopher tortoise
Six-lined racerunner
Southern hognose snake
Spotted skunk

Maritime Hammock
Gray rat snake
Gray squirrel
Ringneck snake
Squirrel treefrog

front leg. Some toads and frogs live in interdune areas and breed in temporary ponds there. Cottontail or marsh rabbits may also live among dunes, as well as small, burrowing animals such as beach mice, moles, shrews, rice rats, and cotton rats. These eat seeds and berries and use seaoats as their main food source.

On barrier islands live some of Florida's most interesting and threatened animals. When sea level was lower, the present barrier islands didn't exist. The land was a flatwoods. As seas reached their present levels, beach ridges were thrown up, dunes formed, and spits and barrier islands first appeared. Probably not long after that, as each island was colonized by small animals, the separated populations began diverging into separate species. (The speciation process was described in Chapter 1, beginning on page 5.)

Each of three Atlantic coast barrier islands and each of five major barrier islands along the western Panhandle has its own subspecies of beach mouse, each with distinct characteristics (see Figure 4–9). Because their habitats have shrunk due to coastal development, their populations have dwindled and today, both the Choctawhatchee beach mouse and the Perdido Key beach mouse are federally endangered subspecies. A direct hit by a single hurricane could wipe out the entire dunefields they inhabit.

Similar island-to-island differences are apparent among other small animal species such as cotton mice, cotton rats, rice rats—and for that matter, common persimmon and titi, too. They are not separate species yet but are distinguishable by certain traits that arose as mutations among the genes of their particular ancestors. The inheritance of a limited set of unique genes, called the founder effect, is seen whenever a small population becomes isolated.

Though small and rarely seen, beach mice, shrews, and rats can be extraordinarily numerous and prolific. As in the flatwoods, their tremendous reproductive ability enables small rodents to support every possessor of talon, forked tongue, and claw in the neighborhood including opossums, raccoons, skunks, hawks, owls, and numerous snakes. Small mammals are major donors to the coastal food web.

Insects are key links in coastal ecosystems, too. Hundreds of plant species provide a variety of microhabitats and foods for insects. (Of sand gnats alone, the infamous tiny biting insects known as "flying teeth," Florida has more than 50 species.) Small insects become food for larger insects, spiders, and others numbering in the thousands of species throughout the state—and for nesting and migratory birds.[5]

And all of this is not to mention the many decomposer organisms that live within the sand, shell, and marl substrates. Remember those piles of seawrack on the beach and overwash plains, and the litter in coastal hammocks? Once shredded to fine particles, these materials sift down into the soil and become food for decomposer organisms. Fires are rare in most coastal ecosystems. Decomposition is the main recycler of nutrients.

Florida native: Coastal dunes crowned snake (*Tantilla relicta pamlica*). This small, burrowing endemic snake remains only along Florida's Atlantic coast from Brevard County south to Palm Beach County and west to the Kissimmee River. When venturing forth from its burrow, it hides under rocks, logs, leaf litter, and other debris.

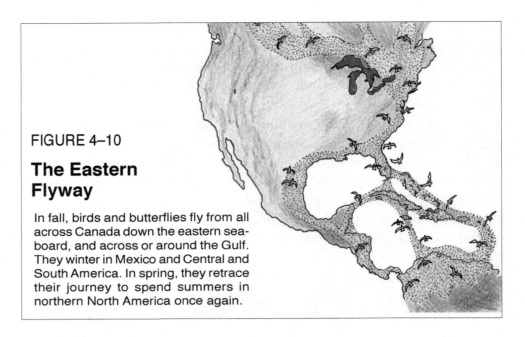

FIGURE 4–10

The Eastern Flyway

In fall, birds and butterflies fly from all across Canada down the eastern seaboard, and across or around the Gulf. They winter in Mexico and Central and South America. In spring, they retrace their journey to spend summers in northern North America once again.

LIST 4–5
Migratory birds seen in one fall and spring on a single barrier island

Fall
American kestrel
Common ground-dove
Eastern wood-pewee
Piping plover
Sanderling
Sharp-shinned hawk
Willet
Yellow-bellied sapsucker
. . . and 54 other species

Spring
Acadian flycatcher
Black-billed cuckoo
Chuck-will's widow
Common ground-dove
Great crested flycatcher
Green heron
Ruby-throated hummingbird
Yellow-billed cuckoo
. . . and 63 other species

Note: These birds were all captured and banded in the fall of 1992 and spring of 1993 on Dog Island, off the Big Bend coast. As of 1993, the total bird species seen on Dog Island had amounted to 252.

Source: Evered 1993.

MIGRATORY BIRDS AND BUTTERFLIES

Florida's coastal uplands not only house numerous resident animals; they also occupy a strategic place on the routes taken by migratory birds and butterflies on their spring and fall journeys north and south. The Gulf coast is an especially important stopping place on the eastern flyway to beaches and forests in Mexico and South America (see Figure 4–10).

Migratory Birds. Beaches, dunes, and interior swales of an undisturbed stretch of coastline or barrier island are a favorite haunt of bird-watchers, whose binoculars can focus on distant individuals well lit by sun and unobscured by thick vegetation. During spring and fall, they can spot dozens of species of migratory birds not seen at other times of year.

The birds' arrival times coincide with the seasons when their food is abundant. For example, in spring, just after horseshoe crabs have laid their eggs, thousands of red knots land on Florida beaches. They gobble up millions of crab eggs, adding 40 percent to their body weights as stored fat. This gives them the fuel they need to fly north to their breeding grounds. The horseshoe crabs survive, because many of their eggs remain buried in the sand and they have laid so many that the birds cannot eat them all.[6]

Forest birds seek out trees and coastal forests, especially the larger maritime hammocks, in which to rest and refuel for the next leg of their journey. Storms sometimes wash great flocks of cold, wet, rumpled birds from the sky to seek cover in the trees behind beach and barrier-island dunes. Because of its strategic importance on the flyway, the Florida Gulf coast is one of the top ten birding locations in the country. A single barrier island may play host to more than 200 species of birds on their ways to and from South America (List 4–5).[7]

Migratory Butterflies. Butterflies also gather on coastal shrubs and trees during spring and fall. More than beautiful, these winged insects are pollinators of plants and food for birds and other animals, important threads in ecosystem webs. Dozens of species of butterflies pass through Florida on wondrous migratory flights to and from their tropical wintering grounds.

The migrations of the monarch butterfly are prodigious. Monarchs breed and spend summers in the northern United States and Canada. Then in the fall, the monarchs fly south around the Gulf, along the coastlines of Florida, Alabama, Mississippi, Louisiana, and Texas and on into Mexico. There, they pile up by the millions in the forests of a high mountain retreat, they feed, and then they go dormant for the winter. When spring comes to Mexico, they awaken and return north.

It takes several generations for the monarch butterflies to make their whole north-south migration. No one butterfly can trace the whole route, because its lifespan is only six weeks long. If one adult monarch starts out from Canada, it will mate and produce eggs in, perhaps, Massachusetts. The eggs hatch there and within the next four weeks the caterpillars eat and grow, wrap themselves in cocoons, and metamorphose into butterflies that make another leg of the trip—say, to Virginia. The next generation may make it to Florida, and the fourth generation flies to Mexico and overwinters there. Only when they go dormant do the butterflies live longer than six weeks. In spring, millions leave Mexico to make the return journey, and it is the seventh generation that arrives back in Canada to start the cycle again. Each butterfly travels its segment of the route entirely by instinct. It remembers nothing of its parents or any of its previous journey.[8]

Left: Green antelopehorn (*Asclepias viridis*). Right: Fewflower milkweed (*Asclepias lanceolata*).

FIGURE 4-11

Two Species of Milkweed Native to Florida

Milkweeds are members of the genus *Asclepias*. More than 100 species of milkweed are native to North America.

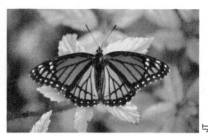

Viceroy (*Limenitis archippus*). This butterfly is of a completely different species and is smaller than the monarch, but mimics the monarch's color pattern almost perfectly.

Monarchs, Milkweeds, and Mimics

The world's flowering plants flourished rapidly after about 65 million years ago, and today they are represented by some 235,000 species. Along with them, many times more species of insects evolved, many of importance as plant pollinators.

Once an insect becomes important to a plant, evolution of both plant and insect amplifies the characteristics that make them work. Plants become increasingly attractive to insects by providing food and developing bright colors and scents that the insects can home in on unerringly from miles away. Attractive plants gain the advantage of more and more successful cross-pollination. One such partnership is that between the monarch and milkweeds. The insect is an important pollinator of milkweeds, and helps to spread their pollen all along their migratory route, favoring wide dispersal and much mixing of genes among plant populations.

Milkweeds also make a poison that, when the caterpillars eat it, is incorporated into their tissues. By this means, the caterpillars gain two advantages. First, they have a food source other insects cannot eat; and second, they develop a toxicity of their own that serves as a defense against predators. Moreover, when the caterpillars metamorphose into butterflies, the toxin persists, so that the butterflies, too, are bitter-tasting and toxic to would-be predators such as mockingbirds. A bird need taste a monarch only once to learn to avoid ever afterward the bright colors that go with that noxious experience.

Butterflies that assimilate plant toxins develop distinctive, bright color patterns—patterns that predators learn to avoid. This leads to mimicry, another example of coevolution. The monarch's nasty taste and bright colors have proved so successful in promoting its survival that birds, mice, and others avoid not only this species but any others that resemble it. As a consequence, many butterfly species have evolved almost perfect replicas of the bold yellow-and-black pattern sported by monarchs. The

PS, PS

Monarch butterfly (*Danaus plexippus*). These butterflies have stopped on Florida's coast to rest and feed before continuing on their way to Mexico. They are feeding on the nectar of a goldenrod species (*Solidago*) to obtain the fuel they need for their flight. When they return to Canada next spring, they must find milkweed if they are to reproduce.

Mimickry in caterpillars. At left is the monarch caterpillar. The stripes on this noxious insect are memorable and the taste is terrible. No bird that ever tasted it would try it for a second time. Thanks to the protection this color pattern affords, other species have evolved similar patterns. At right is the eastern black swallowtail caterpillar (*Papilio polyxenes*). No experienced bird would try this caterpillar either, because it resembles the monarch so closely.

viceroy butterfly and others, although not toxic, escape being eaten by virtue of this successful mimicry.

Not only butterflies but also their larvae, caterpillars, develop warning coloration. As with the adult form, so with the larvae: those that are successful at warding off predation are mimicked by others.

We benefit indirectly from bright coloration that has evolved in butterflies and flowers. We can surround ourselves with pleasing flowers and then win visitations by butterflies that also delight the eye.

The journey is hazardous. Of the monarchs departing Mexico, only one in a thousand makes it to the Florida coast; the others all fall victim to predators, harsh winds, and other fates. Those that make it fly in low to the ground, searching for milkweeds on which to lay their eggs; no other plant will support their development (see Figure 4-11). The monarch-milkweed relationship benefits both the plants and the insects and is an instance of coevolution, comparable in antiquity to that between seaoats and fungi. It is featured in Background Box 4–1.

The timing of the monarch's flight, arrival, and reproduction is synchronized with the milkweed's growing seasons. When mature, each butterfly lays its eggs on a milkweed plant that is just beginning to grow, whose leaves will provide abundant food when the eggs hatch into caterpillars. The first spring generation of monarchs is born in Florida and other southern states. Succeeding generations are born at later stopping places along the way north, and in August, as they head south again, they eat from flowers that are rich with nectar to stoke up on fuel.

The monarchs' Mexican wintering grounds are shrinking rapidly as development encroaches on their borders. The whole species may well die out, but some monarchs are, today, wintering over on barrier islands near

(A) Tiger swallowtail (*Pterourus glaucus*).

(B) Common buckeye (*Junonia coenia*).

(C) Palamedes swallowtail (*Papilio palamedes*).

FIGURE 4–12

Florida Migrants, Natives, and Host Plants

Flowers that have many blossoms in a single flowerhead ease the insects' task of gaining nourishment. From one perch, a butterfly can take nectar from blossom after blossom without having to expend energy flying from one to the next. Many other butterfly-attracting flowers also have closely grouped, multiple blossoms.

(D) Long-tailed skipper (*Urbanus proteus*).

(E) Cloudless sulphur (*Phoebis sennae*).

PLANTS: (A) Lantana (an introduced *Lantana* species). (B) Water oak (*Quercus nigra*), a convenient perch, but not a host plant. (C) Red milkweed (*Asclepias rubra*), a native milkweed and a host plant, one on which monarch caterpillars can successfully develop into butterflies. (D) Lantana (an introduced *Lantana* species). (E) Godfrey's gayfeather (*Liatris provincialis*), a host plant for several butterflies. Godfrey's gayfeather is endemic to coastal habitats in Franklin and Wakulla counties and has become very rare.

Tampa and St. Petersburg. Given more food plants on the barrier islands and in the remaining bits of central Florida scrub, these extraordinary creatures may survive the loss of their ancient winter home.[9]

Millions of other spectacular butterflies move through Florida as the monarchs do (Figure 4–12 shows a few examples). Bright yellow cloudless sulphurs and tawny-brown buckeyes swarm across the north Florida mainland every fall. Great southern white butterflies breed and feed on islands off the east coast where their favorite food plant, saltwort, blooms profusely in late fall. Iridescent long-tailed skippers move down the peninsula by the tens of millions, feeding on goldenrod and many different host plants. Bright red-orange Gulf fritillaries follow the shoreline around the Gulf of Mexico in the early fall, often flying far out over the water.

Of all the migrants that traverse the oceans of air and water along the eastern seaboard, these fragile butterflies seem to be taking on the most impossible task. Yet they must make the trip to perpetuate their kind. They carry their itineraries in their genes, together with the instincts to seek out the food plants they need at each stopping place. Their natural habitats along Florida's coasts are crucial for their survival.

* * *

Beaches are wonderful places for people to seek relief from the stresses of life, to walk and dream, to build sand castles, to picnic and romp and play with children. They provide habitat for coastal plants and animals that are adapted to live in shifting sands and with salt spray. Beaches and dunes protect the land behind them from the assaults of storms: their sands absorb the impact of the waves. And they inspire painters, photographers, and poets with their beauty.

Zebra longwing butterfly (*Heliconius charitonius*). Widespread in Florida, the zebra longwing was named the state butterfly in 1996.

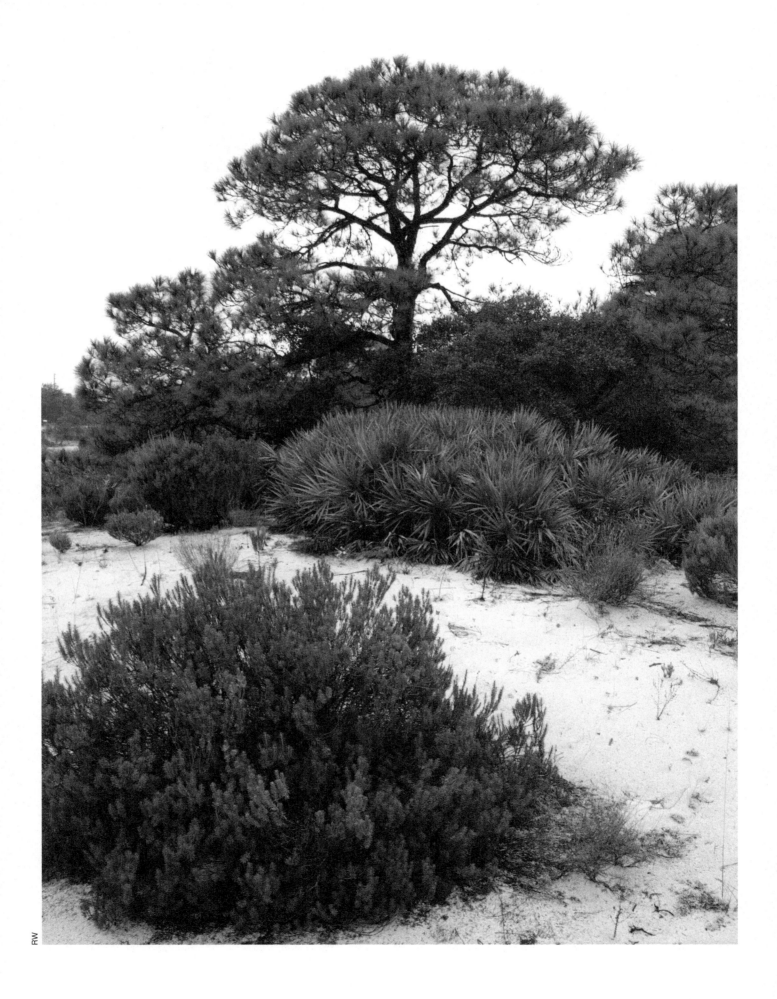

CHAPTER FIVE

FLORIDA SCRUB

From a rural road somewhere in the interior of central Florida, a traveler turns onto a nameless, sandy byway to explore what looks like a natural area. The road ascends gently to a hilltop where one might expect to find a pine grassland, but instead a beachlike scene appears. Even though the ocean has been nowhere near this place for thousands of years, one might sense the tang of a sea breeze on the air and the sound of seagulls calling. Just as on a coastal dune, the sand is powdery and largely bare, and indeed, dune vegetation is growing on it: weathered small oak trees, saw palmettos, rosemary shrubs, and sparsely scattered patches of dry, pale greenish-gray ground lichens. Sea oats are the only missing element.

How did this pile of powdery sand get here? Where did this array of plants come from? This natural community must have originated at the coast. Figure 5–1 shows how a coastal feature may become an inland sandhill.

The sand tells more of the story. If it were coarse and unsorted, then a likely guess would be that this was a beach ridge, sand bar, or spit piled up by water. But because this sand is sorted, fine grains only, it must have been carried here by wind. The plants confirm this guess. These plant species took hold on coastal dunes, and today they remain in the interior of central Florida on patches of dune sands that have persisted, undisturbed, for 100,000 or even a million years or more.

The name *scrub* is given to this ecosystem to describe the scrubby plants that inhabit it. Despite this humble name and their often unassuming appearance, scrubs are rare and special ecosystems. Their remarkable plants and animals and webs of relationships are only now becoming known, even as the land is overtaken by pine plantations, citrus groves, and development.

Florida native: Rosemary crab spider (a *Misumenops* species).

Scrubs are xeric communities growing on well-drained, infertile sand formations of marine origin in both coastal and interior Florida. Evergreen or nearly evergreen scrub oaks or rosemary shrubs or both predominate in some scrubs, while in others, sand or slash pines are present, sparsely or abundantly.

Coastal scrubs grow along today's coastal strand and are influenced by salt spray.

Interior scrubs grew at the coast in the past, then were left in the interior as a falling sea level exposed the land around them. They differ from coastal scrubs in that salt spray no longer reaches them.

Small, scrubby oak trees are casually called **scrub oaks**. There is also a species of oak, known as **scrub oak**, which is endemic to Florida and grows in the Florida scrub.

OPPOSITE: Scrub scene. The floor is of powder-white, mostly unvegetated sand. The shrubs are false rosemary, the endemic Apalachicola false rosemary (foreground) and saw palmetto (background); the trees are slash pines. Alligator Point, Franklin County.

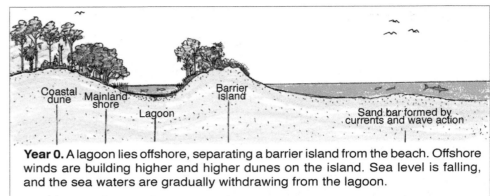

Year 0. A lagoon lies offshore, separating a barrier island from the beach. Offshore winds are building higher and higher dunes on the island. Sea level is falling, and the sea waters are gradually withdrawing from the lagoon.

1,000 years later. Sea level has fallen. The former beach and barrier island are now two long, parallel sandhills separated by a shallow valley. The old barrier island's outer shore is now the main beach, and a new barrier island is forming offshore.

FIGURE 5–1

How a Barrier Island Becomes an Interior Sandhill

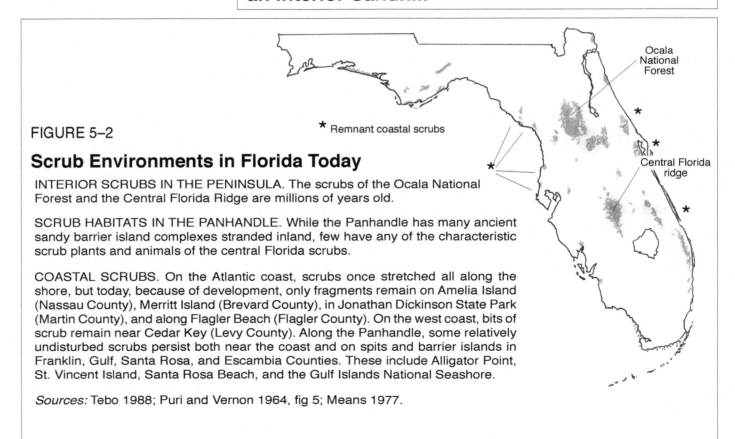

FIGURE 5–2

Scrub Environments in Florida Today

INTERIOR SCRUBS IN THE PENINSULA. The scrubs of the Ocala National Forest and the Central Florida Ridge are millions of years old.

SCRUB HABITATS IN THE PANHANDLE. While the Panhandle has many ancient sandy barrier island complexes stranded inland, few have any of the characteristic scrub plants and animals of the central Florida scrubs.

COASTAL SCRUBS. On the Atlantic coast, scrubs once stretched all along the shore, but today, because of development, only fragments remain on Amelia Island (Nassau County), Merritt Island (Brevard County), in Jonathan Dickinson State Park (Martin County), and along Flagler Beach (Flagler County). On the west coast, bits of scrub remain near Cedar Key (Levy County). Along the Panhandle, some relatively undisturbed scrubs persist both near the coast and on spits and barrier islands in Franklin, Gulf, Santa Rosa, and Escambia Counties. These include Alligator Point, St. Vincent Island, Santa Rosa Beach, and the Gulf Islands National Seashore.

Sources: Tebo 1988; Puri and Vernon 1964, fig 5; Means 1977.

DISTRIBUTION OF FLORIDA SCRUBS

Scrubs remain today only in the small bits of Florida shown in Figure 5–2. The oldest of these bits are ancient sand ridges and dunes that run north-south along the central Florida ridge. Some 25 million years ago or more, there was no Florida; there was just a chain of islands in the sea off a shoreline that lay up in Georgia. Then the ocean retreated, leaving the islands connected, and Florida was born.

Today the scrub patches are still islands, but they stand in the Florida peninsula, surrounded by land, not water. The two largest blocks of ancient scrub that remain in relatively natural condition are in the Ocala National Forest in central Florida, and on the southern end of the central Florida ridge in Polk and Highlands counties.

Large barrier islands of sandy soil were also stranded on the Panhandle when sea levels dropped. Examples are the Munson Sandhills, the Greenhead Slope, and huge sand deposits south of the Yellow River; these great, sandy hills are now a few million years old. More recently, some thousands of years ago, other, smaller barrier islands became stranded closer to the coast among the flatwoods of Gulf, Liberty, and Wakulla counties. The larger, older sandhills are largely covered in high pine, whereas some of the younger deposits have a few scrub species mixed in with elements of the high pine ecosystem.

TYPES OF SCRUBS

Since they were first separated from each other, Florida's scrub patches have evolved independently of each other. As a result, today, different scrubs have somewhat different plant associations and appearances.

Several types of scrubs are shown in Figure 5–3. Rosemary scrub (Figure 5–3A) is open to the sky, often a gardenlike scene that features beautifully spaced, round rosemary bushes with only a few or no sand pines and scrub

D. Sand pine scrub with partially closed canopy. This is the typical aspect of many a sand pine forest. Wind has tilted the pines, but their interconnected roots have kept them standing.

A. Rosemary scrub. Shade is patchy. The white, sterile sand drains fast, and only drought-tolerant plants and burrowing animals can survive.

FIGURE 5–3

Florida Scrubs

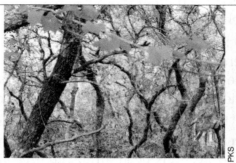

B. Oak scrub. Stressed by drought, the oaks assume twisted shapes. Since the canopy has closed, most of the groundcover plants and shrubs have been shaded out, leaving an inviting, open interior.

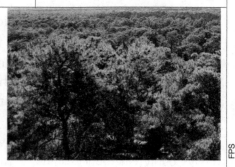

C. Sand pine scrub with closed canopy. The pines have formed a solid forest with deep shade, in which few other plants can grow. This is a mature sand pine forest. The biggest trees are about 65 feet tall and 15 to 20 inches in diameter at breast height.

oak trees. Oak scrub (Figure 5–3B) has more oaks and few or no pines. On its way to maturity, an oak scrub may become an impenetrable thicket of Chapman oak, myrtle oak, and sand live oak, together with a few other plants such as saw palmetto. When the canopy closes completely, many of the groundcover plants are shaded out, the interior opens up, and the scrub becomes an artful and inviting arrangement of small, twisted oaks over ground covered with gray-green deer lichen (often incorrectly called deer moss).

Sand pine scrubs vary. In some sand pine scrubs, the pines have bushy branches all the way to the ground. In others, the pines are tall and robust, forming a closed canopy with a dark, open interior beneath it. A sand pine forest of this type grows in the Ocala National Forest and is shown in Figure 5–3C. Others have a more open canopy (Figure 5–3D), and in still other sand pine scrubs, the pines are stunted and gnarled. Sand pines seldom reach more than 50 to 70 years of age, but if not killed by fire, they may occasionally reach 100 years. The biggest trees are generally only 65 feet tall and 15 to 20 inches in diameter at breast height. The champion tree, which is at Wekiwa Springs, is 85 feet tall, with a diameter of two feet and a crown spread of 40 feet.

Peninsular Florida is thought to have held predominantly rosemary scrubs at one time. Then, over thousands of years, oaks came to dominate these scrubs. Finally, particularly in the central peninsula, some became sand pine scrubs, but along the Gulf coast, rosemary and oak scrubs still persist, together with sand pine, on the driest sand ridges.[1]

FIRE IN SAND PINE SCRUB

Like high pine grasslands, sand pine scrubs are fire-maintained systems, but the nature of the fires and the responses of the plants contrast dramatically with those described in the last two chapters. Imagine this scene for a moment. A high, dry, open forest of sand pine simmers in the blistering sun. Among the pines are widely spaced rosemary bushes, each a sphere of dark green up to six feet across (see photo at start of chapter). Dry, fluffy lichens are scattered across the sand.

Storm clouds gather and a hot wind tosses the dry pine branches. Suddenly, lightning strikes, and within seconds a firestorm is racing through the shrubs and treetops, throwing hot sparks. Within half a day all the trees and the above-ground parts of the shrubs are dead.

Until today, no fire had touched this scrub for thirty years or more. Now everything seems to have been destroyed in a single afternoon. Scorched pine skeletons, dead shrubs, charred pine cones, and black ash piles are all that remain on the ground. Except for a beetle crawling on the hot sand, nothing remains alive—or so it seems.

An hour, a day, or a week later comes the rain. It drains quickly into the sand, leaving it as dry as before, but hints of new life begin to appear. Around each dead rosemary shrub, new seedlings pop up. Over each old

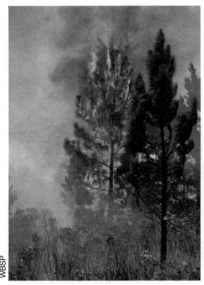

Crown fire in sand pine in the Waccasassa Bay State Preserve in Levy County. Fire readily climbs sand pines and torches their tops. Typically, scrub fires burn hot and fast, devouring everything in their path. Although the conflagration looks devastating, renewal of the scrub absolutely depends on such fires.

lichen bed is a haze of green. Tiny pine seedlings sprout from living seeds that were released from the blackened cones. Thirty years from now, this place will look almost exactly as it did before. Then if lightning ignites another fire, hot winds will fan it through the treetops, and the cycle will begin anew.

Scrubs depend on fire differently than longleaf and slash pine grasslands. In a pine grassland, thanks to its continuous groundcover, fires occur every few years, burn at a relatively cool temperature, and do not climb the trees. In a sand pine scrub, fire occurs only once in every ten to 50 years or more. During that time a dense accumulation of needles, bark, twigs, and the litter of other scrub plants builds up a highly flammable fuel base. When fire eventually does ignite there during dry conditions, it burns very hot, first in the heavy fuel on the ground. Then as the heat rises it warms the canopy to combustion and a canopy fire results. The shrubs burn explosively, and in a closed-canopy sand pine forest, the fire races unbelievably fast through the treetops. One fire in the Ocala National Forest burned 35,000 acres of sand pine scrub in four hours.[2]

The crown fires that occur in sand pine scrubs, although they appear catastrophic, are exactly what is needed for renewal, especially in central Florida. Central Florida's sand pines do not release their seeds except when heated by fires, which cause the bracts to open. By the time they have reached their mature height, they are loaded with seed-filled cones (see Figure 5—4). Then when fire sweeps through, the cones open and scatter seeds all over the ground.

If there are oaks among sand pines, they, too, will appear to be killed by fire, but they actually remain alive. Scrub oak stems burn to the ground, but much of their mass is underground in the roots, alive, and packed with stored energy and nutrients. The oaks quickly resprout and regrow to chest height within three years.

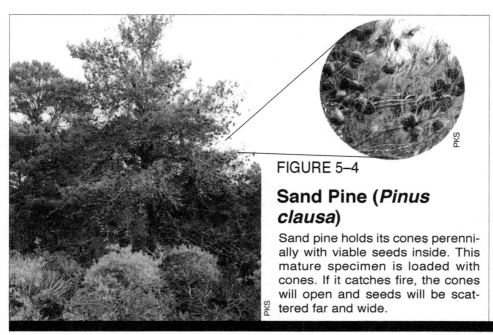

FIGURE 5—4

Sand Pine (*Pinus clausa*)

Sand pine holds its cones perennially with viable seeds inside. This mature specimen is loaded with cones. If it catches fire, the cones will open and seeds will be scattered far and wide.

After a fire, some saw palmettos will look dead,

whereas in some, there will be subtle signs of life. . .

and some will be obviously alive . . .

. . . but all will recover completely within a season.

FIGURE 5–5

Florida Native: Saw Palmetto (*Serenoa repens*)

Two Florida natives: scrub lichens with no common names. Above: *Cladina evansii*. Below: *Cladonia perforata*, an endemic.

Rosemaries die in fires, but their seeds remain viable in the soil and give rise to a new generation of healthy rosemaries right away. Saw palmettos recover within a season (see Figure 5–5).

It must be clear by now why, in a sand pine scrub, the pines so often are all of the same age. They all started up simultaneously from seeds thrown during a fire. The oaks and rosemaries preceded them by a short interval, providing the ideal setting for sand pine seedlings to start growing. Partial shade helps to protect them from the sun's killer heat at first. By the time the young pines have overtaken the shrubs, they are able to grow well in intense sunlight and can tolerate widely fluctuating temperatures, exactly the conditions that they face. The replacement forest then becomes a stand of even-aged trees.

Scrub animals, too, all manifest adaptations to fire. Many animals simply dig escape tunnels down into the sand, where the fire's heat does not penetrate. Other ground animals retreat into their own or gopher tortoise burrows. Birds fly up, and if their nests are lost, they soon renest.

Fire scenarios play out in other ways than those described here. If a scrub does not burn within about 50 to 55 years after the last fire, the sand pines typically begin to decline due to heart rot and then gradually give way over several hundred years to live oaks. In contrast, if a scrub burns too frequently, its sand pines may not have a chance to mature, and longleaf pine may invade.

Scrubs in Panhandle Florida may regenerate other than by fire. North Florida sand pines commonly have open cones and can release their seeds without the stimulus of heat. If space opens up, colonization by seeds can proceed, although it is slow. Hurricane winds at times clear land for the regrowth of sand pines. Still, fire is probably a major agent of renewal under natural conditions.[3]

Of interior scrubs that remain today, those on the central Florida ridge are fairly well described and are under ongoing study. Those in the Panhandle have hardly been studied at all. Most of the information presented here is drawn from central Florida scrub communities in which sand pines, rosemary bushes, palmettos, and lichens are the most noticeable plants.

PLANTS IN CENTRAL FLORIDA SCRUBS

On the central Florida ridge, numerous islands of scrub lie in a matrix of sandhill communities and (today) orange groves and residential developments. Each scrub island is at most only a few miles wide, and each is a world unto itself.

On these ancient islands, hundreds of plant and animal species have become adapted in unique ways to the dry, porous, nutrient-starved soil they live on. About half of all scrub species on the central ridge are endemic, and they are among the rarest species known in Florida. In fact, the central Florida ridge today has more rare and endangered plant species than any other habitat in North America.[4]

The plants in these scrubs are well adapted, not only to periodic hot fires, but to the challenge of their extremely dry environment. They also are stalwart defenders of their territory, even against their own offspring. The many ways in which they cope with their stern environment are lessons in evolutionary adaptation.

Water-Conserving Adaptations. The sand on which scrub plants maintain their foothold drains extremely fast. Water droplets sink down so rapidly that the upper layers are always dry, even in rainy seasons. Most of the woody shrubs have roots of two kinds. One or a few tap roots reach deep down in the sand; while shallow root mats spread around the plants over areas that are broader than the plants' tops. The root mats grab all available rain practically as it falls. This root competition for water, and possibly growth-inhibiting chemicals released by the plants, limit the number of other plants that can grow and account for the expanses of bare sand that often surround those that are present. Few herbs can compete successfully with these water-grabbers; herbs collect less water and lose it more readily to evaporation, so they tend to die in droughts.

The shrubs and the few herbs that can hold their own among them are mostly evergreens with small leaves or needles whose waxy coats protect them from losing water by evaporation. They stay small and low to the ground. An observer notes that "In [oak] scrub, people [are] giants, their heads poking out above the treetops. Many plants grow only a few inches high, producing bouquets of flowers fit for a doll's house."[5] List 5—1 names some of the plants that are often found in scrubs.

Sand pines exhibit an additional, and remarkable, water-conserving adaptation. In stands where they grow close together, the roots of adja-

LIST 5–1
Plants found in scrubs throughout Florida (examples)

Chapman's oak
Fetterbush
Florida rosemary
Ground lichens
 (several species)
Hairsedge species
Jointweed species
Myrtle oak
Pinweed species
Rusty staggerbush
Sand live oak
Sand pine
Sandyfield beaksedge,
Saw palmetto
Scrub oak
Threeawn species

Source: Guide 2010, 49.

FIGURE 5–6

Haloes around Rosemary

This aerial photo of dunes along the Panhandle shows a circle of white sand around each rosemary bush. It is thought that each rosemary releases a growth inhibitor that prevents the growth of other rosemary plants nearby.

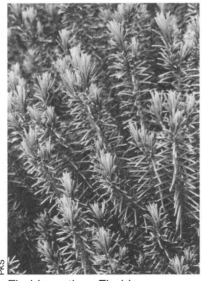

Florida native: Florida rosemary (*Ceratiola ericoides*). This is the species of rosemary that grows in most Florida scrubs.

cent trees interweave and even graft to one another, with the result that the trees become, in a sense, a single organism. As such, they can share water, minerals, and the sugars generated by photosynthesis. They can also withstand storm winds, which are especially powerful along the coast where the sand pines first grew. Notice how often a sand pine scrub seems to consist of trees that are all leaning one way. You would think that many trees would fall in high winds, but they remain standing, thanks to their interconnected roots.[6]

Chemical Defenses. Many scrub plants produce chemicals that act as powerful defenses against competition and insect pests. Several shrubs produce chemicals that, when leached from their foliage into the soil by rain, inhibit the reproduction and growth of pine seedlings and grasses. This may account for the clean boundary that separates pine grasslands from scrub. The chemical released by the Florida rosemary may also keep its own seeds from growing until a fire kills off the parent plant, thus minimizing root competition (see Figure 5–6). Two genera of rosemaries also produce insect repellents that help them to withstand plant eaters.[7]

Another insect-repellent plant is a sweet-smelling wild herb, the scrub balm (Figure 5–7). It was first noticed because its leaves showed little evidence of insect damage. An oil is contained in capsules on the leaves and when released, it serves as a powerful ant repellent. Laboratory studies have revealed that the plant produces twelve volatile aromatic compounds, all of potential usefulness to humans. One is noxious to cockroaches. No other plant is known to make these compounds, just this one species of mint, which grows on only 300 acres, the last remnant of its habitat on earth, which is now in a preserve. Intervening land uses have isolated this population from other habitats where it might be able to grow.[8]

Among its other interesting features, the scrub balm has twenty different species of fungi in its tissues, some of which produce antibiotic compounds

FIGURE 5–7

Florida Native, Endemic: Scrub Balm (*Dicerandra frutescens*)

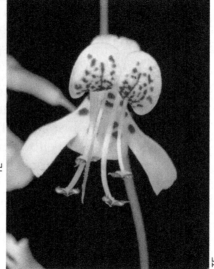

Scrub balm close-up

that are toxic to other fungi. Fungi do not qualify for the Endangered Species list, but if they did, all twenty of these would be listed with their host plant. As the discoverer of this plant says, "In these days of biotechnology, we can access more than just the chemicals of nature. We can access the genes . . . for the . . . chemicals [and put them to use]."[9]

Fungi are everywhere in the soils of the scrub. Some of them decompose dead matter into its component water and carbon dioxide, gathering energy in the process. They capture the minerals that are being liberated and feed these to the scrub plants' roots through tiny filaments. Other fungi, which live inside the plants' roots, capture atmospheric nitrogen, and incorporate it into compounds that the trees can use. Thanks to their root fungi, the trees grow well even though the soil is dry and sterile.

Because of its plants' special adaptations, scrub is considered one of the most botanically important ecosystems in the United States. All of the ground plants are special. More than thirty are listed or under review for listing by state and federal endangered species agencies.

ANIMALS OF CENTRAL FLORIDA SCRUBS

Scrub animals are as challenged by the scrub's harsh environment as are the plants, and like the plants, they are superbly well adapted to cope with heat, fire, lack of water, and their enemies. Many an investigator who began with a casual interest in scrub animals has ended up devoting his or her professional life to studying them. List 5–2 names a few animals that reside in the scrub. Others visit, and are enumerated later.

Insects, Spiders, and Their Associates. Subterranean life makes sense where there is little structure above the ground, and most small scrub animals live in the sand, where they can find the temperature they require

by moving up, down, or sideways. There are 59 species of ants in Florida scrubs, 35 species of velvet ant (actually a kind of wasp), 70 species of bees, 80 species of scarab beetles, 45 species of bark and ambrosia beetles—the list goes on and on.[10]

Each subterranean invertebrate has distinct food preferences. Caterpillar and beetle larvae graze on tender, fine rootlets in the top sand layers. Termites maneuver just beneath the sand to find partly buried leaves and dead twigs. Tiny, pale yellow predatory ants hunt freely among the sand grains and scavenge animal carcasses. Minute larvae of bee flies and robber flies search for grubs and grasshopper eggs. Many burrow-making animals hunt and carry their prey back to burrows in the sand, where they can guard their kills. Hunting wasps hunt by day, wolf spiders by night. The profusion of actively hunting insects is unusual, but abundant prey is available for them.

The Florida harvester ant gathers and eats the seeds of many understory plants. It has developed a kind of basket on its body, made from a ring of long, curving hairs that extend from the jaw parts and the underside of the head. Using this basket, the ant hauls clumps of sand from three feet below the ground to make its nest (and in the process, returns nutrients to the surface, a vital service to the scrub that is described later more fully). A species of scarab beetle is so specialized that, like moles, it never comes to the surface. It has strong, heavy claws like those of a mole, it is blind, and unlike other beetles, it has no wings.[11]

The pygmy mole cricket is a tiny insect, less than a quarter-inch long, that lives in a system of branching passageways just below the surface of the sand. It chooses sites only in full sun, never beneath rosemary bushes or other shrubs. Researchers were mystified at first, wondering how the creature could find enough to eat there. Most other species of mole crickets live on the edge of wet places and graze on algae that grow in the soil or on wet leaves. If one habitat dries out, they fly or swim to another. But this cricket's habitat is dry nearly all the time, it is flightless, and it has no place to swim. Its habitat is open, unshaded, apparently sterile, bare sand.

The mystery was solved when the researchers discovered that a thin layer of microscopic algae grows in scrub sands just beneath the surface. Each time it rains, the algae catch water and grow. Between times, the few translucent sand grains above them protect them from scorching, hold in enough moisture, and admit enough light for them, but offer no hospitality to plants with greater moisture requirements. The cricket makes its living by grazing on these algae wherever they grow.[12]

An oak-leaf-crunching invertebrate, the Florida scrub millipede, may be necessary to the mole cricket's survival. Found only in Highlands County and not in nearby Polk County scrubs, it lives above the sand surface in oak leaf litter, which it chops into tiny fragments and eats. It has no close relatives anywhere else in the world, but in this community it is an important link in the web of life. By keeping the sand clear of leaves, it permits

sunlight to penetrate the top sand layers where the algae grow that become food for the pygmy mole cricket and other tiny creatures.[13]

Millipedes participate importantly in soil food webs. After pulverizing their chosen dead salad greens, they mix them with bacteria in their guts, then deposit fecal pellets. Other bacteria attack the pellets, fungi invade them, and small arthropods eat them. Bacteria in the arthropods' guts attack that material, then the arthropods deposit smaller fecal pellets. Still other organisms eat these, mix them with soil, and start another round of the same events.

Many scrub insects are hidden, but some are in plain sight and still virtually invisible. The rosemary has a specialized moth, whose caterpillar can take two entirely different forms, achieving perfect camouflage in every season (see Figure 5–8). Other moths, beetles, sap-sucking insects, and a grasshopper also appear to be totally dependent on the rosemary.

Study of endemic scrub insects and spiders has enabled researchers to piece together the probable history of their island habitats. Some are found only in the Ocala National Forest, some in scrubs on the north end of the Lake Wales ridge, some on the south end, and some species are restricted to single, tiny patches and are not found even in other nearby scrubs.

The wolf spiders provide a good example. Most young spiders depart from the parental web by "ballooning"——that is, they take to the air hanging from tiny parachutes made of spider silk, and they achieve wide dispersal that way. Probably, when their homes were on islands, though, young spiders that ballooned fell into the sea and drowned. Those that stayed near their birthplaces survived, and passed on their stay-at-home behavior to their offspring. The scrub islands where these spiders are found are now connected by land, but the animals have remained confined, with their offspring, to separate invididual patches of scrub ever since long ago.

A series of beetles and a series of grasshoppers exhibit the same pattern. They are closely related but distinct from one scrub to the next and they are designed not to disperse: the grasshoppers and the beetles are flightless, and the beetles are burrowers. Still other small invertebrates are no doubt endemic to scrubs and remain to be discovered.

The scrub balm was mentioned earlier as an example of a plant with interesting chemistry. It also has a special relationship with a particular bee fly that does 95 percent of its pollinating. The plant attracts the bee fly with a "nectar guide," a dark pink center in its flower. It has a lower petal that serves as a perch, and when the bee fly lands on it, its weight bends the flower so that the nectar cup closes. The bee fly has to thrust its head in, hard, to get nectar. That triggers an explosion of pollen which adheres to the bee fly's belly. There are many flowers, both male and female, on one scrub balm plant, but self-pollination does not occur, because the male flowers are open only in the morning and the female parts, the pistils, are accessible only in the afternoon. Any insect that has picked up pollen from one plant in the morning will be far away, depositing it on another plant,

Florida native, endemic: Rosemary grasshopper (*Schistocerca cera-tiola*). This grasshopper depends solely on the rosemary for its food.

Florida native, endemic: Florida scrub millipede (*Floridobolus penneri*). The beads of moisture, which contain iodine, deter predators.

Florida leatherleaf *(Veronicella floridana)*. By mimicking an oak leaf, this snail slug escapes notice often enough to maintain populations in the scrub.

Florida native, endemic: Lake Placid funnel wolf spider (*Sosippus placidus*). The spider's burrow entrance is a funnel-shaped web that traps small prey animals crawling over it. When an insect or other small creature falls in, the mother subdues it, and then she and the young feast on it together. Young wolf spiders of this species live with their mother until they are about half grown. One young spider is shown in the foreground by its mother's leg.

Source: Anon. 1990 (Wild Florida, Vol. 1).

Twig form Needle form

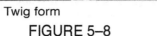

FIGURE 5–8

Emerald Moth Caterpillar on Florida Rosemary

The emerald moth caterpillar (*Nemouria outina*) depends completely on the rosemary for its food. To hide from its predators it assumes different forms. In winter it is gray and looks like a dead rosemary twig (LEFT). In summer it is green and looks like a live rosemary needle (RIGHT). It stays completely motionless by day and eats at night when its predators (birds, mice, and others) can't see it moving.

in the afternoon. In short, as the discoverer of this relationship sums it up, the scrub balm "accomplishes cross-pollination by teaching a common generalist bee fly to act as a specialist, in return for exclusive nectaring rights."[14] Other pollinators have equally mutually rewarding relationships with scrub plants.

Burrowing Reptiles. The vertebrate residents of the scrub are nearly as secretive as the insects, spiders, and others just described. Most are reptiles, which cope with desertlike conditions that would quickly kill most other animals. Many can "swim" through sand. An assortment of these curious animals is shown in Figure 5–9.

A visitor to the scrub might never see these animals, but would see mounds of yellowish sand, from a few inches to three feet in diameter, scattered over the smooth, powdery ground. These mounds are the piles of soil pushed out of burrows by animals who are hiding from the hot sun by day.

The sand skink is camouflaged light brown and has short, vestigial legs that fold back against its cylindrical body, giving it streamlined, submarinelike contours. It has smooth, slick scales and a wedge-shaped snout that is ideal for pushing its way through the sand. It even has lower eyelids

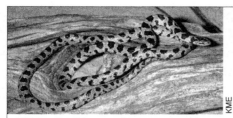

Endemic: Short-tailed snake (*Stilosoma extenuatum*). This constrictor is the rarest snake species in eastern North America. It spends most of its time underground.

Endemic: Florida scrub lizard (*Sceloporus woodi*). This animal occurs in scrubs on the central ridge and also along both coasts in south Florida.

Eastern slender glass lizard (*Ophisaurus attenuatus*). This legless lizard occurs in many eastern U.S. xeric habitats.

Endemic: Bluetail mole skink (*Eumeces egregius lividus*). This rare animal is found on one site only, on the Lake Wales Ridge.

FIGURE 5–9

Endemic: Sand skink (*Neoseps reynoldsi*). This animal, endemic to the central Florida scrub, is the only representative of its genus that remains alive in the world today.

Endemic: Florida worm lizard (*Rhineura floridana*). Not a worm but a reptile related to lizards and snakes, this burrowing animal is extinct everywhere in the world except dry habitats in central Florida.

Native Reptiles of the Florida Scrub

that are transparent, like goggles, so it can keep its eyes covered and still see the termites, ants, and insect larvae in the half-light in which it hunts. The slim, long, elusive, and rare short-tailed snake also swims through the sand in search of its favorite prey, tiny peninsula crowned snakes, which it kills by constriction. The scrub lizard does not swim in sand but stays in the dense shade underneath rosemary bushes, other shrubs, and sand pine. If threatened, it can run extraordinarily fast in the powder-soft sand.

One other reptile lives in scrub that should be mentioned. The gopher tortoise can easily dig its burrows there, although it finds suitable forage in adjacent high pine habitat. Gopher tortoise burrows serve as "safe homes" in scrub just as they do in pine grasslands.

The Florida Scrub-Jay. The scrub-jay originated in the desert Southwest and expanded into Florida when sea levels were lower and coastal strands lined the shore all the way from west of the Mississippi River to the Florida peninsula. Then the ocean rose and covered the beaches, and the Florida jays evolved to become distinct from their western relatives. The Florida scrub-jay is now found almost exclusively in Florida and is considered to be a Florida endemic—the state's only endemic bird.

The scrub-jay finds its most suitable habitat in scrubs along the central ridge where scrub oaks and rosemaries abound under an open canopy of a few sand pines. Unlike its relative, the blue jay, the scrub-jay prefers and is adapted for life on the ground under the cover of the oaks where it scratches and digs with its strong feet for acorns, berries, seeds, insects, spiders, lizards, and small snakes.

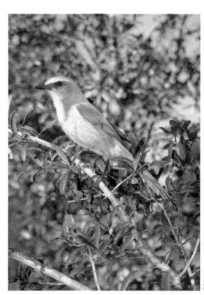

Florida native: Florida scrub-jay (*Aphelocoma coerulescens*). This is the state's only endemic bird species.

The scrub-jay has developed some special adaptive behaviors as its habitat islands have dwindled in size during the last sea-level rise. A scrub-jay pair mates for life and maintains a small family group whose members cooperate in defending the pair's territory and raising the young. Each breeding pair requires about a 20- to 40-acre range in which to forage. Suitable habitat is scarce, and not all jays can pair up and claim territories. Rather, some maturing members of each brood postpone breeding for up to six years, until a place comes available for nesting. Until then, these relatives help a pair to feed each brood, keep the nest clean, and take turns serving as sentinels in the treetops to warn of approaching predators. A sharp whistle signals "Dive: hawk approaching," and a low cackle combined with a directed gaze means "Look out for that predator on the ground." The jays' apparent altruism toward their close kin has led some biologists to study their genetics in search of "generosity genes" that might run in social species.

Scrub-jays provide for their own future food supply. They are omnivorous, but in the fall, when insect food is scarce, each jay eats several thousand acorns and caches several thousand more in the sand.

The scrub-jay thrives in open scrub habitat that has burned within the preceding 10 to 20 years. It abandons patches that become overgrown with pine trees. When you see a resident scrub-jay family that is flourishing, then you will probably see other evidence that you are in prime scrub habitat, just as when you see an active red-cockaded woodpecker clan, you will often recognize your surroundings as a largely natural longleaf pine-wiregrass community.

Scrub Mammals. Like most of the scrub's other animals, the mammals are mostly burrowers. One, the Florida mouse, uses the gopher tortoise burrow as a main chamber and creates its own dwelling in tunnels that branch from it. Over years of evolutionary history, the Florida mouse has become a light tan color that closely matches the sand.

The Florida mouse is a member of the genus *Podomys*, the only genus of mammal endemic to Florida. It apparently evolved in Florida; no fossil records are known from outside the state. It requires a high, dry, well-drained habitat maintained by fire, and because it subsists largely on acorns, it flourishes best on sites that have abundant scrub oaks. The mouse easily scurries up scrub oaks to gather acorns.

The mouse has many predators and no special defenses against water loss. It uses the gopher tortoise burrow, when available, both for shelter and for protection from the sun. Because it digs its nest burrows off the main chamber, it has been called the gopher mouse. If pursued, it freezes and vibrates its tail. If a predator grabs the tail, the brittle sheath slips off, leaving the predator mouseless and the mouse free.[15]

Another scrub mammal is the pocket gopher, a fist-sized rodent with strong digging paws and pockets in its cheeks for storing food. It digs a long, horizontal tunnel system about 30 inches beneath the surface and periodically pushes its diggings out onto the ground surface. Several mounds in a row, equally spaced, are likely to be the work of a pocket gopher.

Florida native: Pocket gopher (*Geomys pinetus*). Several mounds spaced in a row are most likely to be the work of a pocket gopher, who always has sand all over his face.

Evidence of a pocket gopher's work. These mounds are all connected by a long, branching tunnel.

While the scrub serves as habitat for many permanent residents, it also provides a stopping and feeding place for migratory birds and many land animals. List 5—3 itemizes some of the many animals that use the scrub in passing.

PANHANDLE SCRUBS

As mentioned earlier, old coastal formations are stranded inland all across the Florida Panhandle. Their soils are of finely graded and sorted sand, reflecting wind-created dunes. Some now support the same longleaf pine— wiregrass community that grows on the loamy hills just north of them, but some still bear their original cover: sand pine scrub, slash pine scrub, and xeric hardwood forests, primarily oak.

The plants of these ancient beach formations have never been systematically inventoried, but may rival those of central Florida in rarity and uniqueness. They may contain the only living descendants of coastal plants that grew there when the land lay next to the ocean. The endemic Apalachicola false rosemary now grows on just one strip of sand from Liberty to Santa Rosa County that once was a barrier island. Due to clear-cut logging and pine planting over most of the Panhandle, the rosemary's only remaining habitat is in a few patches that have escaped destruction: the high, dry edges of steephead ravines (described in Chapter 6).

The Panhandle sandhills support other rare plants, including some of the healthiest populations of Chapman's rhododendron remaining in the world. On some sandhills, a maritime forest grows, with live oak and sand live oak mixed with southern magnolia and saw palmetto. Animals are seldom seen, but white-tailed deer come to eat the acorns, and occasional birds, such as the eastern towhee and the great crested flycatcher, visit to forage for nuts, seeds, fruits, and insects. Harvester ants are numerous; they gather and eat the seeds of many understory plants. Many reptiles and amphibians are present, but seldom seen.

A light-colored race of kingsnakes occurs between the Apalachicola and Ochlockonee rivers of the Panhandle. Kingsnakes in neighboring areas are black with characteristic widely-spaced cream-colored bands, a pattern that makes them hard to see against the background in which they hide. But the members of this small population of light-colored kingsnakes are protectively colored for hiding against a sandy background, rather than in dark woods (see Figure 5—10). The light-colored kingsnakes presumably evolved in the distant past on a barrier island or spit that today is an inland sandhill. Additional evidence supporting the island origin of this sandhill is that at least 15 other endemic species occur in the same area.[16]

Most people in the region don't recognize the Panhandle's sandhills as ancient beach formations. Many have been bulldozed and plowed for logging and other uses. Other ancient barrier islands may remain in the Panhandle with endemic species that no one has yet discovered.

LIST 5—3
Animal visitors to the scrub (examples)

Amphibians
Barking treefrog
Gopher frog
Mole salamander
Oak toad
Slimy salamander
Southern toad
Spadefoot toad
Striped newt

Reptiles
Coachwhip
Eastern coral snake
Eastern diamondback
 rattlesnake
Eastern indigo snake
Six-lined racerunner
Southeastern five-lined
 skink
Southern black racer

Birds
Common ground-dove
Common nighthawk
Eastern towhee (winter)
Loggerhead shrike
Northern bobwhite
Northern cardinal
Palm warbler (winter)
Turkey vulture

Mammals
Bobcat
Florida black bear
Gray fox
Raccoon
Spotted skunk
Striped skunk
Virginia opossum
White-tailed deer

Sources: Muller et al. 1989; Myers 1990; Clewell 1981/1996, 184.

LEFT: Eastern kingsnake (*Lampropeltis getula getula*). This animal is black with yellow rings, a good camouflage in a shady environment.

RIGHT: Apalachicola kingsnake (*Lampropeltis getula meansi*). Kingsnakes in the Apalachicola River region are cream-colored, a good camouflage where the background is sandy. The color difference suggests that this group diverged genetically from the main population when isolated on an island in the ocean.

FIGURE 5–10

Eastern Kingsnake, Two Forms

The Scrub Ecosystem

Like Florida's natural pine grasslands, scrub is an ancient community, one in which every member both benefits from, and serves, the others. For example, while the burrowing lifestyle meets scrub animals' own survival needs, it also serves another function—that of recycling soil nutrients. Scrub occupies the tops of hills. Without active recovery, nutrients would drain down through the soil and be lost to the system. Swamps and marshes can catch nutrients that flow into them from uphill, but no living system lies uphill from the scrub. The scrub receives a few minerals from rain, but its main source of nutrients is retention via recycling.

Root-associated fungi have already been mentioned as important mineral recyclers, but what of the nutrients that escape the fungal mats and leach down out of reach in the sand? Large burrowing animals can't retrieve them; they lack the elbow room for digging where trees are crowded. But small burrowers are numerous in scrub. The many mounds of yellowish sand on the white powdery floor of the scrub represent burrowing animals and the yellow color signifies that they are mineral rich. A forester counted some 2,000 animal-burrow mounds in an acre, one day, and reported that each mound, on average, weighed about two pounds. This much earth, brought to the surface in one year, amounts to about two metric tons per acre every year.[17]

Another animal activity important in scrub, as in all ecosystems, is what might be called cleanup. The sand-clearing activity of the scrub millipede was mentioned earlier; similar cleanup services are performed by other invertebrates. Plants drop litter on the ground; then beetles, grubs, mites, ants, and others add their wastes, mix them in, adjust the chemistry, loosen the texture, aerate the soil, and enable rainwater to sink into the ground.

Other animals perform other services. Insects disperse the seeds of, and cross-pollinate, many plants. Browsers such as white-tailed deer nibble twigs and branches, and the plants respond much as they do to a gardener's pruning: they branch and grow thicker, providing more shade and wildlife cover. Seldom do browsers overeat the food supply in any one area. In one study, one deer was found for every 101 acres of forest, even though the avail-

Track of the sand skink. Tracks like these are a notable feature of the dry, sandy environment of the scrub, where animals "swim" just beneath the surface of the sand.

able food could have supported one in every 38 acres. This margin allows for other herbivores to coexist with the deer. Predation does not wipe out whole herds, but thins them and eliminates diseased and aging animals.

In short, the scrub system is truly a web, an ecosystem. There is overlap, too. Several species perform most vital functions.

VALUE OF THE SCRUB

Like all ecosystems, scrubs perform environmental services. Because their sandy soils let rain percolate quickly down to the water table, interior scrubs are vitally important in recharging the aquifer. Scrubs are also potential refuges for coastal species, because, if or when sea level rises, their cousins on the present coastal strand may be wiped out. Later, when the sea retreats again, interior scrubs can become sources from which plant and animal populations can expand to repopulate the coast.

Scrubs are also important to the understanding of evolution, because so many of their plants and animals are the last remaining remnants of ancient populations now all but extinct. The plants contain important information, because they are supremely successful in the scrub's harsh surroundings, where no other plants can perpetuate themselves for long. They have all evolved over millions of years to deal with wet summers, dry seasons, and poor soil, much as farmers have to do in most of the world's agricultural areas. John W. Fitzpatrick, a scrub researcher, says the scrub is a "gold mine of genetic information. . . . These plants may be holding secrets to how we can end up genetically engineering our agricultural systems to improve them, especially in dealing with a warmer planet."[18]

Perhaps above all, though, the scrub is simply valuable in its own right. Its peculiar plants and animals are endlessly fascinating and promise to yield many more discoveries in future research.

This chapter concludes the series on north and central Florida's fire-dependent pine communities except for south Florida's pine rockland, which is treated in Chapter 7. In contrast, hardwood forest systems are notable for their exclusion of fire, and it is to these that the next chapter turns.

Florida native: Glorious flower moth *(Shinia gloriosa)* on a Florida endemic plant, Feay's palafox (*Palafoxia feayi*). Active only at night, the moth "disappears" at dawn by settling on this plant. For years, because it was so well camouflaged, no one knew where this moth went during the day.

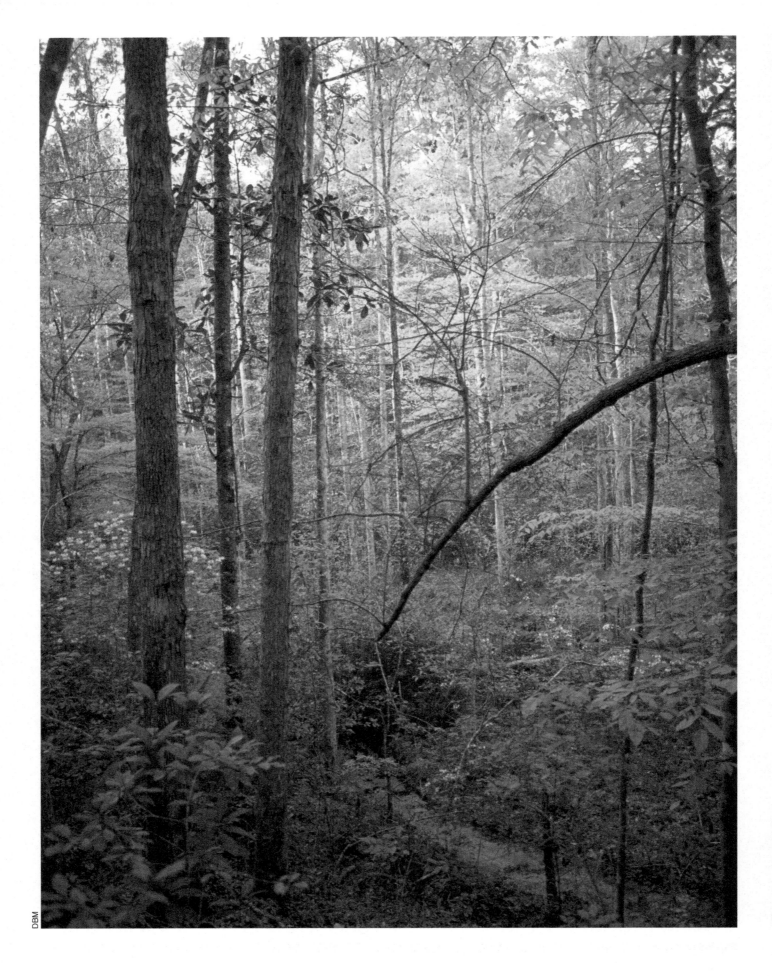

CHAPTER SIX

TEMPERATE HARDWOOD HAMMOCKS

Hardwood trees and shrubs have been growing on the southeastern U.S. Coastal Plain for more than 50 million years. During hot, wet times, the trees that flourished most abundantly were those of tropical rainforests. During times of cooler climates, temperate hardwoods tended to take over. Today, both types of trees comprise Florida's hardwood hammocks. Temperate hammocks occur all over north Florida, and tropical hammocks in extreme south Florida. Forests of mixed temperate and tropical composition are arrayed between these two extremes (see Figure 6-1). This chapter deals with temperate hardwood hammocks and Chapter 7 discusses the tropical hammocks of the Everglades and Keys.

In presettlement times, hardwoods naturally occupied fire-protected areas such as steep slopes near rivers, lakes, and sinks because fires don't burn down slopes well. However, now that natural fires are not permitted to burn, hardwoods have seeded uphill and extensively invaded once pine-clad uplands. The upland landscape now—if not human-created by agriculture, silviculture, and development—is a mixture of hardwoods and shortleaf and loblolly pines rather than longleaf pine. After most of the longleaf pines were logged and fires suppressed, the more aggressive hardwoods and other pines readily took over. The original hardwood forests and hammocks may have occupied only some 1 to 2 percent of Florida's land area, but today stands of mixed pines and hardwoods blanket the uplands of central and north Florida, as well as reaching all the way to Virginia and east Texas.

The driest hardwood forests are nearly as dry as high pine; the wettest are wetlands. The Florida Natural Areas Inventory (FNAI) classifies them as xeric, mesic, and hydric. Xeric hardwood forests are of oak, often live oak and laurel oak. Hydric forests often consist mostly of cabbage palm, swamp bay, and red cedar. Between these extremes are mesic forests containing many mixtures of trees (slope forests, upland forests, and mixed forests), and at the wet extreme are swamps known as floodplain and bottomland forests (these are treated in Volume 2 of this series, *Florida's Wetlands*).

Many variables besides soil moisture influence each forest's composition

Softwoods include pines and other conifers. Most are true evergreens: they retain their leaves (needles) all year, shed only a few from day to day, and add new growth at the branch tips in spring. **Hardwoods** are broad-leafed, flowering trees and most are deciduous: they shed their leaves in fall and grow new ones in spring.

Temperate hardwoods are those that grow best in the temperate zone (in which Florida lies). **Tropical hardwoods** grow best in extreme south Florida and beyond.

A **forest** is a large community of trees and shrubs. The name **hammock** is commonly given in Florida to non-pine forests. (Florida hammocks do contain a few non-hardwoods, such as cabbage palm and red cedar, however.)

Florida native: Northern mockingbird (*Mimus polyglottos*). Hardwood forests afford nesting sites for parent birds and insect fare for hungry hatchlings.

OPPOSITE: A hardwood hammock in the Apalachicola Bluffs and Ravines Preserve in Liberty County. Forests like this have hundreds of species of vascular plants and a diverse assortment of animals.

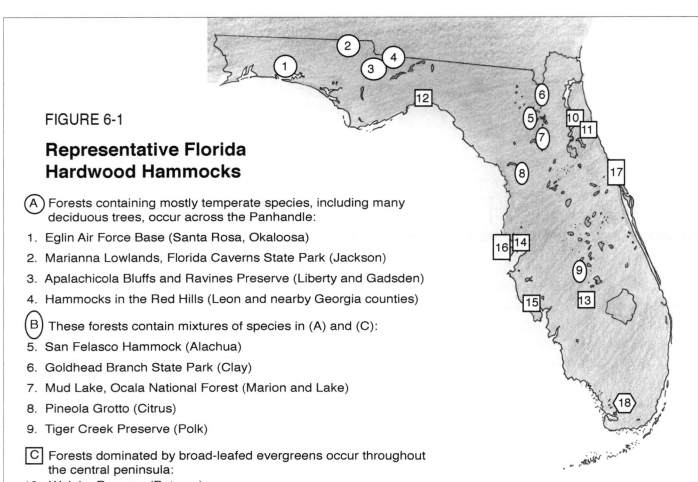

FIGURE 6-1

Representative Florida Hardwood Hammocks

(A) Forests containing mostly temperate species, including many deciduous trees, occur across the Panhandle:

1. Eglin Air Force Base (Santa Rosa, Okaloosa)
2. Marianna Lowlands, Florida Caverns State Park (Jackson)
3. Apalachicola Bluffs and Ravines Preserve (Liberty and Gadsden)
4. Hammocks in the Red Hills (Leon and nearby Georgia counties)

(B) These forests contain mixtures of species in (A) and (C):

5. San Felasco Hammock (Alachua)
6. Goldhead Branch State Park (Clay)
7. Mud Lake, Ocala National Forest (Marion and Lake)
8. Pineola Grotto (Citrus)
9. Tiger Creek Preserve (Polk)

[C] Forests dominated by broad-leafed evergreens occur throughout the central peninsula:

10. Welaka Reserve (Putnam)
11. Anastasia Island State Park (Flagler)
12. St. Marks National Wildlife Refuge (Wakulla)
13. Highlands Hammock State Park (Highlands)
14. Alafia River hammocks (Hillsborough)
15. Little Salt Spring, Myakka River State Park (Charlotte and Sarasota)

[D] Mixtures of (C) and (E) predominate here:

16. Highlander Hammock (Pinellas)
17. Turtle Mound (Volusia)

(E) Tropical hardwood hammocks are scattered across the Everglades and Florida Keys:

18. Everglades National Park (Miami-Dade and Monroe)

Note: The Panhandle forests (A) may be called southern hardwood forests. The peninsula forests (C) may be called temperate broad-leafed evergreen forests. The tropical hardwood hammocks (E) may be called tropical rainforests.

Source: Adapted from Platt and Schwartz 1990, 200, fig 7.1.

and appearance. Climate is a major factor: north Florida's forests are temperate; south Florida's are more tropical. Other factors include the presence of seepage or frequency of flooding (if any), steepness of slope, compass direction toward which the slope faces, soil texture and drainage, soil chemistry (especially

whether limestone-influenced or not), and the forest's own past history and age. Each of these factors varies widely and many different combinations are found together, so one forest can be quite distinct from most others.

The expansion of hardwood forests into upland sites in the last several centuries has afforded opportunities for species to come together in places and mixtures not seen only a few centuries ago. "New" forests have sprung up wherever natural pinelands have been cleared, then used for a while for farming, silviculture, or human settlement, and then abandoned. Today, many of Florida's abandoned farm fields, pastures, and neglected backyards have grown up into forests of pine, oak, and hickory that never existed originally on most upland sites. Pine-oak-hickory woods are the result of clearing followed by fire exclusion and invasion of temperate hardwoods, shortleaf pine, and loblolly pine into areas once dominated by high pine grasslands. Forests of this kind now occupy large areas of Florida.

However, the emphasis in this chapter is on living communities of ancient origin or of enduring types, the products of relatively long periods of ecologically stable conditions and evolutionary adaptation of their plants and animals. The hammocks identified in Figure 6-1 fit that description.

AN EXAMPLE: A BEECH-MAGNOLIA FOREST

Imagine standing in a tall, shady hardwood forest partway down a slope somewhere in north Florida—a forest that has grown here, constantly renewing itself, for thousands of years. It is summer. The trees have all leafed out, and the shade is deep, except in a sunny patch where a giant southern magnolia has fallen over. The ground is covered with leaves and there is little undergrowth. Listen: you hear several bird songs: the distinctive chicky-tucky-tuck of a summer tanager, the loud, clear call of a yellow-throated warbler, the chip-trill-chip of a white-eyed vireo, and the hoarse caw-caw of a crow. Squirrels are scurrying up and down the trees, and chasing each other across the canopy.

You recognize two of the biggest trees from their bark and from the leaves they have dropped around their bases. Southern magnolias have gray bark, smooth to the touch, and large, dead, oblong leaves piled a couple of inches thick beneath them. American beeches also have smooth, gray bark, but only small, crinkly, rusty-tan leaves on the ground. Looking up, you see no sunlight through the myriad light-green leaves of an American beech; looking down, you see few or no plants growing beneath it. The shade it casts is so dense that nothing can find light here.

The forest is named a beech-magnolia forest for these trees, but there are many other tree species including several kinds of oaks, two hickories, American holly, spruce pine, and others—altogether, 25 to 35 species of broad-leafed flowering trees (hardwoods) mixed with a handful of conifers. Some have attained the canopy with the beeches and magnolias, some are midstory trees, and a few low-growing shrubs and herbs have found spots to grow on the forest floor. List 6-1 names some of the canopy and midstory

LIST 6-1
Tree layers in hardwood forests (examples)

Overstory trees
American beech
Basswood
Black walnut
Carolina ash
Florida maple
Hickories (several species)
Laurel oak
Live oak
Loblolly pine
Shortleaf pine
Southern magnolia
Southern red oak
Spruce pine
Sugarberry
Swamp chestnut oak
Sweetgum
Tuliptree
Water oak
White oak

Midstory trees and shrubs
American holly
American hornbeam
American plum
Cabbage palm
Common serviceberry
Common sweetleaf
Eastern hophornbeam
Eastern redbud
Flowering dogwood
Green ash
Hawthorn (several species)
Red buckeye
Red maple
Red mulberry
Silverbell
Southern arrowwood
Sparkleberry
Wax myrtle
Wild olive
Winged elm
Witchhazel

Source: Adapted from Wolfe and coauthors 1988, 131.

trees that grow in forests of this type.

This forest is strikingly different from the pine grasslands and scrubs described earlier. What makes it possible for so many trees to grow so close to one another? How do they all obtain water, sunlight, and places to reproduce? What animals live in, on, and around them, and why?

Gap Succession. Perhaps the greatest distinction between this forest and a pine forest is that this forest resists burning. Its thickly vegetated edges and closed canopy hold moisture in and shield the interior from wind. The trees drop moist litter that rots slowly, keeps the ground cool and damp, and compacts the fuel beds beneath it, excluding air. Within this deep shade, saplings that need abundant sun such as longleaf pine cannot grow, so there are no fire starters or carriers. Faced with these obstacles, even if an occasional fire should, during a drought, creep into a beech-magnolia hammock from a nearby fire community, it would not burn hot or far across the ground and could not leap to the layers above. (This is true of all hardwood hammocks, with only a minor exception. Mild surface fires clear the undergrowth in mature oak woods from time to time.)

If fires do not kill trees and open the canopy for new growth, then how do the trees in a beech-magnolia forest renew themselves? The answer is by gap succession—that is, by the periodic death of mature trees. Trees are snapped off or blown down by windstorms or die from injury and disease, and this opens gaps in the canopy and on the ground. They are succeeded at first by a mass of young trees of many species; these undergo intense competition for sunlight and resources; many die; and finally, the gap is refilled by one or two mature trees of the same species as those nearby. Renewal by gap succession takes place continuously. Diverse tree seeds are present at all times in the soil, having been dropped by the trees and by birds and other animals, especially squirrels. Whenever a tree loses major branches or dies and falls over, young trees start up immediately in a flood of sun. Small, fast-growing saplings are the first to shoot up, so they get a head start, but slower-growing, shade-tolerant evergreens soon follow. Finally, even slower-growing and more shade-tolerant trees overtake the others and close the canopy above all the others. A natural hardwood hammock displays all the stages of gap succession: the trees are always diverse and in varying stages of growth. This ongoing process permits many different tree species to find places in the forest.[1]

Plant Adaptations. Because hardwood forests are multi-layered forests in which trees compete for sun at every level, each tree species has somewhat different ways of obtaining sun. The trees that grow fast as saplings command most of the sunlight in a gap at first while they attain their mature height. Slower-growing trees manage to grow in the sparse shade beneath them; they develop more massive, stronger trunks and can ultimately attain more height. Some of the adaptations of magnolias and beeches, which are slow-growing trees, are mentioned in Figure 6-2.

Trees also display great variety in the ways they capture sunlight. Because the canopy trees reflect most of the green wavelengths of light, lower-growing plants live in a bluish shade and are adapted to catch light in that range of wavelengths. Moreover, because some canopy trees are deciduous, midstory

Gap succession is the process by which hardwood forests renew themselves. Each gap created by the death of an old tree is filled by seedlings of the same or other species.

Tardily deciduous hardwoods hold their leaves well into winter before finally dropping them. American beech and live oak are examples.

Broad-leafed evergreen hardwoods retain their older leaves until new ones start to come in. Southern magnolia and American holly are examples.

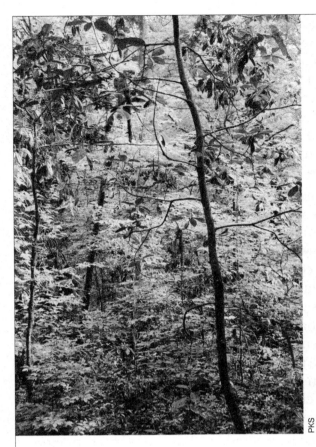

American beech (*Fagus grandifolia*).

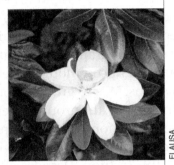

Southern magnolia (*Magnolia grandiflora*).

Magnolia fruit.

FIGURE 6-2

Layers in a Beech-Magnolia Forest

The trees with dark green leaves are magnolias. The trees with light green leaves, which are spread horizontally to catch the sun, are beeches. The beeches give a layered look to the forest.

In their young lives, slow-growing magnolias and beeches often have to grow in the shade. Magnolias are evergreen hardwoods and can grow in the winter sun while deciduous trees are bare. Beeches, thanks to the planar arrangement of their leaves, catch every possible ray of sunlight that filters down to them from above.

Both species can grow beneath other trees at first, and can ultimately overtop most of their competition. They create a dense shade—the magnolias, by holding their leaves all year long, and the beeches by retaining their leaves even after they have turned brown. Beech leaves fall late, mostly when the new leaves are starting to grow in early spring.

Both trees compete at the ground level, too. Magnolia leaf mulch presents a formidable barrier to other seedlings' growth, and decaying beech leaves may release chemicals that inhibit the growth of all but the beech's own seedlings. Ultimately, beeches and magnolias come to dominate the canopy, and shade out many midstory trees.

Source: Means 1994 (Temperate hardwood hammocks).

trees and shrubs can compete for sun below them by holding their leaves later in fall. These tardily deciduous trees do much of their growing after most of the trees above them are bare. Other midstory trees, such as hollies, are evergreens. They gather a lot of their energy in winter when all the deciduous trees are dormant. Also, at Florida's latitude, especially in winter when the sun is at an angle to the earth, sunlight sneaks into the interior of forests from their edges and enables a low layer of herbs, shrubs, and small trees to leaf out and flower in early spring. In effect, there are many different habitats for plants in a forest, and there are plants to take advantage of each one.

On the floor of a beech-magnolia forest, the herbaceous groundcover and soil organisms also repopulate gaps left where trees have fallen. The renewal process is most rapid and complete where trees fall naturally, rather than being cut. When trees fall, they raise tip-up mounds and leave pits behind, creating small variations in contour which foresters call pit-and-mound microtopography. Different plants colonize different small surface features around tip-up mounds. Ferns grow well on the shady side of upraised root systems. Mosses grow best on shady, damp spots. Other plants seize other sites. In this way, the groundcover remains diverse for centuries. (In contrast, conventional forestry may prepare ground for new planting by leveling it—and not all groundcover plants can reestablish themselves in soil exposed to sun in this fashion. Decades after clear-cut, leveled forests have been replanted, they still lack groundcover diversity.)[2]

Key functions are performed by numerous plants in a beech-magnolia hammock. Pine grasslands have one dominant fire-starter tree (such as longleaf or slash pine) and one dominant fire-spreading groundcover plant (such as wiregrass). In hardwood hammocks, many trees, shrubs, and herbs play overlapping roles. Still, whichever species are present, the hammock's structure is similar, with broad canopy boughs at the top, many branches at the midstory level, and lots of shade, moisture, leaf litter, and decay on the forest floor.

Puffball (a *Lycoperdon* species).

Witches' butter fungus (*Tremella mesenterica*).

FIGURE 6-3

Onion-stalk lepiota (*Lepiota cepaestipes*).

Fungi Native to Florida Forests

Each of these fungi performs chemical dismantling work in the forest. What you see is only the tip of the mushroom. A mushroom is the above-ground fruiting body of the fungus, whose masses of underground filaments called hyphae have been decomposing the dead wood for a long time.

Hardwood hammocks differ from pinelands in many other ways. Pinelands are open, sunny, and spacious; hardwood forests are closed, shady, and full of branches and vines. Much of the photosynthesis in pine grasslands is conducted by the groundcover herbs, whereas in hardwood hammocks it is the canopy that captures most of the sun's energy and converts it into substance. Living groundcover is less abundant due to both low light intensity and root competition by trees and shrubs. In pine communities, fire recycles most nutrients; in hardwood forests, decay agents do. Figure 6-3 shows three fungi that perform this task in Florida forests.

Animals. Because most of the productivity of a hardwood hammock takes place in the canopy, animals that live there have to be able to fly or climb. The hammock's many compartments offer diverse habitats for animals. Thanks to the diversity of tree species, all kinds of branches offer shelter and support at every height. Diverse flowers and fruits are also available as foods for insects, birds, and other animals. Some 45 species of birds breed and nest and raise their young in north Florida's mesic hardwood forests, and 13 species breed only in such forests (see List 6-2). The deeper the forest interior, the greater the diversity of breeding birds. Many migratory birds, too, prefer large hardwood forests over small ones.

Because the adaptations animals have made to life in hardwood forests are different from those in pinelands, different sets of animals exist in the two habitats. Some, such as the wild turkey, use both, but most animals are more closely tied to one than to the other. As an example, animals seeking nuts and berries in a longleaf pine forest find many growing in the diverse, low groundcover, but in a hardwood forest, they will have to climb high on branches. Thus while the pine forest is home to the ground-foraging fox squirrel, the hardwood forest has the tree-climbing gray squirrel. The pine forest is home to the great horned owl, whose wingspread of 55 inches is easily accommodated by the pinelands' open spaces. Lowland hardwood forests have the smaller, barred owl, which navigates skillfully among the more closely spaced trees (see Figure 6-4). In the open pine forest, there is the red-tailed hawk (wingspread 48 inches), which soars over open spaces and dives for its prey. The hardwood forest has the red-shouldered hawk (wingspread 40 inches), which usually hunts from a perch and drops to the ground to catch its prey.

Florida native: Patent leather beetle (*Passalus cornutus*). The grub shown above develops into the beetle shown below. This is one of dozens of species of beetles and other invertebrates that eat rotten wood in Florida forests.

Inconspicuous plants and animals in hardwood forests are also diverse. A single fallen tree provides habitat for dozens of interacting organisms and the litter on the ground feeds and shelters many more. There may be fungi spreading through the rotting wood, lichens and mosses growing on it, bacteria and algae working within its tissues. There may be spiders in the cracks, bark beetles, boring beetles, tunneling beetles, and termites eating the wood. Preying on these are scorpions, centipedes, oribatid worms, and earwigs. Preying on these are birds, of course, and on them, others. Keen observers find hundreds of creatures living in habitats like these, where a casual glance might reveal few or none.

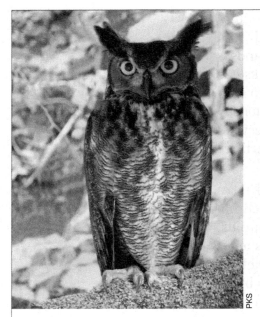
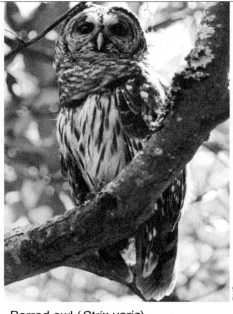

FIGURE 6-4

Owls of Florida's Pine and Hard-wood Forests

The great horned owl is the night-time winged predator of Florida's pine forests. The barred owl is the nighttime, winged predator of Florida's hardwood forests. Sets of species like this, which perform the same roles but in different habitats, are known as *geminate (paired) species.*

Great horned owl (*Bubo virginianus*). Barred owl (*Strix varia*).

SELECTED HARDWOOD FORESTS AND HAMMOCKS

The beech-magnolia forest just described illustrates the principles that govern growth and competition among hardwoods, although details vary from one to the next. Moisture varies so much from the top to the bottom of a slope that,

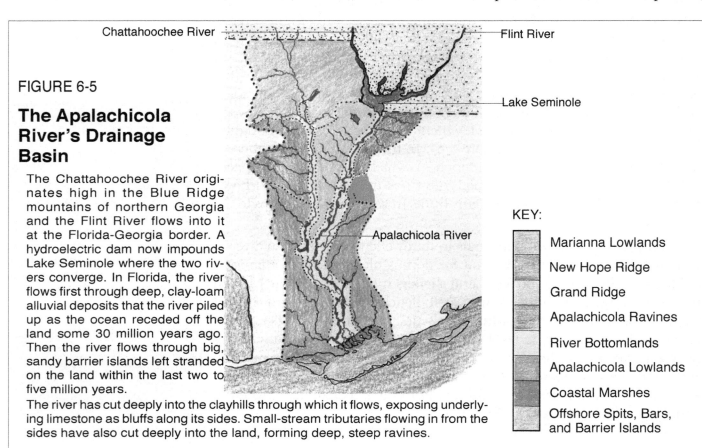

FIGURE 6-5

The Apalachicola River's Drainage Basin

The Chattahoochee River origi-nates high in the Blue Ridge mountains of northern Georgia and the Flint River flows into it at the Florida-Georgia border. A hydroelectric dam now impounds Lake Seminole where the two riv-ers converge. In Florida, the river flows first through deep, clay-loam alluvial deposits that the river piled up as the ocean receded off the land some 30 million years ago. Then the river flows through big, sandy barrier islands left stranded on the land within the last two to five million years.

The river has cut deeply into the clayhills through which it flows, exposing underly-ing limestone as bluffs along its sides. Small-stream tributaries flowing in from the sides have also cut deeply into the land, forming deep, steep ravines.

Source: Adapted from Means 1977.

Chattahoochee River — Flint River — Lake Seminole — Apalachicola River

KEY:

Marianna Lowlands
New Hope Ridge
Grand Ridge
Apalachicola Ravines
River Bottomlands
Apalachicola Lowlands
Coastal Marshes
Offshore Spits, Bars, and Barrier Islands

FLORIDA'S UPLANDS

FIGURE 6-6

Steephead Ravines

A steephead ravine cuts into a sandhill, not because water runs over the surface and erodes it, as in clay hills, but because water runs out from beneath the hill and carries sand away. The steephead's walls slope at a 45-degree angle to the earth.

BELOW: Diagram of a single ravine showing the valley contours. Note how water runs out from beneath the sandy slopes through which it has percolated, rather than from the top of the ravine.

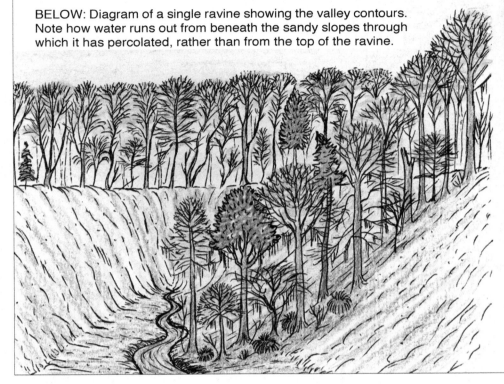

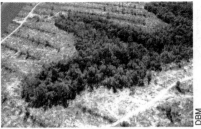

ABOVE: Aerial view of several steepheads. Shown are heads of three ravines that run into Sweetwater Creek, a tributary that flows through deep sand into the Apalachicola River from the east. Notice how abruptly each ravine drops off from the surrounding, level agricultural land.

Other steephead ravines are found on other stranded, ancient barrier islands: on Eglin Air Force Base in Santa Rosa and Okaloosa counties; by the Econfina River north of Panama City; by the Ochlockonee River along Lake Talquin; and along Trail Ridge in Clay and Bradford Counties.

Source: Means 1991 (Florida's Steepheads).

even in a single forest, many different trees and shrubs grow, each in a zone to which it is especially well adapted. People who can recognize most hardwoods can guess quite accurately how far down a slope they are from the mix of species there.

Variation also occurs along Florida's north-south axis. In general, the northern hammocks are richest in species. Only 60 percent of the tree species of the temperate hammocks of north and central Florida hammocks range as far as the southern one-third of the peninsula. The same is true of native amphibian and reptile species. Tropical hardwoods make up for the deficit in trees, with a variety having colonized the south part of Florida, but native amphibians and reptiles simply decline in number in the south.

A decline in species numbers toward the tips of peninsulas is seen elsewhere in the world and is known as the peninsula effect. In Florida's case, a reduction in diversity of elevations may be responsible. South of the northern end of Lake Okeechobee, for instance, elevations are all below 25 feet. There are no ravines, no north- and south-facing slopes, no moist stream bottoms for salamanders, and no high sand ridges for high pine grasslands. As the variety of soil and habitat types declines, so do the numbers of species dependent on them.

Many forests and hammocks in Florida are prized for their special characteristics. A few are selected for treatment here.

A decline in species numbers toward the tip of a peninsula is known as the **peninsula effect**.

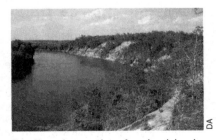

Bluffs along the Apalachicola River. The steep slopes, rich soils, and limestone outcrops along the river support diverse hardwood communities.

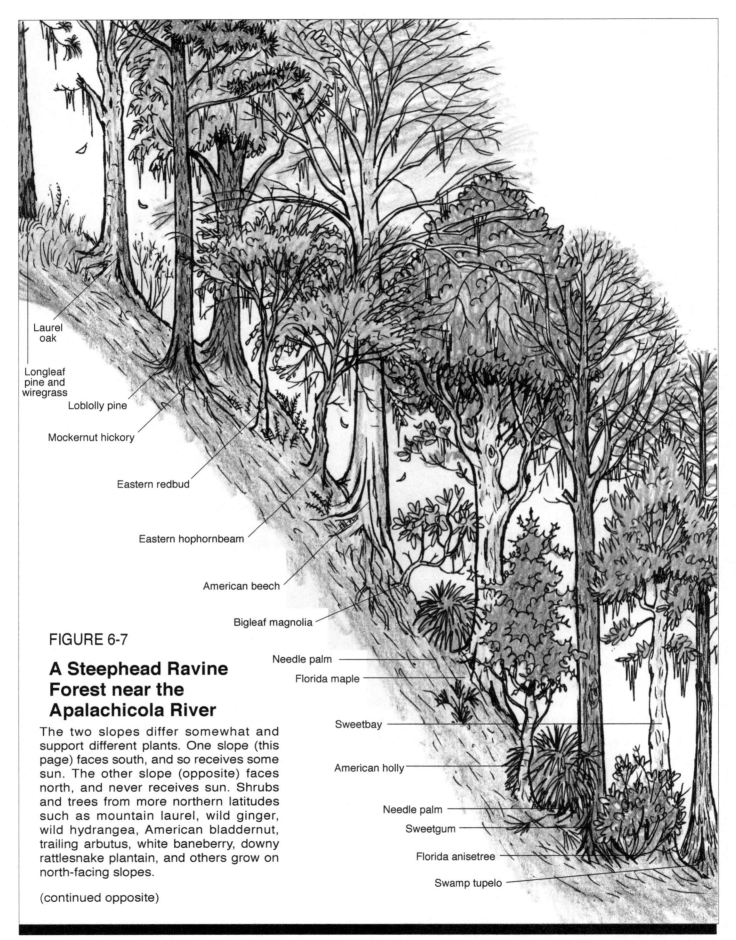

Laurel oak

Longleaf pine and wiregrass

Loblolly pine

Mockernut hickory

Eastern redbud

Eastern hophornbeam

American beech

Bigleaf magnolia

FIGURE 6-7

A Steephead Ravine Forest near the Apalachicola River

The two slopes differ somewhat and support different plants. One slope (this page) faces south, and so receives some sun. The other slope (opposite) faces north, and never receives sun. Shrubs and trees from more northern latitudes such as mountain laurel, wild ginger, wild hydrangea, American bladdernut, trailing arbutus, white baneberry, downy rattlesnake plantain, and others grow on north-facing slopes.

(continued opposite)

Needle palm

Florida maple

Sweetbay

American holly

Needle palm

Sweetgum

Florida anisetree

Swamp tupelo

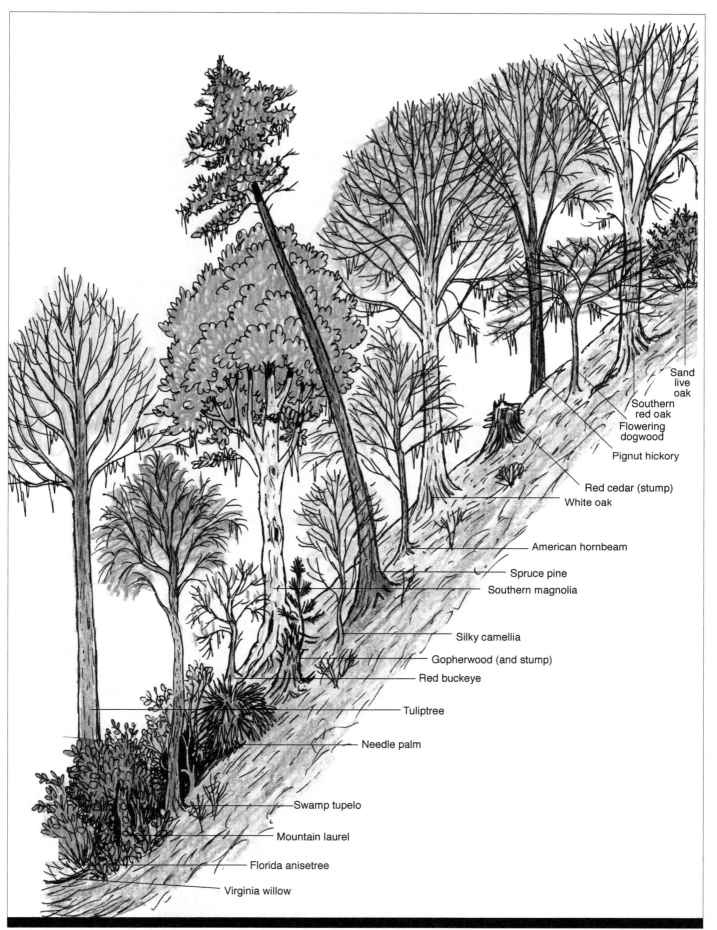

Sand live oak
Southern red oak
Flowering dogwood
Pignut hickory
Red cedar (stump)
White oak
American hornbeam
Spruce pine
Southern magnolia
Silky camellia
Gopherwood (and stump)
Red buckeye
Tuliptree
Needle palm
Swamp tupelo
Mountain laurel
Florida anisetree
Virginia willow

Florida native: Pyramid magnolia (*Magnolia pyramidata*). This rare small tree was photographed skyward from deep in one of the Apalachicola ravines.

FIGURE 6-8

Florida Native: Gopher-wood (*Torreya taxifolia*)

This evergreen conifer (whose genus name is pronounced *toe-RAY-uh*) is endemic to Gadsden, Jackson, and Liberty counties and to Decatur County, Georgia. Its range now is limited exclusively to the east side of the Apalachicola River north of Bristol. It is endangered in Florida: fewer than 2,000 individuals remain in the wild.

The gopherwood's habitat requirements are stringent. It grows only on wooded ravine slopes and bluffs, at elevations from 35 to 100 feet above constantly running streams, and in moist soil of moderate to rich organic content, most often on north-facing slopes.

In the past, a gopherwood could be a massive tree. A large specimen could be 60 feet tall with branches some 25 feet long. All specimens in Florida are of less than sapling size now, however, possibly due to a fungal blight.

Sources: Godfrey 1988, 59-60; Clewell 1985, 56; Schwartz and Hermann 1993, 1-3, 20.

Apalachicola Bluffs and Ravines. Parts of the Apalachicola River area have been above sea level for some five to ten million years, and some of its plant populations are even older because they were already established nearby before Florida emerged from the sea. Now, climate changes of the past have fragmented the ranges of some of the plants, but they still are protected within the deep, steep ravines of tributaries flowing into the Apalachicola River from the east. Many are recognizably related to plants elsewhere in the world. Several of the tree and shrub species resemble those in similar ravines in eastern Asia. A few mosses and ferns that grow in the protected understory also grow in Mexican tropical cloud forests.

Species from the Appalachian Mountains to the north are especially abundant around the Apalachicola River. The deep ravines all along the river's watershed are shady, protected valleys into which Appalachian plants and animals were able to spread and persist. All other rivers in Florida originate on the Coastal Plain, but the Apalachicola's headwaters are in the Blue Ridge mountains of northern Georgia. No other river valley near the Gulf of Mexico, not even that of the mighty Mississippi, is inhabited by so many northern plants from times long past.

Figure 6-5, shown on page 96, highlights several areas in the river's watershed that are discussed in this and other chapters. Forests in the ravines and in the Marianna Lowlands are described here; communities of the river bottomlands, coastal lowlands, and coastal marshes are wetland systems and are described in Volume 2 of this series, *Florida's Wetlands*.

The ravines in the younger sandhills are of particular interest because

Florida native: Wild ginger (*Asarum arifolium*). This plant, growing in the Apalachicola Bluffs and Ravines Preserve, is a member of a species population that is centered in the southern Appalachian mountains. Another common name for it is heartleaf.

they are stable repositories of ancient species. Water flows through them steadily all year long, regardless of fluctuations in rainfall on the high land around them. In contrast, creeks in the more northern ravines in clay-lined valleys go dry between rainfalls. The sandy ravines are 50 to 100 feet deep, and their walls are among Florida's steepest slopes. Locals call them "steephead" ravines, because the head of each valley has deep, steep walls. Views of steephead ravines are shown in Figure 6-6.

Figure 6-7 reveals how the trees and shrubs respond to the several gradients in a steephead ravine. The soil is coarse sand, well drained throughout, but other conditions grade from top to bottom, supporting great diversity among the plants. Soil temperature varies with the season at the top, but deep in the "V" of the ravine it remains relatively constant the year around. The top is sunny, hot, dry, and windy. The bottom is shady, cool, humid and still. Steephead ravines provide Florida's most dramatic examples of the ways trees and shrubs sort themselves out on slopes

To appreciate the details, imagine standing at the edge of a typical ravine. The level land behind you supports a high, dry, longleaf pine-wiregrass community (or more commonly today, a stand of planted pine). In front of you, the thickly forested ravine slope plunges so steeply to the ravine floor that you are looking down into the tops of tall hardwood trees growing up from below.

Now, walk down into the ravine. Go carefully: at each step, your heels must sink deeply into the soft sand, otherwise you'll pitch forward and tumble down a dangerous incline. Grasping the stems of small oaks and some vines, you can brake your descent hand-over-hand until you are halfway down. You have already passed through a couple of bands of trees. At the rim was a very well-drained forest composed mostly of live oak or sand live oak; just below it, a mixture of laurel oak, mockernut hickory, wild olive, red cedar, and other trees adapted to dry soil, because the sandy substrate holds water so briefly after each rain.

About midway down, the forest becomes more shady and therefore more open near the ground. The slope is paved with crinkly, light-brown beech leaves or leathery, rattling, and slippery magnolia litter. The beech-magnolia combination bears testimony that the soil is more moist here. Unlike other mesic forests, though, this one has a few ancient understory trees, such as gopherwood (Figure 6-8), bigleaf magnolia, and pyramid magnolia. Gopherwood may be one of the oldest plant species in the ravines. It closely resembles fossil gopherwood from southern Appalachia that dates back about 100 million years——well into the age of the dinosaurs.

The floor of the ravine, where the water seeps out from beneath the ravine's sides, holds saturated soil and supports a true wetland dominated by sweetbay, tall gallberry, and Florida anisetree. In its center flows a perennial clear-water stream that is an ecosystem all to itself——the steephead stream described in Volume 2 of this series, *Florida's Wetlands*.

Because the Apalachicola River runs from north to south, its tributary streams run east-west. As a result, each ravine has a north-facing and a south-facing slope. The path just described descended the ravine's north

Florida native, near-endemic: Croomia (*Croomia pauciflora*), seen growing in the Apalachicola Bluffs and Ravines.

Florida native: Oakleaf hydrangea (*Hydrangea quercifolia*), growing in Torreya State Park in Liberty County.

Florida native: Wild columbine (*Aquilegia canadensis*). This plant, at the extreme southern end of its range, grows in the Marianna Lowlands forests, and in the forests of the Apalachicola Bluffs and Ravines.

LIST 6-3
Rare and unusual plants in the Marianna Lowlands

Northern Plants
American lopseed
Barbara's buttons
Black walnut
Blacksnakeroot
Bloodroot
Canadian lousewort
Carolina holly
Golden stars
Jack-in-the-pulpit
Mayapple
Meadowparsnip
New Jersey tea
Red mulberry
Roundleaf ragwort
Rue anemone
Smooth Solomon's-seal
Tall thistle
Wakerobin
White basswood
White indigoberry
Wild blue phlox
Wild columbine

Other Unusual Plants
American bellflower
Broad beech fern
Canadian woodnettle
Cutleaf toothcup
Florida flame azalea
Flyr's nemesis
Greater Florida spurge
Lakecress
Mountain spurge
Eastern sweetshrub

Isolated Populations
Blueridge carrionflower
Coralberry
Eastern false rue anemone
Tennessee leafcup

Source: Adapted from Mitchell 1963.

Spanish moss is an **epiphyte**—that is, a plant that grows on another plant. Actually not a moss, it is a bromeliad, related to the pineapple. Chapter 7 features several other bromeliads.

slope, the one that faces south and receives at least some sun each day. Look across at the opposite slope, which faces north and never receives direct sun. Many of its species are those typically seen much farther north. Wanderers may wonder in surprise whether they have suddenly been transported to the mountain cove valleys of the Appalachian Blue Ridge.

Besides the trees in the ravines, diverse shrubs, vines, herbs, fungi, and lichens contribute complexity. All these plants enable many animals to use the ravines as foraging, breeding, and nesting sites.

Most of the birds and mammals that frequent the ravines are the same as those that inhabit other stream valleys, lake and pond basins, and other lowland forests. However, in steepheads, small animals whose lives depend on continual moisture are tightly confined to the ravine bottoms because the sidewalls are so sandy, well-drained, and dry. Only at the level of the stream does much moisture and organic matter accumulate. Three species of salamanders reside only in the shallow seepages along steephead streams.

Wherever frogs and salamanders reside in a particular steephead stream, their progeny will surely dwell nearby. Many other such differences doubtless also exist. One naturalist has observed that black widow spiders in the Apalachicola ravines live in trees and shrubs, whereas elsewhere in Florida, as far as we know, they live on the ground.[3]

The single 35-mile stretch of ravines on the east side of the Apalachicola River in Florida harbors more total plant and animal species, and more endemic species in particular, than any other area of the same size on the southeastern Coastal Plain. The ravines are home to more than 100 rare and endangered species. Despite their fame, however, the Apalachicola Bluffs and Ravines have never been exhaustively surveyed; they have many more

Florida native: Live oak (*Quercus virginiana*). Live oak hammocks are common in central Florida and hold masses of Spanish moss and resurrection fern. This was photographed at sunset, hence the orange tint.

Florida native: Resurrection fern (*Pleopeltis polypodioides* var. *michauxiana*). This is a true fern with a knack for surviving dry times. It dries to a brown, crackly remnant of itself that looks dead. Then, after rains, it turns green almost instantaneously and continues its life.

Florida native: Spanish moss (*Tillandsia usneoides*). The tiny gray scales of this epiphyte absorb dew, which provides water and nutrients. Spanish moss flourishes on trees with a leafy canopy, which protect the humidity on which it depends.

secrets to reveal in times to come. The Florida Biodiversity Task Force has ranked the Apalachicola River basin, together with the central Florida ridge, as a "hot spot" of endemic species, a site of great value to global biodiversity. The Nature Conservancy has purchased hundreds of acres of the bluffs and ravines for ongoing preservation and now a large percentage is owned by the state and managed as Torreya State Park.[4]

The Marianna Lowlands Forests. West of the Apalachicola River around Marianna in Jackson County lie the Marianna Lowlands, centering on the Chipola River. Once continuous with the clay-loam highlands on both sides, this 450-square-mile area has extensively subsided and eroded. Today, masses of limestone are exposed at and near ground surface, and only partially capped by a mixture of largely clayey sediments. This unusual combination of clay and limestone supports a hardwood forest with species not found anywhere else in Florida, even in the nearby Apalachicola Bluffs and Ravines (see List 6-3). Within the lowlands, the Florida Caverns State Park supports many plant populations that are now evolving separately from their sister populations in both northern and tropical habitats. Other ancient and isolated populations can be found in the nearby Chipola floodplain.

The Marianna Lowlands' groundcover herbs include many that are at the extreme southern ends of their ranges, such as wild columbine, Mayapple, and bloodroot. It is thought that these plants first found refuge there more than two million years ago. They have persisted there ever since, thanks to the Lowlands' rich, limestone soils and deep, shaded habitats that are similar to the mountain coves of the southern Appalachians.

Other plant populations in the forests are ferns and mosses isolated from much more southern, and much more northern, groups. Because they reproduce via spores, which can float in on the air, they can grow wherever they find suitable habitat, and the limestone exposures around Marianna are ideal for them. Observer Richard S. Mitchell remarked that the mixture of species he found seemed to defy the existence of north-south zones.[5]

Xeric Oak Hammocks in Central Florida. Central Florida's slopes hold scattered hammocks of all three classes: xeric, mesic, and hydric. For reasons unknown, American beech and white oak do not occur

Florida native: Cope's gray tree-frog (*Hyla chrysoscelis*). This treefrog calls from hammock trees and bushes on warm, rainy nights, and eats arboreal insects. Like other frogs, it seeks out ponds at mating time.

A **mast year** is one in which a population of trees (frequently, oaks) produces a much larger crop of seeds (acorns) than the average.

Florida native: Spadefoot toad (*Scaphiopus holbrookii*).

Spadefoot in retreat. To hide, the spadefoot digs its way backward into the ground until only its eyes are showing.

this far south. Other trees predominate, especially oaks (other than white oak) and hickories. Some forests have abundant cabbage palms. One of the most distinctive forest types in north-central Florida is the live oak hammock, whose trees often bear festoons of Spanish moss so abundantly that naturalist Archie Carr called the forest a "moss forest." Carr asserts that "A big old live oak without its moss looks like a bishop in his underwear."[6]

Live oak, and also laurel oak, grow slowly, some to a century and a half. They ultimately reach majestic proportions of 75 feet in height and more than 100 feet in crown diameter, with trunks up to five feet across at breast height. By the time they are fully mature, these oaks form a closed-canopy forest beneath which the understory is often sparse, presenting an inviting aspect to walkers.

New oak groves may supplant pinelands wherever fire is newly excluded, halting natural fire-induced regeneration of the pines. Once the oaks are past the sapling stage, they can withstand mild surface fires. In fact, fires help to clear the undergrowth and free the oaks of competition by other, upcoming saplings. Without periodic fires, beech, dogwood, hickories, and others might in time convert an oak grove to a mesic forest type.[7]

Where there are oaks, there are acorns, of course, and animals that eat them. Acorns are especially abundant in mast years, when their major consumers, mice and deer, crowd into oak groves. Gray squirrels, wild turkeys, and wild hogs also flock to oaks to feast on their acorns. So do ducks, even on high, dry hills. Naturalist Archie Carr says the most spectacular event of a mast year is the coming of wood ducks to the live oak woods: they land in droves, even where there is no water. How they know the acorns are there remains to be discovered.[8]

Other animals visit: rat snakes, barred owls, flying squirrels, opossums, and armadillos. Many microscopic animals reside permanently on the ground in the oak forest, together with many small animals that eat them: fast-running wolf spiders, crickets, millipedes, snails, the eastern spadefoot toad, and a tiny lizard, the ground skink. Under rotting logs, Carr says, are "big, black shiny beetles *(Passalus cornutus)*, wireworms (the larval stage of click beetles), centipedes, newts, a short-tailed shrew, and little burrowing or litter-inhabiting snakes including the eastern coral snake."[9]

One might never guess most of these animals are there: you have to know where to look. The spadefoot toad, for example, digs a burrow with spurs on its hind feet, then backs into it and comes out only at night. Spadefoots are so inconspicuous that even forest lovers seldom see them, but they can be numerous. One observer reported more than 2,000 toads per acre of woodland hammock. Fortunately for the toad, oak hammocks grow especially well around ponds and lakes, a necessity for an animal that breeds briefly in water after heavy rains.[10]

The abundant Spanish moss in a live oak forest provides needed habitat for a variety of animals. A warbler, the northern parula, nests in clumps of living Spanish moss and apparently never builds its nests anywhere else. Three kinds of bats—the yellow, Seminole, and eastern pipistrelle—also

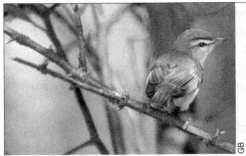

Summer breeder: Red-eyed vireo (*Vireo olivaceus*). Fruits are not abundant in summer, but the vireo eats berries, seeds, and insects and so does not run short of food.

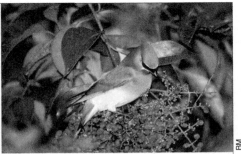

Winter visitor: Cedar waxwing (*Bombycilla cedrorum*). The cedar waxwing, which depends largely on oak mistletoe berries, spends all winter in Florida forests.

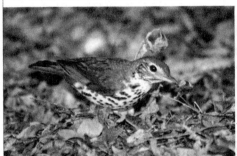

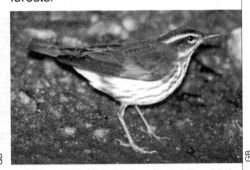

Spring and fall migrants: At left, the wood thrush (*Hylocichla mustelina*), which finds spring and fall fruits in Florida's forests. At right, the Louisiana waterthrush (*Seiurus motacilla*), which eats insects and spiders from the ground and water.[a]

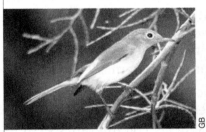

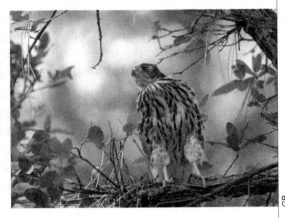

Year-round residents: Above, the blue-gray gnatcatcher (*Polioptila caerulea*). At right, a young Cooper's hawk (*Accipiter cooperii*). As its name implies, the gnatcatcher eats insects, which are available in Florida forests all year. The hawk is a top predator and finds abundant prey among birds, small mammals, snakes, and other animals in forests.

FIGURE 6-9

Birds in Florida in Different Seasons

Note: [a]Some of these thrushes spend whole summers in north Florida forests.

roost in Spanish moss. This must be why rat snakes climb the oak trees, because they avidly hunt the birds, bats, and skinks that hide in the moss. For most animals, Spanish moss collects too much moisture to make suitable nesting habitat, though. The gray squirrel uses true mosses, together with strong, slender threads pulled from cabbage palms, to build its nests.

Florida native: Common blue violet (*Viola sororia*). In a hardwood hammock, seedlings start up wherever light and moisture are sufficient to support them.

Mesic Central Florida Hammocks. Mesic hammocks in central Florida are more of a mixture of evergreen and deciduous trees. Seen from above in winter, they are a patchwork of green and gray blotches. Besides live oak, tree species in these forests include laurel oak, mockernut hickory, pignut hickory, southern magnolia, red bay, sweetgum, and two or three dozen others.

All of Florida's hardwood hammocks are important for birds, and none is more so than the San Felasco Hammock in Alachua County. San Felasco provides indispensable food and shelter for birds that are passing through on spring and fall migrations, other birds that are staying through the winter, and still others that are breeding there in summer (see Figure 6-9). An in-depth study made in the San Felasco Hammock illuminates an age-old relationship between the hammock's fruits and fruit-eating birds. The birds benefit by eating the fruits, of course, but the plants also benefit, because birds disperse and fertilize their seeds. After birds eat fruits, they excrete the seeds, which are still viable, with their droppings. Shrubs, midstory trees, and vines with fleshy fruits, the kinds birds like and help disperse, make up half of the mesic hammock's plants—45 species in all.

The plants of San Felasco bear fruits in all seasons, but birds are especially dependent on those that ripen in winter, summer, and fall. Winter fruits are so abundant that birds can stay as residents throughout the season. Twenty species of plants, mostly evergreens, produce ripe fruits from late fall to early winter. Winter-fruiting plants include Carolina laurelcherry which, along forest edges attracts wintering robins and woodpeckers; and oak mistletoe, which grows high in treetops and attracts cedar waxwings. Cedar waxwings arrive in Florida just as the mistletoe berries are first ripening. They derive most of their nourishment from mistletoe.

Fall fruits support migratory birds that fly through on their way to winter homes farther south. The fruits ripen at times that coincide with the two peaks of the fall migration (see List 6-4). The migrants seem to have evolved in concert with the southern mixed hardwood forest's ability to provide them with fuel for their journey. The strategy works out well, both for them and for the plants they help disperse.

In summer, birds are scarce. They spend summers farther north and so are unreliable as dispersal agents for the seeds of summer fruits. As if responding to this shortage of birds to spread their seeds, the nine hammock plants that fruit in summer attract mammals, too.

Like fruit-eating birds, insect-eating birds are important to the forest. In hardwood hammocks, as in pine grasslands, scientists have found that trees are not overwhelmed by leaf-eating insects if patrolled by enough insect-eating birds. Wood thrushes, warblers, tanagers, grosbeaks, titmice, vireos, cuckoos, chickadees, and dozens of other species of birds control leaf-eating caterpillars and other insects so successfully that their efforts noticeably improve tree growth.[11]

The San Felasco Hammock is the largest protected stand of classic mesic hammock in Florida. It is an object lesson illustrating the principle that

the larger a habitat island is, the more species it will support. All of the 45 species of birds that breed in north Florida's hardwood forests do so in the San Felasco Hammock.

Many other types of hammocks, not shown or described here, contribute to the state's ecosystem diversity. The variety is nearly endless.

Highlands Hammock in Central Florida. It is often thought that forests with temperate tree species are restricted in Florida to its northern two thirds and that none exist in the southern third. It is true that the farther south the forest, the fewer temperate tree species it has, but some temperate trees are found all the way to the tip of the peninsula. Examples are red maple, live oak, Carolina ash, and sugarberry. Highlands Hammock State Park boasts a virgin forest of immense live oak and cabbage palm, including the nation's largest specimen of the latter, and there are numerous other tree species. No tropical elements are present, probably because of occasional winters with freezing and near-freezing temperatures. Highlands Hammock is Florida's southernmost large, protected, temperate forest.

VALUES OF HARDWOOD HAMMOCKS

Like pine grasslands, Florida's hardwood hammocks help to maintain the atmosphere, regulate the climate, and contribute to regional rainfall. They help prevent runoff and water pollution. They keep the soil soft, facilitating infiltration by rain and recharge of the aquifer, and they offer enjoyment and learning to people. They also cloak the terrain with endlessly interesting combinations of trees, shrubs, and associated wildlife. Moreover, because they are so biologically diverse, they serve as a repository of species, all adapted to the slopes of the southeastern Coastal Plain and all providing habitat for numerous other native organisms.

These diverse natural communities together possess a resilience that ensures that the land can continue to be protected by tree cover even in changing times. All that forest managers must do to ensure their continuance is to allocate land to them and protect the conditions they require in order to renew themselves. The many services they render, and their immense diversity, argue for as many different native forests as possible.

Among the factors that promote a natural forest's renewal, the soil is one of the most important. Earlier, the diversity of organisms in forest soil was mentioned, and it was said that this diversity persists most reliably in undisturbed forest soil. The natural process in which large, old trees age and fall, uneven ground results, and nearby soil organisms and plants colonize this ground best guarantees the continuance of all of the native organisms. They all contribute to the ecosystem's stability and resilience: biodiversity promotes the renewal of healthy forests.[12]

Florida native, endemic: Leafy beaked ladiestresses (*Sacoila lanceolata* var. *paludicola*). This rare orchid blooms in moist woods and swamps in southern Florida.

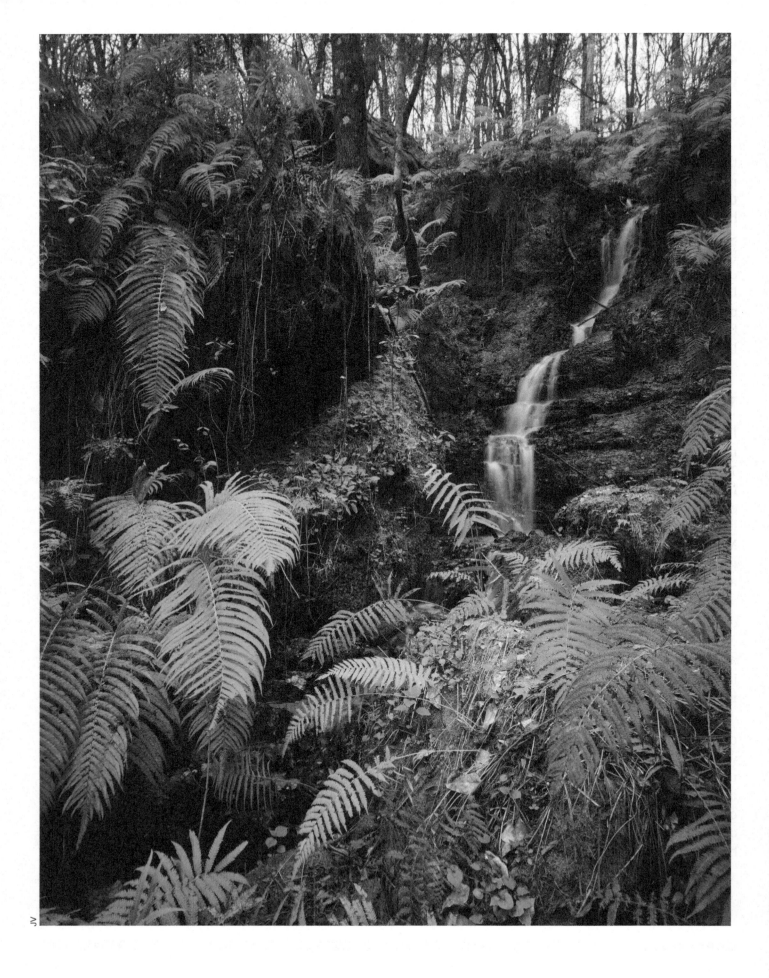

CHAPTER SEVEN

ROCKLANDS, UPLAND GLADES, AND CAVES

Limestone dominates the five communities treated in this chapter. The first two are strictly south Florida types. One is a pine community: pine rockland. The other is a hardwood community: rockland hammock. Both of these grow on roughly level limestone plains or on raised outcrops. The third type of community, known as a sink community, occurs all over Florida, growing on and around the walls of solution holes or sinks. The fourth type of community has only recently been recognized: upland glades, which occur in the Florida Panhandle. The fifth type of community also occurs all over Florida, but underground: caves. Most of Florida's caves are filled with circulating groundwater which we discuss in Volume 3 of this series, *Florida's Waters,* but some caves in central and Panhandle Florida are air-filled caves. These are neither upland, wetland, nor aquatic environments, but are valuable ecosystems that most logically fit in this chapter.

PINE ROCKLANDS

Pine rocklands and rockland hammocks once occupied south Florida uplands as shown in Figure 7-1. The pine rocklands were a vast and beautiful fire-dependent ecosystem, similar to the longleaf pine grasslands of central and north Florida, but with slash pine in place of the longleaf. The pines formed an open canopy, growing above a diverse, patchy understory of tropical and temperate shrubs and many herbs. They once dominated more than 186,000 acres on the Miami Rock Ridge and the lower Florida Keys, holding sway wherever fire was frequent. Rockland hammocks grew where fire was excluded.[1]

Today, clearing and development have obliterated the pine rocklands from much of their former territory and they are considered one of the most threatened habitats in Florida. They occupy less than 4,000 acres, almost exclusively on Long Pine Key west of Homestead in Everglades National

Florida native: Florida butterfly orchid (*Encyclia tampensis*). This common orchid grows in hammocks and swamps in central and south Florida.

Rockland communities grow on land with exposed limestone and little or no soil. **Pine rocklands** have an overstory (usually sparse) of slash pine. **Rockland hammocks** consist largely of tropical hardwoods.

In south Florida, the word **hammock** refers specifically to an isolated stand of broad-leafed evergreens, including many West Indian species.

OPPOSITE: Sidewalls of a limestone sink. Water from a surface stream falls into the bottom of this deep sink in the Devil's Millhopper State Geological Site in Alachua County.[1]

LIST 7–1
Plants predominant in pine rocklands (examples)

<u>Dominant Tree</u>
Slash pine

<u>Temperate Hardwoods</u>
Dahoon
Swamp bay
Wax myrtle
Winged sumac

<u>Tropical Hardwoods</u>
Blolly
Florida poisontree
Hammock velvetseed
Key thatch palm
Long Key locustberry
Marlberry
Myrsine
Rough velvetseed
Smallfruit varnishleaf
Willow bustic

<u>Groundcover Plants</u>
Broomsedge bluestem
Coontie
Fivepetal leafflower
Florida bluestem
Florida clover ash
Florida Keys noseburn
Oblongleaf twinflower
Pineland spurge
Silver bluestem
Wiregrass

Sources: Adapted from Osorio 1991, Stout and Marion 1993.

Reminder: A decline in species numbers toward the tip of a peninsula is known as the **peninsula effect**.

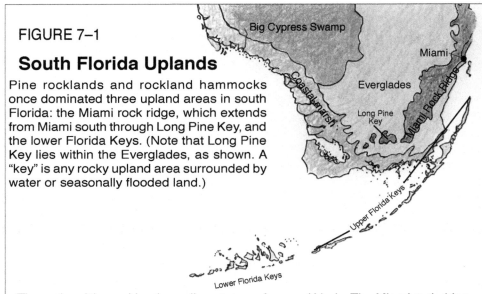

FIGURE 7–1

South Florida Uplands

Pine rocklands and rockland hammocks once dominated three upland areas in south Florida: the Miami rock ridge, which extends from Miami south through Long Pine Key, and the lower Florida Keys. (Note that Long Pine Key lies within the Everglades, as shown. A "key" is any rocky upland area surrounded by water or seasonally flooded land.)

The rocks of the rocklands are limestones of several kinds. The Miami rock ridge and the lower Florida Keys are based on Miami oolitic limestone. The upper Keys are composed of Key Largo limestone. In the southern portion of Big Cypress Swamp, the Miami limestone layer thins and gives way to Tamiami limestone.

Source: Snyder, Herndon, and Robertson 1990, 220, 234–235 and 234, fig. 8–1.

Park. A few very small pine rockland areas (smaller than 20 acres each) are privately owned. Nearly all are of second-growth pines following logging early in the last century.

List 7-1 names a few of the plant species of the pine rocklands, and one of them, coontie, is featured in Figure 7-2. Figure 7-3 displays one of the few remaining pine rockland communities and its legend explains the ways in which their pines and groundcover plants resemble those of longleaf pine-wiregrass communities.

Some of the animals in south Florida's pine rocklands are of the same species as in north and central Florida pine grasslands, notably the eastern gray squirrel, the red-bellied woodpecker, and the northern bobwhite, to name a few well known ones. But some of north Florida's species are not distributed all the way to the tip of Florida. One reason is that the south end of the long, somewhat narrow Florida peninsula is less physically diverse than the north end and Panhandle; another, that the climate of south Florida is too tropical for some species. The south Florida groups occur mostly as isolated populations, cut off long ago from the main populations farther north. Some, such as the green treefrog, rough green snake, red-bellied woodpecker, cotton mouse, raccoon, and white-tailed deer, are virtually identical genetically to their northern relatives, but some south Florida populations have become endemic species or subspecies. Kingsnakes on the Miami Rock Ridge are markedly different from north Florida populations—they are yellow like the limerock of their environment.

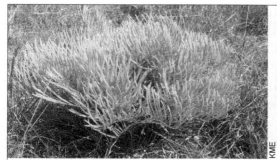

Coontie (*Zamia pumila*). Coontie is a cycad, an ancient tropical gymnosperm, and one of many drought-resistant, fire-tolerant plants of the rocklands.

Florida atala caterpillar (*Eumaeus atala*) on coontie leaves. Coontie is the atala butterfly's only native larval host plant.

FIGURE 7–2

Florida Natives: Coontie and the Florida Atala

Florida atala butterfly laying eggs on coontie.

FIGURE 7–3

Slash Pine Rocklands

The slash pine of the pine rocklands closely resembles the longleaf pine of north Florida. Perhaps in response to the more tropical environment and calcium-rich soil of the rocklands, slash pine in south Florida is a more fire-tolerant tree than slash pine in north Florida.

Like a young longleaf pine, a young south Florida slash pine invests much of its energy in root growth and hugs the ground in grass-stage form, protected from fire by a thick fountain of moist needles. Once its stem has begun to elongate, its thick, scaly bark resists heat. The outer scales may burn off, but the inner, growing layers remain alive.

When they were flourishing, before they were cut, mature south Florida slash pines not uncommonly reached more than 100 feet in height, 100 or more years in age, and a yard in diameter at breast height. They were flattened at the top like mature longleaf pines in north Florida.

Besides the pines that remain, pine rocklands support nearly 200 species of native vascular plants. Many are small trees, shrubs, and herbs endemic to south Florida and many are extremely rare. No other pineland in Florida has so many endemic plants in such a small area.

The groundcover plants of pine rocklands exhibit adaptations to fire just as do the plants of pine grasslands. Most of the plants bloom within four to 16 weeks following summer fires. Several are fire-carrying grasses including wiregrass. Others are herbs with thick, tuberous roots that store moisture and nutrients. Coontie, whose starch-filled roots the Native Americans used to make flour, is an example. Within a week or two after a fire, underground stems of coontie push out new foliage and reclaim their territory.

Sources: Glitzenstein, Streng, and Platt 1995; Doren et al. 1993.

Florida native: Key tree cactus (*Pilosocereus polygonus*). This cactus can attain a height of 20 feet, hence its name.

Roothold in limestone. The roots of a gumbo-limbo hang on for dear life in the rugged limestone of south Florida's rocklands.

A **key** is a low island or reef surrounded either by water or by seasonally flooded land.

The **Florida Keys** are limestone-based islands that are strung out in an arc that curves south and west from the tip of the Florida peninsula.

The **Everglades keys** are tree islands on the south Florida peninsula.

A **glade** is an open, grassy space in a woodland. It is thought that *Everglades* may be derived from *riverglades*, grassy expanses in a river.

South Florida also has some animals whose populations don't extend to the north end of the state. Most of them are birds, bats, and flying insects such as butterflies, dragonflies, and moths, whose forebears probably flew or blew in from the West Indies. Others are small animals such as snails that were able to survive transit on floating debris. Because there was never a land connection between the West Indies and Florida, larger West Indian land animals are not present.

ROCKLAND HAMMOCKS

Temperate hammocks may at one time have formed a continuous forest along the easternmost Miami Rock Ridge, where warmth and humidity delivered by the Gulf Stream sustained them. Tropical hammocks also once occupied much of south Florida's west coast, where they were surrounded by temperate species such as oak, and thereby shielded from both fire and drying wind. Tropical hammocks have also probably grown for hundreds of years on most of the Florida Keys and on the tree islands in

BACKGROUND 7–1

Keys

Islands in south Florida are often called keys, whether surrounded by seawater or by freshwater marshes, as in the Everglades. Dozens of large, ocean-surrounded islands lie off the tip of south Florida (the Florida Keys) and hundreds of small tree islands surrounded by freshwater marsh lie in the Everglades (the Everglades Keys). Figure 7-4 shows the locations of these islands.

Present-day south Florida from the tip of Lake Okeechobee to Key West has had a complicated geological history. Most of south Florida's uplands now lie less than 25 feet above sea level, but at several times in the past, sea levels have been higher and have covered all of south Florida—whereas at other times, sea levels have been much lower than they are now. At least five episodes of rise and fall during the late Pleistocene are recognized, with sea levels 20 or more feet higher than today and the shoreline up to 150 miles farther inland. In contrast, during the episodes between these times, sea levels were 350 to 395 feet lower than today and all of south Florida, including Lake Okeechobee, the Big Cypress Swamp, and the Everglades, were dry land.

What made the numerous slightly higher elevations that became tree islands is debated by scientists, but the first trees to colonize these islands and ridges probably arose from seeds carried in by birds from the West Indies. Bathed in sun and fresh rain water, they sprouted, twined their roots down into the stony labyrinths of limestone beneath them, and began to grow.

Once the first trees were there, birds flew in, landed, ate the fruits, and left droppings containing fertilizer and viable seeds from other trees elsewhere.

Tree islands in the Everglades. Each supports a tropical hardwood hammock.

Winds carried still other seeds to the islands. Communities of hardwood trees started up.

Protected from fire by the surrounding marsh, the hardwoods grew taller, and a green canopy closed over each hill. A thick border, composed of dense shrubs and vines, formed around the sun-exposed edges. The interior, now that it was shady and protected from wind and cold, grew more moist and tropical. Ferns, orchids, bromeliads, and mosses took hold on limestone ledges and on the trees. Depending on local temperatures, winds, and humidity, and on what seeds might have been carried in, each island developed a character of its own.

South Florida's tropical **hammocks** grow on **hummocks**, small rocky hills surrounded by either land or water. The two words are related.

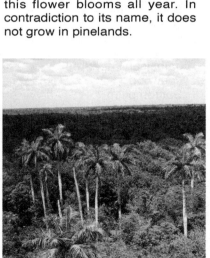

Florida native: Pineland passionflower (*Passiflora pallens*). A rare inhabitant of tropical hammocks, this flower blooms all year. In contradiction to its name, it does not grow in pinelands.

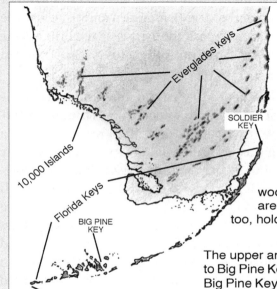

FIGURE 7–4

South Florida's Keys and Tree Islands

The Everglades "keys" are tree islands in the vast, flowing, freshwater marsh of the Everglades and each holds a tropical hardwood hammock. The Florida Keys are true islands in the sea, and they, too, hold tropical hammocks.

The upper and middle Keys, from Soldier Key to Big Pine Key, originated as coral reefs. From Big Pine Key to Key West, they are composed of limestone like that on most of the south Florida mainland.

Florida native: Florida royal palm (*Roystonea regia*). A few tropical hammocks are graced with this rare Florida–West Indies native towering high above them. The royal palm, whose white trunk looks like a concrete pole, can be almost 100 feet tall. These are growing in the Royal Palm Hammock in Everglades National Park.

the Everglades—raised islands of humus anchored to the underlying rock and protected from fire by a wet moat of marsh or prairie. (Background Box 7-1 describes keys.)

Mainland Rockland Hammocks. Before European alteration of south Florida, there must have been hundreds of hardwood hammocks scattered among the pinelands on the Miami rock ridge and hundreds more standing among the marshes and swamps of Big Cypress Swamp. Today, remnants testify to their rich plant assemblages and diverse animal populations. Hammocks around Miami sport some 150 species of trees and shrubs, most of which are tropical and do not grow in north Florida. Hammocks on Long Pine Key display great diversity: each has a well-known name and a

distinct tree-species profile. The Wright Hammock has a preponderance of 40-foot-tall live oaks; the Osteen Hammock has tropical Asian trees known as tamarinds, also 40 feet tall. Other hammocks have larger trees. Some have false mastics, large wavy-leafed trees up to 60 feet high with trunk diameters of two to three feet at breast height. Royal Palm Hammock (also known as Paradise Key) has tall, straight Florida royal palms emerging above its canopy of broad-leafed trees."[2]

The Everglades hold thousands of tree islands, one to ten acres in size. Each is shaped like a teardrop, because marsh water flowing around each island from the north rounds it off at the upstream end and drops silt at the downstream end, forming a point. Typically, each island has a solution hole in the center and is surrounded by a moat. The hole in the center enlarges as leaf litter accumulates there, holds moisture, turns acidic, and eats down into the underlying limestone. The moat around the outside of the island forms as acidic water runs off the outside of the hill and dissolves the surrounding limestone. The island is seldom touched by either fire or flood. Dry-season fires that sweep across the Everglades cannot cross the moat, and rainy-season floods cannot cross the island's high limestone walls. As a result, the island holds a self-maintaining, closed-canopy forest that may persist for centuries.[3]

The would-be visitor to an Everglades tree island encounters a formidable, almost impenetrable barrier. One has to wade through the surrounding, deep marshy moat, struggle up the bank, and then push through a dense outer thicket of sprawling bushes and tangled vines: fierce, thorny devil's claws, muscadine, Virginia creeper, eastern poison ivy, and snowberry. One visitor complains that "It's too low to crawl under and too high to crawl over."[4] But inside, thanks to the thick canopy overhead, the tree cluster opens up. Spider webs are everywhere, and exotic, skunky odors assail the nostrils; still, the effort is rewarding. The shady, moist, cool, and quiet interior is a climate-controlled greenhouse for orchids, which bloom at eye level and higher in the trees. Bright butterflies flash in the dappled shade, and at night pale moths catch the moonlight and fireflies sparkle.

Competition for space is fierce on the limited area of a tree island. Growth piles upon growth. Epiphytes cope with the shortage of space by growing on other plants that are already there (see Figure 7–5). Each has evolved a way of capturing water: orchids and most bromeliads in funnel-like leaf whorls; mosses in specialized scales that can gather humidity from the air. The strangler fig perches in a cranny at first and absorbs nutrients from rain, then puts down twining roots that draw water from trapped litter. Finally, the roots reach the ground and the fig wraps its host in an embrace that ultimately kills it (see Figure 7–6).

Mule-ear oncidium (*Trichocentrum undulatum*). This rare orchid grows on trees in south Florida's tropical hammocks.

FIGURE 7-5

Native Epiphytes in Tropical Hammocks

Cardinal airplant (*Tillandsia fasciculata*). This is a common resident of south Florida hammocks.

Florida Keys Hammocks. The hardwood hammocks on the ocean-surrounded, Florida Keys differ from the mainland hammocks in several ways. They have mostly tropical species. They are drier, both because ocean breezes blow through them and because, especially toward Key West, they receive less rainfall.

The fig seed first roots in a crevice on a host tree.

As it begins to grow, it puts down hanging roots that tightly entwine the host. When they reach the ground, the roots rob the host of needed water and nutrients, and the host begins to decline. Finally the host dies and decays, and . . .

. . . the strangler fig stands around the empty space left by the tree it has killed, with its huge branches supported by the columns of its roots.

FIGURE 7–6

Strangler Fig (*Ficus aurea*)

As a result the trees are smaller: not more than 40 feet high in the upper Keys, 25 to 30 feet high in the lower Keys, and toward Key West more like shrub thickets than trees. Where undisturbed, the ground supports coastal prairies. Hammocks on the lower Keys are fringed by well-developed mangrove swamps. (These are described in Volume 2 of this series, *Florida's Wetlands.*)

Although, as mentioned, many of the plant populations in the Florida Keys are derived from sister populations in the West Indies, some have evolved on site and are endemic to south Florida's rockland communities. List 7–2 offers a sampling of the tree, shrub, vine, and cactus species found in Keys hammocks. Each hammock is different, all are diverse, and many plants are not mentioned here. Key Largo alone, which is just an island off south Florida, has more tree species than most *states* in the United States.[5]

Epiphytes grow less profusely than in the larger mainland hammocks but many find places where there is enough light and water to support them—some in the canopy, some below it, and some only in hammocks near the ocean. Several cactuses perch in the trees; so do several ferns: strap fern, resurrection fern, shoestring fern, and golden polypody. Mahogany mistletoe grows on West Indian mahogany trees.[6]

Altogether, Florida's rocklands contain several dozen species of animals that are today so rare that they are classed as threatened or endangered. Lists 7–3 and 7–4 present examples from the mainland rocklands and the Keys hammocks and the next paragraphs describe a few of them.

Among invertebrates, Florida's tree snails bear witness that the Everglades keys began as true islands even though they are now parked on land. The snails arrived on floating logs from the West Indies, and whatever snails happened to lodge on a given island, only their descendants continued propagating there. Thousands of generations after they arrived, each island's snail population has evolved its own distinctive markings. Figure 7–7 shows a few of the many patterns they exhibit.[7]

Insects occupy many microhabitats among the hammocks' diverse plants. The Schaus' swallowtail butterfly lays its eggs on torchwood or wild lime trees, where its larvae find the food they need to metamorphose into butterflies. Other insects thrive, together with algae, in tiny pockets of water in wells at the bottoms of air plants. The three-inch bark mantis, camouflaged like a lichen, lies in wait for ants and beetles on tree trunks. Butterflies and moths drink the nectar of tiny, bright bromeliad blossoms and help to pollinate them. Tiny fig wasps drill holes in figs, enabling the fig seeds to be fertilized.

The relationships between birds and plants in the Keys hammocks resemble those already described for the temperate hardwood hammocks of central Florida. More than 70 percent of the woody plants in the Keys produce colorful, tasty fruits and thereby take advantage of the dispersal mechanisms offered by birds and other animals that eat them. The plants produce fruits in all seasons, guaranteeing a sure food supply for the birds.

FIGURE 7–7

Florida Tree Snails (*Liguus fasciatus*)

As if painted by children using bright watercolors, tree snails are decorated with pink, yellow, russet, green, and orange stripes and checks. Sixty distinct color patterns exist, some found on only one tree island or cluster of islands.

The snails' life cycles are tightly tied to the specialized habitats they occupy. Each snail starts life as an opalescent pink egg the size of a fat peanut, laid by the parent in the fall and remaining dormant over the winter dry season. The spring rains stimulate the buried eggs to hatch as "buttons," tiny but fast-growing snails. By the end of the rainy season, each snail has two or three twists to its shell and is ready to mate.

The snails mate on the trees, remaining intertwined for up to 48 hours. Both are female as well as male, so both become pregnant. Then they descend the trees, dig into the litter on the ground, and lay their eggs. The adults reascend the tree, glue themselves to it, and go dormant inside sealed shells until the first spring showers dissolve their seals. They feed by scraping up algae and lichens that grow on tree bark, with mouth parts that are specialized for the purpose. They will live for four to five years, attaining a length of two to three inches at maturity.

Sources: Anon. 1998 (Key Largo); Sawicki 1997; Toops 1998, 57.

LIST 7–4
Animals of Keys hammocks (examples)

<u>Invertebrates</u>
Keys Cesonia spider
Keys green June beetle
Keys ochlerotatus
Keys scaly cricket
Keys short-winged
 conehead

<u>Amphibians</u>
Cuban treefrog*
Green treefrog
Greenhouse frog*

<u>Reptiles</u>
Bark anole*
Brown anole*
Corn snake
Eastern coral snake
Florida Keys mole skink
Green anole
Knight anole*
Reef gecko*
Rim rock crowned snake

<u>Birds</u>
Antillean nighthawk
Bachman's warbler
Carolina wren
Cuban yellow warbler
Gray kingbird*
Mangrove cuckoo
Merlin
Northern cardinal
Pine warbler
Prairie warbler
Red-bellied woodpecker
Short-tailed hawk
White-crowned pigeon

<u>Mammals</u>
Florida Key deer
Hispid cotton rat
Key Largo cotton mouse
Key Largo woodrat
Raccoon
Virginia opossum

Note: *Some of these animals do not occur naturally in the tropical hammocks but have been introduced by man.

Sources: Adapted from Snyder, Herndon, and Robertson 1990, 264–267; Ashton 1994 (Invertebrates), Ashton 1992 (Amphibians and Reptiles), Ashton 1996 (Birds), and Ashton 1992 (Mammals).

The birds spread and fertilize the seeds, ensuring reproduction of the plants. These mutually beneficial relationships are important in maintaining the enormous diversity of the Keys hardwood hammocks.[8]

Some special mammals also occupy Keys hammocks; two are shown in Figure 7–8. The Key Largo woodrat is endemic to Key Largo. It is a "sweet

Florida native: Florida purplewing (*Eunica tatila*). This endemic butterfly lives in Keys hardwood hammocks and in a few sites in Miami-Dade County. It looks brown except when in direct sun, so it is well camouflaged to rest on tree-trunks in deep shade.

Key Largo cotton mouse (*Peromyscus gossypinus allapaticola*). This mouse is a tree dweller and is active at night.

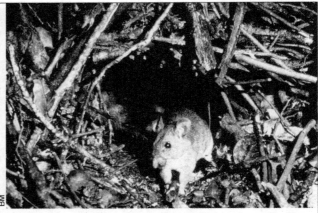

Key Largo woodrat (*Neotoma floridana smalli*). The woodrat constructs a large, multi-chambered tunnel underground and usually conceals the entrance with a pile of sticks and debris. It eats the same foods as the cotton mouse, but is active by day.

FIGURE 7–8

Two Rodents Endemic to the Keys

animal," says one who knows the species. "[Its] fur is soft and dense, [its] ears and eyes exceptionally large and round. Fastidious bathroom habits characterize these animals, who deposit their droppings in one place in tidy piles."[9] For reasons unknown, it hoards shiny objects, many of which, today, it finds as people's discards: belt buckles, keys, foil, even golf balls.

The same habitat supports a nocturnal relative, the Key Largo cotton mouse, which occurs in several of the upper Keys. The mouse is a tree dweller; it even builds its nests in trees as squirrels do. By dwelling in different niches and being active at different clock times, the rat and mouse share the available resources without competing directly for them.[10]

The Florida Key deer is a subspecies of the white-tailed deer and is endemic to the Keys. Although descended from the same ancestral stock, it does not cross-breed with the common white-tailed deer, so it is considered a distinct species. It is a much smaller animal than the mainland deer, only about the size of a German shepherd dog. A doe deer weighs about 50 pounds, a buck about 100 pounds. Their habitat needs are well met by the Keys, where they have no natural enemies except people in vehicles.

UPLAND GLADES

Calcareous soils contain large amounts of calcium carbonate and have a chalky consistency.

A series of isolated calcareous prairies and glades (herbaceous openings in an otherwise forested landscape) are found in the southeastern United States from eastern Texas to examples in Gadsden and Jackson counties in the Florida Panhandle. The calcareous soils in the herbaceous centers of Florida's small 0.1- to 2-acre glades are shallow, only 4 to 14 inches deep above limestone. They are on upland sites—sometimes hillcrests—and are not seepage areas. The herbaceous vegetation is dominated by grasses

and sedges, especially blacksedge, which is not known from any of the other glades outside Florida. Red cedar is the dominant woody plant scattered on the open glades and around their perimeters on deeper soils.

From aerial photographs, up to 72 potential glades have been identified in the two counties, but botanists considered only 21 authentic enough to do a plant survey. Some that were field checked could have been glades but the invasive centipede grass that forms a dense turf may preclude colonization by native glades species. The total number of plant species tallied for the 21 glades was 311, of which 280 are native species. Most of these are calcophiles—plants that like calcium (limestone)—with 14 listed as endangered by the State of Florida's Department of Agricultural and Consumer Services. Many are northern species that reach their southernmost limits in Florida's upland glades. These unique ecosystem types have only been recognized and explored in the past three decades. Whether animals such as insects and earthworms might be dependent on glades has yet to be studied and discovered.

KARST FEATURES

Karst features begin with the dissolution of subterranean limestone. Circulating water (especially acidic water) dissolves the limestone, creating water-filled caves and tunnels. Water works its way down fissures and cracks in the limestone, then spreads horizontally along planes between layers (bedding planes). As the limestone dissolves away, a maze of complicated, water-filled spaces forms. These become major storage places for fresh water, and subsequent events lead to the formation of many other karst features.

Solution Holes and Sinks. After an underground cave has formed, the water table may fall (because of withdrawals from wells or because the sea level declines). The water will drain away, being replaced by either air or sediment (the latter, effectively ending its identity as a cave).

A cave in which the water has been replaced by air may remain an air-filled cave for centuries, but ultimately, other events may follow. The ceiling of the cave may fall in and overlying sediment may slide down into the cave, forming a deep, conical hole in the ground that is dry all the way to the bottom—a dry sink. Or the hole may intersect the water table, and become a water-filled sink with limestone walls, a wet sink or "karst window" into the aquifer. Still later, more earth may slide down into the sink from its surroundings and plug it closed, making a basin that holds a wetland, pond, or lake. Figure 7-9 depicts the progression from a water-filled cave to a sinkhole.

Solution holes and sinks occur in karst areas all over the state and are among the most naturally protected environments in Florida. They have high, rocky sidewalls which, like chimneys, protect the air from disturbance by wind. The limestone is moist and cool, and the water at the bottom is cold, so the air in a sink tends to stay moist and cool, too—the Greeks would have called it a grotto.

> **Karst topography** is the topography of land that is influenced by the dissolving of underlying limestone

> A **solution hole** is a hole in surface limestone that does not intersect the water table. The water in a solution hole is rain water.

Ferns around a sink in Paynes Prairie, Alachua County

Acidic water begins to dissolve the limestone underlayer:

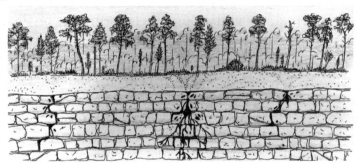

An underground cave forms and the land above it begins to subside:

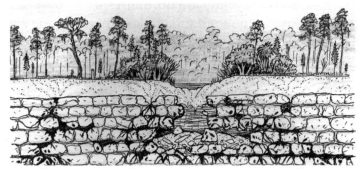

Surface sediments fall in. The groundwater is now visible from the surface:

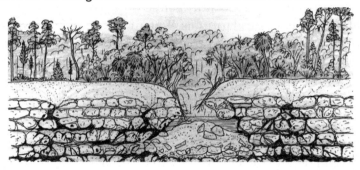

If more sediment falls in, the pile of rubble at the bottom may grow large enough to plug the hole. It will then become a pond, lake, or wetland.

FIGURE 7–9

How a Sink Forms

A **sink**, or **sinkhole**, is a circular depression on the land surface caused by dissolution of underlying limestone.)

A **wet sink**, or **lime sink**, is a deep, conical hole in the ground that intersects the water table. The water at the bottom of a wet sink is aquifer water. The collapsing limestone fell into the groundwater.

A **dry sink** is a shallower, conical hole in the ground that is dry all the way to the bottom. The collapsing limestone remained above the water table.

Overhanging trees also impede evaporation, and seepage keeps the surrounding walls continuously wet. In such a cool, humid environment, beautiful assemblages of delicate plants can grow around the water of solution holes and sinks. Above all, mosses, liverworts, and ferns grow luxuriantly around sinkholes, especially where the walls are steepest. Some are threatened and endangered species——Venus'-hair fern, fragrant maidenhair, southern lip fern, hairy halberd fern, and others. They are specialists. They differ from epiphytes in that they grow with their roots in the moist, alkaline environment provided by the limestone rather than in the acidic water found in niches on the trees.[11]

Groundcover plants are less numerous. Only two grass species are common, and where the shade is darkest, nothing grows. As for animals, sinks support many species of small creatures that love moisture such as salamanders and small invertebrates.

Bluffs and Limestone Outcrops. Sometimes dissolution and mechanical processes create vertical cliffs, bluffs, riverbanks, and smaller vertical rock walls in limestone. Especially along rivers and in flowing-water marshes such as the Everglades, limestone outcrops lend picturesque features to the landscape and provide nooks in which animals find homes and crannies into which plants can twine their roots.

Depression Marshes and Ponds. One typical karst features is a depression on the ground where the land has begun to subside. This may become a marsh for a while or may deepen enough to form a pond.

Rocklands. South Florida's uplands consist largely of rocky limestone plains, ridges, and hummocks. The pinelands and hammocks described in this chapter occur on these features.

Springs. Large and beautiful freshwater springs are still another feature of karst areas, and present striking evidence of the underground presence of fast-flowing rivers. Where the upward hydraulic pressure becomes strong enough, water bursts forth as a spring that gives rise to a clear, cold, beautiful surface stream that is known as a spring run. Florida has more than 1,000 springs, a higher concentration per land area than any other place in the world. (Springs are featured in Volume 3 of this series, *Florida's Waters.*) Some springs spout their water offshore, on the seafloor, and some are found in the bottoms of rivers that have eroded their beds down to the underlying limestone. The Suwannee River is especially notable for having many springs in its bed.

Karst Lowlands. Over time, the subsidence of small land areas over limestone add up to subsidence of whole regions. Karst features signify that the land is sinking down, slowly but relentlessly, century after century. Subsidence accounts for the lowlands around Marianna, whose temperate hardwood hammocks are described in Chapter 6.

> The sinking down of land is **subsidence** (sub-SIGH-dense, or SUB-si-dense). It commonly occurs as sub-surface limestone dissolves.
>
> Sudden, major subsidence of an area, as when an underground cave's ceiling falls in, is **collapse**.

CAVES

Over past millennia, circulating groundwater has dissolved great spaces in Florida's subterranean limestone, creating thousands of miles of underground tunnels and caves. Where these spaces are deeply buried, they are still filled with water, but where the groundwater level has fallen, the uppermost spaces are now filled with air. These are known as terrestrial caves. They are the ones that most people are familiar with and they are discussed in this chapter. (Volume 3 of this series, *Florida's Waters*, covers aquatic caves.)

As Figure 7-10 shows, terrestrial caves are especially abundant in Florida's three karst area, which center on Marianna, Woodville, and Ocala,

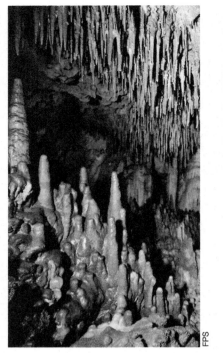

Interior of an air-filled cave

For as long as a cave exists, rain water keeps soaking into its limestone from above and continuing to dissolve it. Here, the water is dripping from the roof of the cave, saturated with dissolved calcium carbonate. When this water evaporates, it leaves the calcium carbonate behind as a stony "icicle" (a stalactite).

Water drops fall to the floor from stalactites and evaporate, forming pinnacles (stalagmites). The two formations finally meet and form a column, which helps to hold up the cave roof.

Columns form in air. The columns are evidence that this cave has been above the water table for years. Someday, this cave may collapse, forming a sink.

Florida Caverns State Park, Jackson County

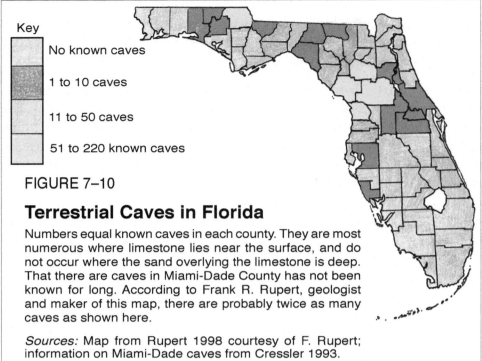

Key

▢ No known caves

▨ 1 to 10 caves

▢ 11 to 50 caves

▢ 51 to 220 known caves

FIGURE 7–10

Terrestrial Caves in Florida

Numbers equal known caves in each county. They are most numerous where limestone lies near the surface, and do not occur where the sand overlying the limestone is deep. That there are caves in Miami-Dade County has not been known for long. According to Frank R. Rupert, geologist and maker of this map, there are probably twice as many caves as shown here.

Sources: Map from Rupert 1998 courtesy of F. Rupert; information on Miami-Dade caves from Cressler 1993.

but there are other areas all over north and central Florida and some even in south Florida where the earth is honeycombed with air-filled spaces in limestone. They vary in size. Some are tiny pockets in the rock, some are room-sized, and some are the size of concert halls or even larger. The formations within them are the work of hundreds of thousands, or millions, of years: a century adds one cubic inch to each. And cave-dwelling organisms have had all those years in which to adapt to the limestone environment.

Life in Caves. Caves hold communities radically different from those of sun-exposed ecosystems because they are dark. Photosynthesis does not take place there, so there are no green plants except near cave entrances, yet in their sunless interiors, healthy caves hold well-developed, self-perpetuating ecosystems full of animals. Some, such as the woodrat, are casual visitors that use caves for shelter but forage outside for food. Some, such as the slimy salamander, nest in caves if sites are available, but may nest elsewhere, too. Some, such as cave crickets, can live only in caves. They are known as obligatory cave dwellers.

How do obligatory cave dwellers obtain their nourishment? It comes from several sources—from foods other animals have carried in, from plant litter washed in by rain and runoff, and even from the droppings and carcasses of resident bats and visitors, processed by decomposer organisms (bacteria and fungi). And of course some cave dwellers. Then these organisms become food for insects and other animals. Thus in many ways, the cave ecosystem works like any other. It has sources of energy and materials, organisms that use them, and interactions among these organisms. The system seems radically different only because the lack of light so powerfully influences all of the cave inhabitants.

FLORIDA'S UPLANDS

Imagine entering a cave environment for a while, with all senses tuned and receptive. Your guide has instructed you to bring a flashlight, of course: it will be totally dark not far beyond the entrance. The example chosen is a small terrestrial cave hidden in an upland glade in Jackson County.

The Twilight Zone. It is easy to miss the mouth of the cave, draped as it is with an overhanging fringe of grasses and ferns that are growing on its roof. Once inside the opening, it is just possible to stand upright below the cave's ceiling. The earthen floor slopes gently downward toward the back of the cave. Distinctive plants are growing on the walls and floor near the entrance, but they are microscopic algae and call no attention to themselves. What is noticeable, though, is the ambiance.

Within the cave, there is only peace and stillness. Outside, the weather may have been hot and dry, or cold and windy, or rainy—regardless, the air inside is a comfortable, humid, near-70 degrees. Any organism that can do without the sunlight and greenery of the outside world gains a trade-off in the cave's stable environment.

In the dim light, in a nook in one wall, a small nest of twigs is visible where an eastern woodrat has made a home. A knowing search would turn up many other animals that divide their lives between the cave and the outside world, but except for a few spiderwebs strung across crannies in the wall and ceiling, they are not yet apparent.

Suddenly, hundreds of small, brown bats come into focus, hanging from the ceiling just a few feet inside the opening. They are asleep, and so still that they are easy to miss at first, but they are major contributors to the life of the cave. Beneath them, the cave floor is perilously slippery from an inches-thick coating of bat guano. Your guide chooses to stop here and describe the bats of Florida.

Florida's Bats. Bats are common residents of caves, and also trees, in Florida. Sixteen bat species have occupied the state since two million years ago and are integral parts of the region's ecosystems. Twelve of them are still Florida residents, and each has its own home range, preferred foods, and habitat preferences (see List 7-5). The available resources are divided among them so that they do not compete with one another. Three are cave-roosting species: the gray bat (limited to Jackson County), the southeastern bat, and the eastern pipistrelle.[12]

Human fears of bats are based on misinformation. Bats are not blind, they do not attack humans, and they never get tangled in hair. They use the echoes of their own sharp cries to locate and avoid all obstacles in the dark. They rarely carry rabies and pose little threat when they do. (Vampire bats do bite, but none remain in Florida today, although fossils of their ancestors have been found in caves in central Florida, in Marion and Alachua counties). Bats are not ferocious animals, either. They are gentle, furry creatures that, like all mammals, suckle their young and tend them attentively. They are not rodents and do not breed explosively; they average only two offspring per mature female per year. Even as adults they are tiny. The gray bat weighs 1/3 ounce at maturity; the southeastern bat weighs

Entrance to Cal's Cave in Wakulla County. This partially dry cave quickly drops into an underwater conduit known as the Pipeline or Chip's Hole Cave system. It holds three and a half miles of mapped underground passages.

even less, about 1/5 of an ounce. One of the largest of Florida's bats, the big brown bat, weighs one whole ounce when mature, well fed, and pregnant. In some ecosystems, bats eat fruits, seeds, pollen, and other plant parts as birds do, so they are important pollinators and seed distributors.

Florida's bats are night-time insect eaters, and as such, they are powerful clearers of the air. Each one eats its own body weight in insects every night——500 insects an hour. The bat population of a single large cave can consume several tons of insects nightly. They are as effective as insecticide sprays but are nontoxic and self-renewing. Thus a swarm of bats against the moon at night is a welcome sight. Many mosquitoes bent upon sucking human blood have never raised a welt on anyone's skin but have passed through the cave food web as bat food instead. Out of appreciation for this amenity provided by bats, some resorts encourage bats to take up residence by constructing special houses for them.[13]

Other Cave Animals. Other animals using the cave are less conspicuous, but numerous. A search might turn up any of three salamanders——the slimy, the two-lined, or the three-lined salamander. Their prey are tiny flies, tiny snails, worms, and other invertebrates, which in turn eat organic matter dropped by the bats and others. Without the influx of bat and rat droppings and debris to feed on, the numerous other cave dwellers would have little or no means of subsistence, but with the whole system operating naturally, a cave environment supports its inhabitants and visitors reliably from year to year. New materials are brought in at about the same rate that waste materials are disposed of. In a sense, a functioning cave ecosystem is self-cleaning, although "clean" as applied to caves is not the same as applied to homes.

The Dark Zone. Now step deeper into the cave. Ease around a corner to a space where no daylight penetrates. Be careful: the floor is so slippery with guano that it seems coated with oil. Touch a wall to steady yourself, and——are you ready? Turn out your light.

Blackness.

On keeping still for several minutes, you may sense that the pupils of your eyes have enlarged as far as they can. Or you may have closed your eyes; it makes no difference. Either way, you see nothing at all. You hear your own bated breathing and sense your heart's slightly accelerated beat, but otherwise detect only the sounds of dripping water and occasional rustling noises from the cave walls and ceiling.

The dark zone, which may consist of many caves and tunnels penetrating deep into the earth, is where the full-time cave dwellers spend their lives. List 7—6 identifies a few of these very specialized animals and three of them are shown Figure 7-11. Animals to which sight is utterly useless have other senses that are keen instead. Many cave dwellers are designed like the familiar daddy longlegs: they have long, attenuated limbs with which they can probe and feel their way from place to place. Many have keen chemical sensors that function like our organs of taste and smell, but much more sensitive and finely tuned. Some have motion-detecting

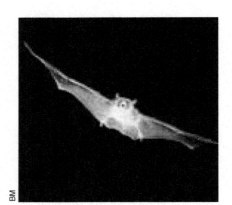

Florida native: Big brown bat (*Eptesicus fuscus*), flying at night.

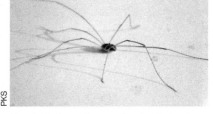

Daddy longlegs (*a Leiobunum* species). This arthropod, which can live inside or outside of caves, serves as a janitor, cleaning up debris. It is not a spider and does not sting.

Cave spider (Baiami teganaroides). This is one of many spiders that live in caves.

Cave millipede (Cambala annulata). This millipede makes its home in Florida caves and in many other parts of the world, especially across central Africa. It cannot live outside of caves.

FIGURE 7-11

Florida Cave Animals

organs to pick up on disturbances of the air, or of the water where they swim, so that they can escape predators and find prey. Most are colorless, having lost the genes for skin pigments at some time in the past. In a 100-percent dark environment, no advantage comes from having any color pigment. In the light of a flashlight, cave animals show up defenselessly white and vulnerable, but in the total darkness of a cave, they go unseen. Many are not only blind, but eyeless, for the same reason. Their ancestors that lost the genes for eyes could invest resources in more useful traits and so produced more offspring.

The dark zones of Florida's caves are inhabited by many isolated, endemic populations of cave-adapted animals. Future study of these animals should bring to light more interesting details about them and perhaps will reveal more species. Some are aquatic animals, notably crayfish, salamanders, shrimp, and snails. Each endemic population is thought to have begun evolving from ancestors that first crept into Florida's cave system a million years ago or more, when the seas last moved off the land. Future study of these animals should bring to light more interesting details about them and perhaps will reveal more species.

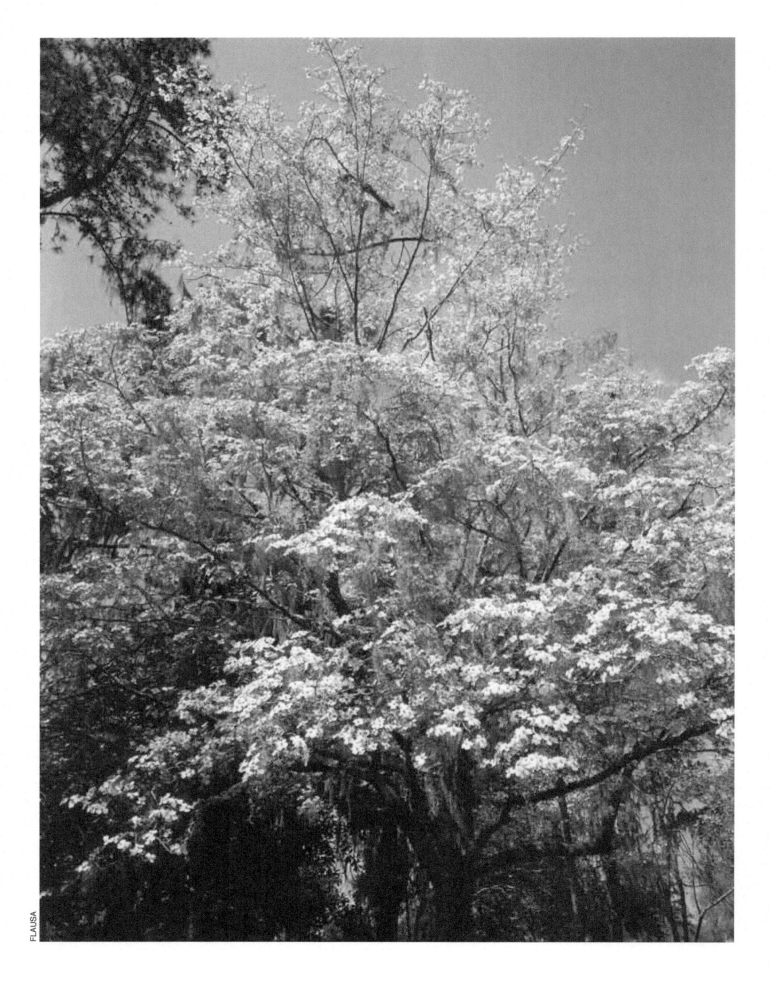

CHAPTER EIGHT

THE PAST AND THE FUTURE

Florida today has thousands of species of plants, animals, and other living things in dozens of living communities. How did they all get here? To trace them to their origins, we must travel back many millions of years—a journey worth taking, because it reveals how immensely valuable and irreplaceable they are. The last four photos in this chapter reinforce this perception by depicting "next generation" members of native Florida species--the seeds of a red maple, some newborn mice, a fawn, and a pair of red skimmer nestlings. The intent is to bring to mind the increasing vulnerability of our native species and the importance of protecting them as well as we can.

But where should we begin this journey? Must we go back 25 or 35 million years, to the time when Florida first appeared above sea level at its present location? Or 65 million years, when a tremendous extinction event opened the way for the evolution of so many of today's species? Or 250 million years when the Florida platform was forming beneath the sea on the northwest corner of Africa? Or 550 million years, when the first, many-celled ancestors of our Florida species, were swarming in the oceans?

The story goes back farther. Living things were present in the early seas at least three and a half *billion* years ago and every organism now alive has a history that began with the origin of life on Earth. In fact, everything alive today took its start from the explosion-into-being of the entire Universe, some *fourteen* billion years ago, when the atoms and molecules of which everything is made were formed.

This narrative skips those early stages and begins at the start of the Cenozoic Era, the era in which we live. Background Box 8-1 shows how the Cenozoic is divided into periods of significance to Florida history. By any standard, it is clear that Florida's rich heritage of natural ecosystems and native species has a history millions of years long.

An event of immense importance marks the start of the Cenozoic Era: a giant asteroid slammed into the floor of the Caribbean Sea, splattering magma onto what is now Haiti and the Texas Gulf coast, spewing sulfurous

Coralroot orchid (a *Corallorhiza* species). This very rare, terrestrial orchid, photographed in the Apalachicola National Forest, is part of Florida's rich inheritance from the past.

OPPOSITE: Flowering dogwood (*Cornus florida*). Flowering plants were already present in North America before Florida surfaced from under the sea. At the first opportunity, they swarmed all over Florida.

127

Three eras span the last 550 million years—the Paleozoic, Mesozoic, and Cenozoic eras. Details are shown only for the last of the three, "our" era. Florida's terrestrial history begins in the late Oligocene and continues through the Miocene, Pliocene, and Pleistocene epochs.

All spans of time used here are rounded off roughly. For purposes of this treatment, only the durations and approximate starting and ending times are important.

PALEOZOIC ERA (540 to 250 mya)

MESOZOIC ERA (250 to 66 mya)

CENOZOIC ERA (66 mya to the present)

Tertiary Period	Millions of years ago (mya)
Paleocene epoch	66–56
Eocene epoch	56–34
Oligocene epoch	34–23
Miocene epoch	23–5
Pliocene epoch	5–2.6

Quaternary Period

Pleistocene epoch (2.6 mya to 11,700 ybp)

Holocene (Recent) epoch (11,700 ybp to the present)

Source:

ejecta all over the planet, and destroying the ozone layer in the outer atmosphere. This terrifying event, known as the Cretaceous cataclysm, delivered a death blow to all of the dinosaurs that were then roaming the earth, and drastically altered the environment for the next tens of millions of years.

Without the ozone layer to screen out the sun's harsh ultraviolet rays, photosynthesis drastically slowed, and most of the earth's plant life was extinguished. All of the dinosaurs died and so did The only survivors were those that could escape the killing light: nocturnal animals, burrowing animals, animals in lakes and in the ocean. But although most plants had died, their seeds remained alive—especially fern spores and the seeds within the fruits of flowering plants.

The world changed dramatically as the effects of the Cretaceous cataclysm waned. Most groups of organisms on land and in the sea made new beginnings and the earth took on a new look. By 53 million years ago, sunlight was again shining down. The earth grew warm again, plants flourished anew, and their metabolism restored ozone to the atmosphere, recreating conditions in which life could thrive. The age of gymnosperms

and reptiles was giving way to the age of angiosperms and mammals.

Although Florida remained under water until about 35 million years ago, species and communities were evolving on exposed land nearby that would migrate into Florida when the seas receded. The stage was set for the widespread dominance of species of today. Temperate parts of the nearby coastal plain supported many trees we would recognize such as oak, elm, maple, and others; warm areas held tupelo, magnolia, and sweetgum; and tropical coastlines sported seagrapes and figs.

At 37 million years ago, the planet was so warm that crocodiles were living as far north as Wyoming. Roaming the Great Plains were many peculiar-looking creatures related to today's camels, horses, giraffes, elephants, bears, wolves, and others. Some went extinct, others prospered. Then another major extinction event occurred and many of these animals went extinct. It may be that the deep ocean currents changed at about this time. Whatever the reason, the climate grew cold, massive ice sheets piling up on Antarctica locked up large volumes of water, the sea level dropped dramatically, and Florida was born.

FLORIDA'S DEBUT

At about 35 million years ago, a few of the highest parts of Florida-to-be broke the ocean surface for the first time in millions of years. Immediately, the newly exposed land began to receive plants and animals immigrating from nearby terrestrial areas, but soon the sea rose and washed the developing ecosystems away again. These events were repeated many times over, but by about 25 million years ago, the ocean had receded from the Panhandle's northern highlands, leaving them above water until today. As for the Florida peninsula, it grew, then shrank, then grew, but since 23 million years ago it has never again disappeared completely beneath the ocean.[1] Figure 8-1 shows that at times Florida was a group of islands, at times a peninsula.

Florida appeared at a time when flowering plants were diversifying greatly. Composites, grasses, and legumes flourished on land, aquatic plants thrived in lakes and streams, and seagrasses spread beneath coastal waters. Herbivores flourished, eating all these plants. Carnivores diversified, finding abundant herbivores to eat. *La Florida*, the Land of the Flowers, was born at an auspicious time to develop immense diversity.

Fossil finds are available from different geologic times to offer richly detailed scenarios from past epochs. The discoveries described below are separated by at least *several million years*—a long enough time to bring about drastic changes in species and ecosystems. For perspective, keep in mind that only *two million years ago*, early hominids were just beginning to learn to use tools in Africa.

A **composite** is a special kind of flowering plant that belongs to the family Compositae or Asteraceae (daisies, sunflowers) and has many blossoms in a single flowerhead. Composites are the flowers that butterflies like best, because they can drink nectar from many different blossoms without having to spend any energy flying from one to the next

Florida native: Starry rosinweed (*Silphium asteriscus*), a composite. The center of the flower has elongated yellow petals that are actually parts of tiny flowers called "ray" flowers. The shorter parts in the center of the inflorescence are also tiny flowers that are called "disc" flowers."

At about 30 mya, only a few islands were above the surface of the water.

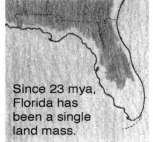

Since 23 mya, Florida has been a single land mass.

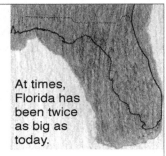

At times, Florida has been twice as big as today.

FIGURE 8–1

After 35 mya: Florida Emerges from the Sea

Green areas represent the land mass(es) of Florida at various earlier times. Black lines show the contours of today's Florida.

The exact shapes that Florida assumed from its first emergence to the present will never, of course, be known. However, geologists can easily tell whether sediments were deposited above or below sea level and make maps approximating the dynamic history of shifting shorelines. Some layers accumulated on top of the land during times when it was below sea level, as currents carrying heavy loads of sediments slowed down and dropped them in piles on the ocean floor. Then they were scrubbed off and sometimes completely washed away by erosion when sea level fell again.

Above sea level, the land performed many disappearing acts, as its limestone layers dissolved and were carried to the sea by underground rivers. The land sank down as this dissolution took place, but then in some areas, as its overburden of sediments grew lighter, deeper layers heaved upwards, raising the surface again. Florida's geographical history is pieced together through the use of geological clues—and importantly, from fossils entombed in the rocks.

FLAUSA

Florida native: Sweet pinxter azalea (*Rhododendron canescens*)

FLORIDA'S EARLY NATIVE PLANTS AND ANIMALS

To capture the thrill of discovery of Florida's ancient history, let us pretend that, instead of being paleontologists digging up fossils, we are time travelers who can actually visit sites in Florida millions of years ago when the fossils were first laid down. The entries that follow are written as if in the voices of people who can see the ancient plants and animals still alive. For scholarship's sake, though, references for each entry point to reports of the actual fossil finds.

The Late Oligocene (25 to 23 mya). Our time machine first takes us back 25 million years, to a site near Gainesville (the "I-10 site"), close to the very beginning of Florida's Cenozoic terrestrial history. We might write in our journal as follows:

> *Route I-10, 25 mya. We have pitched our tent by a sinkhole in a mesic forest. We spy many animals, and some are vaguely familiar. A tribe of beaverlike animals is at work felling trees nearby to dam a stream and we see a hedgehog amble by. Turtles are numerous. Other animals are of recognizable groups—there are rodents and a rabbit that look like those of today; lizards, snakes, and frogs that seem very different. There's a tortoise that may be a distant relative of today's gopher tortoise. At night, we see flocks of bats of at least five different species,*

Reminder: A **mesic** forest is one with moist soil.

and peccaries (piglike animals with boar tusks). There is an insect-eating animal rather like an anteater, and a primitive opossum.

One day we explore a savanna inland from our campsite, and find a thrilling assortment of large mammals, somewhat like horses, deer, and goats. Fires obviously burn frequently across this grassy plain. The plants nearly all grow low to the ground and signs of a recent fire are apparent as blackened twigs of shrubby growth.

On another day we hike to the shore. There, too, we see creatures we can almost name—seven different species of sharks, a sting ray, and a bony fish. Birds of all kinds are numerous, but we cannot get good impressions of them—literally: they have left few and faint fossil traces.

There is danger here—there are large and small carnivores. We know there are sabercats at other sites nearby.

If this campsite is typical, and we hope it is, then we can correctly describe the Florida of this time. Mesic forest predominates, with animals that are adapted to it, and they are so well distributed into the many available habitats that we think they have been evolving here for a long time. We will be back to see how well they persist, but we won't find another informative site until the early Miocene.[2]

Florida native: Virginia opossum (*Didelphis marsupialis*). Forebears of today's 'possums have been roaming in Florida since more than 25 million years ago.

The Miocene (23 to 5 mya). Early in the Miocene, communities north and south of the Suwannee River are developing differences that have persisted to the present. Many trees found north and west of the Suwannee seem never to have crossed that river to occupy peninsular Florida.

In central Florida, special scrub communities are developing, each on its own "island"—that is, on a high sand hill surrounded by mesic forests that most of its plants and animals cannot cross. Special freshwater communities are developing, too. Many freshwater mollusks of central Florida are endemic, as are many freshwater fishes.[3]

Of our first visit, which takes us to Gilchrist County early in the Miocene, we might write:

Thomas Farm, 18.5 mya: We are camping in a patch of deciduous forest complete with ponds, sinks, and caves, where we can observe a tremendous number of animals. Turtles and frogs are numerous in the ponds, and the caves are full of bats of many species. On the ground and in the trees we recognize many cousins of today's treefrogs, squirrels, turkeys, and deer. Peccaries and opossums are still here. Songbirds are calling in the branches above our campsite.

Our reptile specialist is excited to discover half a dozen snakes including a racer; a tree boa, and a vine snake. There are various lizards: a skink, a gecko, and others. The amphibians are exceedingly diverse and most are of the same genera as today—sirens, newts, salamanders, and many frogs and toads.[4]

From others' observations, we know that many animals are endemic to the Gulf coast along Florida and Texas. They do not occur in the interior of the continent, probably because the Great Plains are too dry. Among the endemics are three cameloids and a rhinocerotid.

Florida native: Southern leopard frog (*Lithobates sphenocephala*), an inhabitant of lakes, ponds, marshes, and streams across the U.S. Southeast. The protective coloration of this frog reflects millions of years of evolution within its habitat.

Florida native: Seminole bat (*Lasiurus seminolis*). This animal's ancestors were present in Florida by 20 million years ago.

This appears to be a well-established community. All of the animals show adaptations to forest life. Many are browsers, rather than grazers; and most, such as the bush hogs, have short legs that enable them to run through undergrowth.[5]

Other investigators have hiked eastward and report vast savannas that support great herds of grazing animals. Three-toed horses are especially numerous and make up 80 percent of our sample. Other grazers are even-toed: camelids, deerlike ruminants, an oreodont, and a cameloid with a peculiar "slingshot" horn above its nose. This strange beast will soon go extinct—soon, meaning within less than ten million years. A grazing tortoise also thrives on the savanna's herbs and forbs, and little pocket mice are scurrying about in the grasses collecting seeds. Several kinds of kites fly over the grasses searching out small animals.

Preying on all the small herbivores are diverse types of bears, wolves, and cats—some large, some medium, some small—at least ten distinct species. The most astonishing discovery comes at dusk when huge flights of bats emerge from caves deep in the woods. Some of these bats are large nectar feeders; others are small, swiftly-soaring insect feeders; and there are at least three of intermediate size, food habits unknown.[6]

We think these sites are typical of Early Miocene Florida. It is a patchwork of mesic forest and savanna, somewhat more tropical than today.[7]

Our time machine next takes us to Alachua County, later in the Miocene. We might write in our journal:

Love Bone Bed, about 10 mya: Again we are near the Gulf of Mexico. A stream runs out here and we have pitched tents on platforms over a freshwater marsh where the water rises and falls in concert with the tides. This is the richest Late Miocene vertebrate site in eastern North America. The marsh holds chicken turtles, soft-shell turtles, garfish, and alligators. Every time the tide rises, sharks, whales, and other swimmers move inland in great schools. Along the stream bank a lush forest rings with the songs of numerous birds.

Vast grasslands have opened up across North America and grazing animals find abundant food. Herbivores, including many species of horses, have grown large. We hike inland to explore a grassy savanna and find a stupendous number of species. The samples are so numerous that we have had to resort to a list to convey their extent (see List 8–1).[8]

The ground sloths are from South America and the temptation to speculate on how they got here is too great to resist. We imagine they may have floated in on a great pile of debris washed down a South American river into the Gulf of Mexico. As for the sabercats and bears, they must have come from Eurasia across a land bridge in the vicinity of Alaska or Greenland.

While we are exploring the Love Bone Bed, news arrives from some botanists who are camping in the Panhandle. They stumbled upon a botanically rich site at Alum Bluff on the Apalachicola River, at the north border of Liberty County. They have found several tropical plant assemblages growing along the river including palms, figs, breadfruit, orchids, and camphortrees. The gopherwood will persist at Alum Bluff for at least 13 million years, all the way to the 21st century.

The Pliocene (5 to 2.6 mya). We return later, again by time machine.

The western Great Plains are now very dry, predominantly grasslands. Many grazers have gone extinct in the middle of the continent, but in Florida, enough watering holes remain on the savannas to support huge herds of large animals. We make these observations in Polk County:

> Bone Valley, 5 mya: The climate is now very dry. Florida's above-water landmass has grown larger. Browsing animals are present (such as a large browsing horse) but grazing animals greatly outnumber them—there are ten species of grazing horses. Giant mammals include three elephant genera (mastodons, mammoths, gomphatheres). And if these weren't enough, other large grazers and browsers are also present including a large camelid, a medium-sized giraffoid, and a tapir.

> This vast panorama reminds us of the Serengeti Plain of Africa today. It has numerous hoofed animals resembling zebras, gazelles, giraffes, and others; and it has catlike and doglike carnivores similar to cheetahs, leopards, lions, and others). We are staggered by its richness.[9]

> Subtropical forests also remain in central Florida, where we see a large flying squirrel, an early version of the white-tailed deer, and a long-nosed peccary.

This is the last trip we make in our time machine and the last entry in our imaginary journal. For several million years, we can make no more observations, because the seas rise dramatically and remain high from 5 to 2.6 million years ago, eroding the perimeter of the highlands. Henceforth, Florida remains a single land mass. And although we have no opportunity to observe it, the continents of North and South America are becoming connected by the Isthmus of Panama, and when sea level falls, a land bridge will emerge between the two and animals will be able to migrate north and south across it.

Our narrative now resumes as regular text.

The Pleistocene (beginning about 2.6 mya). By the early Pleistocene as South America became joined to North America, profound impacts became apparent. The land bridge between North and South America separated the Atlantic and Pacific oceans, changing the courses of global ocean currents. As a result, Atlantic and Pacific shrimp, once all of the same species, became distinct species.

After the upheaval of Panama, an Atlantic current washed into the Gulf, circulated around it, and exited at the tip of Florida to flow up the east coast—in short, the Gulf Stream began to circulate as it does today. The warm, shallow Gulf waters became nutrient poor, a quality that is ideal for the growth of coral reefs. A dozen earlier genera of corals went extinct, but 21 new ones evolved, including beautiful staghorn and elkhorn corals. The reefs off the Florida Keys became unlike any others in the world.[10]

Ice ages occurred repeatedly during the Pleistocene, as a variety of factors became synchronous: eccentricities in the Earth's rotation and orbits around the sun, changes in ocean and wind currents, and consequent changes in the climate. Each time, rain on the poles turned to ice, and polar ice spread over the continents. Then as these factors lost their synchrony,

LIST 8–1
Vertebrates found at the Love Bone Bed, 10 mya

MAMMALS STILL HERE AS AT EARLIER SITES
Giraffelike animals, a new species (*Pediomeryx*)
Grazing rodent, small (*Mylagaulus*)
Horses—many species
Peccaries
Pronghorn antelope
Rhinoceroslike animals, 2 kinds
Tapirs
. . . and other animals

MAMMALS NOT SEEN EARLIER
Bears, primitive—from the Old World
Ground sloths, 2, from South America
Sabercats—from the Old World

BIRDS
(Stream, streambank, pond, marsh, and wet prairie specimens = 284 species!)
Anhingas
Coots
Cormorants
Ducks
Flamingos
Geese
Grebes
Herons
Limpkins
Ospreys
Rails
Shorebirds
Storks

REPTILES
(These are much like those of today.)
Alligator
Land tortoises, 2
Turtles, several
Crocodile with a narrow snout for catching fish, 20 feet long! (*Gavialosuchus*)
Snakes—several
(Boa-type constrictors are no longer present.)

AMPHIBIANS
(Salamanders and frogs are much like those of today.)

Sources: Webb and co-authors 1981; Meylan 1984.

Native to Florida waters: Elkhorn coral (*Acropora palmata*). This coral evolved in the shallow seas off Florida within the last ten million years.

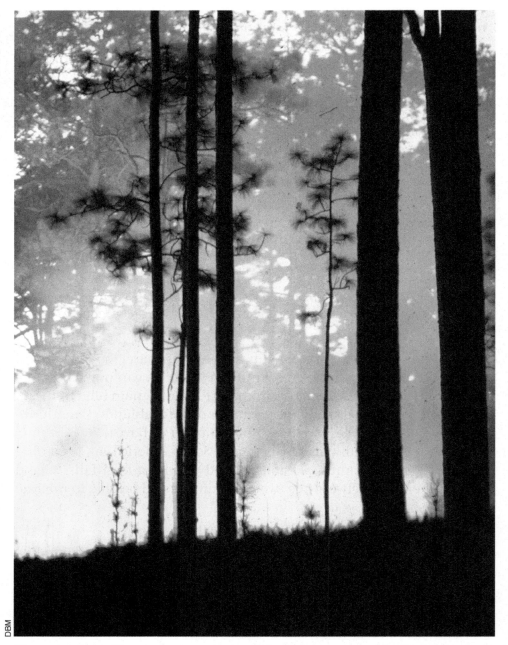

Pine grassland. Fire-dependent pinelands have been present in Florida for more than two million years.

the planet warmed again and the ice sheets retreated. (Glacial periods have occurred many times in earth's history. Today we live in an interglacial stage of the Pleistocene Epoch in which glacial climates persist over periods of 100,000 years or so and warm interglacial periods about 10,000 years. We would now be sliding into another glacial period, but global climate warming caused by human activity is acting to prevent this.)

The Great American Interchange. During each ice age, ocean water became tied up in land ice and the seas fell dramatically. Land areas expanded, and new land routes became available to and from distant places. Now the Isthmus of Panama was a broad land bridge above water. North

and South America's plants and animals, which had evolved independently for nearly 200 million years, began crossing that bridge, invading each other's territory, and mingling (see Figure 8-2). New relationships evolved as predators and prey began to mix in new combinations.

Florida's appearance changed dramatically. When it first appeared above sea level some 35 to 25 million years ago, Florida was clad predominantly in hardwood forests within which patches of pine forest and savanna lay scattered. At 2.6 million years ago, the pattern was reversed: pine forest and savanna were continuous and the hardwood forests had broken up into patches. A major new, dry-adapted ecosystem was now in evidence in southern Levy County: coastal longleaf pine savanna, the precursor of today's fire-dependent pine grasslands.

During drying cycles, plants and animals that preferred mesic habitats became confined to deep, moist ravines, especially along the valley sidewalls of the major rivers of the Panhandle and along the shaded, moist sidewalls of deep sinkholes. Today, many of Florida's ancient endemic plants are found in such habitats along the Apalachicola River.

The fossil record shows that many major species of animals vanished

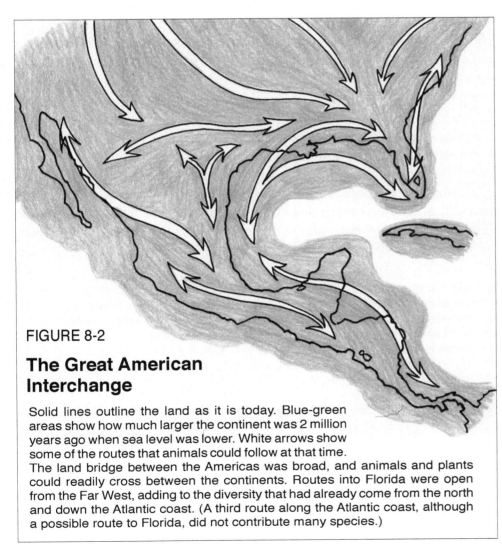

FIGURE 8-2

The Great American Interchange

Solid lines outline the land as it is today. Blue-green areas show how much larger the continent was 2 million years ago when sea level was lower. White arrows show some of the routes that animals could follow at that time.
The land bridge between the Americas was broad, and animals and plants could readily cross between the continents. Routes into Florida were open from the Far West, adding to the diversity that had already come from the north and down the Atlantic coast. (A third route along the Atlantic coast, although a possible route to Florida, did not contribute many species.)

**LIST 8–2
Pleistocene finds at various sites, about 2 mya**

MAMMALS—300-odd species!

STILL PRESENT FROM EARLIER TIMES:
Animal with proboscis (a sort of long nose) and short jaw
Horses—3 kinds
Llama
Oxlike animal
Peccaries—2 genera

NEW, NOT SEEN EARLIER:

From South America—
Armadillolike animals— 3 sizes with bony shells. One is *huge*; shell is fused and more than 3 feet across
Flying squirrel
Large rodent—part land, part aquatic (a grazer— like a capybara)
Large mammal—a sort of sloth the size of a bean
Many others—forest types

FROM THE FAR WEST:
Jack rabbits (one type is the antelope jackrabbit, *Lepus alleui*)
Pocket gophers (*Geomys*)
Small pronghorn antelope (*Antilope americanus*)

AND AT OTHER SITES:
Glyptodont (size of a Volkswagon bug), shaped like an armadillo)
Ground sloth, small
Manatees (like today's)
Vampire bat
And many more finds

BIRDS—many species, among which one is a giant bird, flightless, predatory, 5 ft tall (*Titanis walleri*)

Source: Webb 1990.

from North America during the Pleistocene Epoch. In their place were many others, never seen there before. New animals were present from South America, the Far West, and the northern mountains. Again, an abbreviated record has to serve (see List 8-2).

As the climate warmed, the ice sheets retreated, and huge volumes of melt water roared down North American rivers, widening their channels and delivering sediment that built broad deltas at their mouths. On the Mississippi delta, vast wetlands developed, too wide for most plants and animals and even some birds to cross. Florida's connection with the west weakened and many groups split into eastern and western subpopulations.

At least ten more cycles of cooling and warming followed during the Pleistocene's last million years. The climate cooled and warmed about every 100,000 years and sea level fell and rose along with it. Whenever sea level fell, Florida became very arid, favoring savanna and high pine communities. Whenever sea level rose again, hardwood forests expanded their ranges, wetlands enlarged, and lakes became numerous. At 18,000 years before the present, when the Wisconsinan ice age was most intensely cold and Florida was drier, the sea level was 300 or more feet lower, and the peninsula's area was twice as broad as it is today. The whole continental shelf lay exposed. A vast, dry pine savanna flourished over a hundred million acres, patchily decorated with hardwood forests, mostly oak, including turkey oak. Thousands of acres of wet flats and seepage bogs were ablaze with wildflowers and carnivorous plants.[11]

Animals were again migrating into North America from Asia over the land bridge between Siberia and Alaska. Some long-horned bison migrated from Asia into Alaska, then crossed the entire span of the Great Plains and entered Florida to gradually become today's familiar short-horned bison. Herds of giant animals roamed from one water hole to the next: mammoths, mastodons, camels, sabertooth cats, dire wolves, giant sloths, armadillos, tapirs, peccaries, bison, giant land tortoises, glyptodonts, horses, giant beavers, capybaras, and short-faced bears.[12] Naturalist Archie Carr, contemplating what Florida must have been like at that time, marveled at the sights we might have seen:

> *Right in the middle of Paynes Prairie itself there used to be creatures that would stand your hair on end. Pachyderms vaster than any now alive grazed the tall brakes or pruned the thin-spread trees. There were llamas and camels of half a dozen kinds; and bison and sloths and glyptodonts; bands of ancestral horses; and grazing tortoises as big as the bulls . . . making mammal landscapes that, you can see in even the dim evidence of bones, were the equal of any the world has known.[13]*

Figure 8–3, on the next two-page spread, shows what Florida's vast savannas might have looked like when those great animals were here. Only a few remain from that time, and the figure legend identifies only those that have since gone extinct.

FLORIDA'S UPLANDS

The Coming of Humans

After about 15,000 ybp, another warming trend began. The ice sheet began to melt and the first bands of nomadic hunters migrated from Alaska down an ice-free corridor of land east of the Canadian Rockies (Figure 8-4). At 14,425 ybp, Florida's earliest dated human-occupied site was the Page-Ladson Site on the Aucilla River.

As on the Plains, the giant animals all died off at about the time the humans arrived (see List 8–3). In Florida's case, however, human hunters are not thought to be the only agent causing the extinctions. In Florida, small mammals as well as big ones went extinct, often just as other similar animals migrated in, suggesting that newcomers were displacing residents. Moreover, some of Florida's extinctions predated human arrival. Perhaps climate change pushed the animals to the brink and human hunters struck the last blow in some cases. Whatever the reason, only the fossils of those giant animals remain.

Like all prior comers, Florida's first people became part of its ecosystems. They selected certain wild plants to eat, they hunted, and they cleared some forests for hunting, sometimes by burning them. Once the large game animals of the past were extinct, they adapted to eating snails, then oysters, scallops, and sea turtles. By 5,000 ybp, they were making pottery, and by 1,000 ybp they were engaging in corn agriculture.

Meanwhile, coastal wetlands were swamped by rising seas and Florida shrank to half its former area. Cypress and other wetland species escaped extinction by finding refuge in deep, wet habitats in the interior. They persisted there, as if awaiting the next climatic turn to recolonize coastal lowlands. Seepage bogs dwindled in size and separated into remnants, the Everglades marsh developed, and mangroves began to grow along the coast.

LIST 8–3
Changes in the fossil record since 13,000 ybp

EXTINCT in
North America
Large mammals, 35
 genera
Large birds, 2
 (*Gymnogyps*, *Teratornis*)
Giant tortoise
 (*Geochelone*)

GONE, E of the
Mississippi[a]
Jack rabbits
Pronghorn antelopes

GONE FROM FLORIDA[b]
Bog lemming (*Synaptomus*)
Porcupine (*Erythizon*)
Muskrat (*Ondatra*)

SPLIT into two populations E and W of Mississippi River
Cactuses, 8 genera
Scrub-jay
Whip scorpions

REMAINING
Reptiles: Of 31 species
 that came in from the Far
 West, 24 are still here in
 dry savannas and high
 pinelands

Notes:
[a]Eastern North America
 became too wet for these
 desert animals.
[b]Summers became too
 hot and wet in Florida
 and these animals moved
 north.

Source: Adapted from
Webb 1990.

Florida native, now extinct: Mammoth *(Mammuthus colombi)*. Paleontologists discovered this skeleton in the bottom of the Aucilla River in 1968. It is more than 12 feet tall at the shoulder and 16,000 years old by radiocarbon dating.

FIGURE 8-3

Pleistocene Giant Animals in Florida

At left is a mesic forest with peccaries (1), a giant sloth (2), a glyptodont (3), a tapir-like animal (4), as well as some dire wolves (5) and a sabercat (6). At center and right is a savanna of the type that probably occupied most of Florida during much of the Pleistocene. Roaming the savanna are herds of giraffe-camels (7), horses (8), and bison (9).

THE EUROPEANS (500 YBP)

When the Europeans arrived, the pace of change quickened. In the early 1500s, the Spanish "discovered" Florida and preempted it as their own. Spanish aggression and diseases decimated the native peoples, and by about

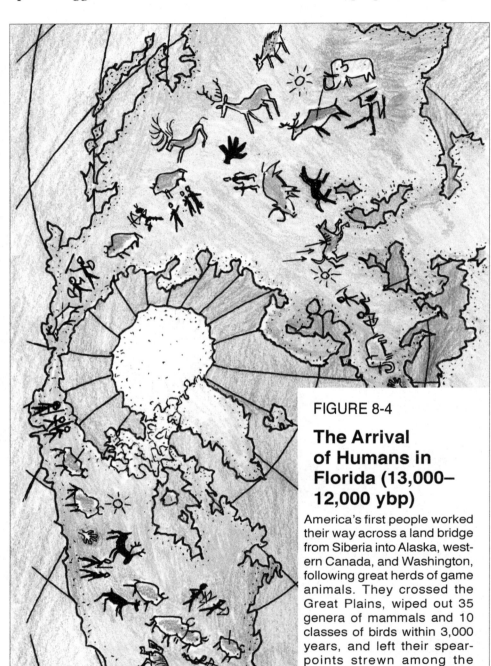

FIGURE 8-4

The Arrival of Humans in Florida (13,000– 12,000 ybp)

America's first people worked their way across a land bridge from Siberia into Alaska, western Canada, and Washington, following great herds of game animals. They crossed the Great Plains, wiped out 35 genera of mammals and 10 classes of birds within 3,000 years, and left their spearpoints strewn among the skeletal remains. By 12,000 ybp they had arrived in Florida.

Scores of different tribes occupied different parts of Florida. Nearly 10,000 villages, camps, and mounds pepper the state; some 885 such sites are on Eglin Air Force Base alone (in Santa Rosa, Okaloosa, and Walton Counties).

Source: Anon. 1991 (Survey unearths Eglin's past).

1700, had largely wiped them out or driven them from Florida. (A few tribes returned to Florida later, notably, in the mid to late 1700s, members of the Mikasuki and Creek tribes—the latter renamed Seminole.)[14]

Other Europeans followed the Spanish and established forts, settlements, and citrus plantations along the coasts, on the rivers, and on the highlands. By 1775, St. Augustine, St. Marks, and Pensacola were major Florida towns. Then, in the 1800s, industry came to Florida, and in the 1900s, roads, cars—and some 17 million people.

Today, human uses of the land are fragmenting and destroying natural habitats (see List 1-1 in Chapter 1). Moreover, global gas concentrations are changing, the earth's temperature is rising, and more ultraviolet rays are penetrating the atmosphere. As a result, the earth's biodiversity is diminishing. But those natural ecosystems that remain are the once-on-a-planet, once-in-the-universe products of a history hundreds of millions of years long, and they still hold an enormous and diverse legacy from the past.

A TREASURE TROVE OF INFORMATION

An immense amount of information is stored in each of Florida's species. Some of that information is a set of "directions for life," such as how to respire, grow, and repair injuries. Some is specific and provides instructions for adapting to natural, local environments: cypress trees to swamps; mussels to river beds; caterpillars to their host plants; corals to their sites on the continental shelf. Taken all together, the quantity of detail in each species is staggering. Even a single bacterial "cell," which is smaller and simpler than a "true" cell, is built according to a blueprint of some 3,000 genes, each of which in turn is composed of tens of thousands of atoms. A more complex organism, such as a microscopic worm, inherits and passes on much more information—some 19,000 genes. A common mold may have as many as 100,000 genes.

Florida native, next generation: Red maple seeds (*Acer rubrum*). Red maple grows well in many kinds of habitats with both dry and moist soils.

If each "simple" species uses thousands of genes to direct the development of its members, how much more information must the barking treefrog, scrub balm, horseshoe crab, and longleaf pine have? How much information is contained in a whole ecosystem, or in the dozens of ecosystems that we have in Florida? To convey how awesome such a quantity is, biologist E. O. Wilson offers this description of a single, tiny ecosystem in soil:

> A handful of soil and leaf litter . . . contains more order and richness of structure . . . than the entire surface of all the other (lifeless) planets . . . Every species in it is the product of millions of years of history. . . . Each organism is the repository of an immense amount of genetic information.

Florida native rearing next generation: Perdido Key beach mouse (*Peromyscus polionotus trisyllepsis*). This mother was tending her tiny, pink newborns on a barrier island beach.

For the sake of illustration, let us use the "bit," the smallest unit of information content used in computer science, to measure the amount of genetic information contained in an organism. . . A single bacterium possesses about ten million bits of genetic information, a fungus one billion, and an insect from one to ten billion bits according to species. . .

If the amount of information in just one insect—say an ant or a beetle—were to be translated into a code of English words and printed in letters of standard size, the string would stretch over a thousand miles. The life in our one little sample of litter and soil would just about fill all the published editions of the Encyclopedia Britannica.[15]

In light of the time and information each one represents, then, Florida's natural ecosystems are of great value. One aspect of that value is that natural ecosystems perform services useful to life and society.

ECOSYSTEM SERVICES

Ecosystem "services," meaning natural processes that support life on earth, were referred to in the first chapter, and succeeding chapters pointed out some of them. To bring them back into focus, a brief summary follows.

First, consider what green plants do for life on earth. Green plants provide the oxygen we breathe, and oxygen supports the metabolism of almost all life on earth. Green plants consume carbon dioxide, removing it from the atmosphere and oceans and storing it in plant tissues and sediments that fall to the bottom of the seas. Healthy plants also purify air. They absorb sulfur and nitrogen compounds, ozone, and heavy metals into their tissues, leaving the air clean, breathable by animals, and less laden with tissue-burning acid rain.

Then there is the contribution of green plants to the health of the planet. Oxygen released by plants forms ozone in the outer atmosphere, and ozone screens out wavelengths of sunlight that, if they penetrated freely to the earth's surface, would destroy all exposed life. Moreover, green plants consume carbon dioxide (which holds heat in the atmosphere), thereby helping to keep the global temperature within limits suitable for life. At the same time, green plants and their organic residues in ecosystems hold huge volumes of carbon out of the atmosphere and thereby prevent overheating of the globe. Among carbon-holding systems, the ocean's communities of algae, the earth's soil communities, and the plant populations of wetlands and forests are especially important.

Earlier chapters have already enumerated many other ecosystem services: water purification, soil conservation, erosion control, flood abatement, recycling of nutrients and minerals, aeration of soil, disposal of wastes. Finally (and this has been the focus of this book), natural ecosystems provide habitat: nurseries, feeding and breeding grounds, and shelter that permit native species populations to conduct all phases of their life cycles unaided by us.[16]

SPECIES DIVERSITY

Species diversity greatly enhances ecosystem value. The greater the number of species in an ecosystem, the greater the system's productivity and resilience. In a grassland, for example, a mixture of different grasses can produce a greater mass of living material than a crop of any one grass, and species-rich grasslands can withstand and recover from stresses such as drought much more successfully than can low-diversity systems.[17]

Because species diversity has value, the loss of just one species can weaken a whole ecosystem. Species diversity is expressed most fully in large, ancient, undisturbed ecosystems like Florida's original pine grasslands, rocklands, and scrub, whose component plant and animal populations have evolved and interacted for millions of years. In contrast, less biodiversity is seen in small, isolated patches of habitat and in modified communities such as parks and farms, which are of more recent origin and are usually much less complex than natural communities.[18]

What will it take to ensure that the priceless biodiversity of this corner of the continent will be preserved? Florida's species are adapted to local conditions, and Florida is the best place to preserve them. To take on the care of a species outside of its natural habitat is costly, burdensome, energy-intensive, time consuming, and unlikely to succeed. Small sets of specimens can at best be maintained for short times under controlled conditions in greenhouses and zoos, but they cannot perpetuate themselves without help except under natural conditions. The best site in which to conserve each species is its own natural habitat.

Beyond the value of diversity, beyond the utilitarian value of ecosystem services, and beyond their beauty and fascination, the other creatures, plants as well as animals, simply have the right to be here. They have traversed the same, long, evolutionary time span, and the same bumpy road of life and death through myriad generations, as we have. They share with us the eloquent language of DNA; they are our kin. They need us to pay attention to their plight in the wake of our hurtling journey into the future. And indeed, if we don't pay attention and safeguard them against the repercussions of our own pursuits, we will learn too late that we needed them, too, more than we knew.

Florida native, next generation: White-tailed deer (*Odocoileus virginianus*), fawn. This species began to appear in the fossil record more than 3 million years ago and is widespread from North to South America.

Florida native, next generation: Black skimmer nestlings (*Rynchops niger*). The black skimmer is one of thirteen bird species that nest on Florida beaches.

Florida flame azalea (*Rhododendron austrinum*) in the Apalachicola Bluffs and Ravines, Liberty County.

REFERENCE NOTES

CHAPTER 1——NATURAL ECOSYSTEMS AND NATIVE SPECIES

1. *Guide* 1990, *Guide* 2010.

2. Discussion of the term *natural* inspired by Clewell 2000.

3. Speciation may occur in still other ways. For example, an accident during fertilization may produce offspring with more chromosomes than the parents possessed—polyploid individuals, the progenitors of a new species. This may be a sudden occurrence, but the point here is that speciation probably usually takes long times.

4. Species names for plants are from Wunderlin and Hanson 2003; for freshwater fish from Page and coauthors 2011, for marine fish from Anon. c. 1994 (Fishing lines), for amphibians and reptiles from Collins and Taggart 2002, and for birds, Bruun and Zim 2001.

5. Heath and Conover 1981, 43; Winsberg 1990, 110; Anon. 1991 (Rainy rescue).

6. Heath and Conover 1981, 43; Winsberg 1990, 110; Anon 1991 (Rainy rescue)."

7. Florida rainfall from Fernald and Patton 1984, 19.

8. Wolfe, Reidenauer, and Means 1988, 33.

9. Lightning frequency from Waters 1988 (Nature notes); Frank 1982; Ray 1992.

10. Brown, Stone, and Carlisle 1990.

CHAPTER 2——HIGH PINE GRASSLANDS

1. Platt 1999.

2. Wells and Shunk 1931; Bridges and Orzell 1989.

3. Komarek 1965.

4. Platt and Schwartz 1990, based on data in early land survey records reviewed by Schwartz and Travis 1995.

5. Komarek 1964; Clewell 1981/1996, 76–79; Fowells 1965.

6. Snedaker and Lugo 1972, 120; Andre F. Clewell, note to Ellie Whitney, December 1995.

7. Walter. R. Tschinkel, letter to Ellie Whitney, 25 January 1998.

8. Begley 1995.

9. Need for snags from Wuerthner 1995; snakes from Means 1996.

10. Minno and Minno 1993; Weigl, Steele, Sherman, Ha, and Sharpe 1989, 48.

11. Weigl, Steele, Sherman, Ha, and Sharpe 1989.

12. Leveton 1995.

13. Svingen 1995; Hooper, Robinson, and Jackson 1990.

14. Information on the arboreal ant from Hahn and Tschinkel 1997.

15. Hooper, Robinson, and Jackson 1990.

16. Means 2006.

17. MacArthur and MacArthur 1961; Anon. 1993 (Some like it old).

18. McKibben 1996.

19. Fossil records from Means 1996; interdependence from Clewell, 1981/1996 160–164.

20. Means 1996; Clewell 1981/1996, 150, 157–158.

21. Norse 1990.

22. Hooper, Robinson, and Jackson 1990.

23. To make sure most pine seedlings survive, managers can note areas where seedlings have survived in late winter and protect these from fire for at least a year, but otherwise burn frequently in summer. Management of several large and significant longleaf pine communities in the Apalachicola National Forest, at Torreya State Park, and on Eglin Air Force Base proceeds according to these guidelines.

Chapter 3—Flatwoods and Prairies

1. Significance from DeSelm and Murdock 1993; present status from Platt 1999.

2. Glitzenstein, Streng, and Platt 1995.

3. Root adaptations from Stout and Marion 1993.

4. Researchers who sampled the groundcover at seven different times during the year counted 147 species of forbs in a frequently burned longleaf pine flatwoods. Platt et al 1988b as cited by Stout and Marion 1993.

5. Stout and Marion 1993. The ant species are *Crematogaster lineolata, Aphaenogaster traetae, Aphaenogaster fulva,* and *Conomyrma insana.*

6. Earthworm species worldwide from Margulis and Schwartz 1990, 216; Florida earthworms from Reynolds 1994; calculations from Darwin 1881; and Hickman, Roberts, and Hickman 1984, 343.

7. Brower 1997, 82–83.

8. Hutto 1995, 117.

9. That the turkey nests on dry ground burned a year earlier is from Boyles-Sprenkel 1991.

10. Rat statistics from Means 1985 (Cotton rat).

Chapter 4—Beach-Dune Systems

1. Doyle, Sharma, Hine, Pilkey, and coauthors 1984, 17.

2. Clewell 1981/1996, 181.

3. Plants on foredunes from Clewell 1981/1996, 188–190; Holzer 1986; Gore 1986. Rapid growth from Johnson and Barbour 1990.

4. Johnson and Barbour 1990.

5. Number of sand gnat species from Tunstall 1998.

6. Cox 1988; Dunne 1995.

7. Emmel 2000.

8. Ball 1992; Stevens 1990.

9. Bates 1986.

Chapter 5—Florida Scrub

1. Myers 1990, 155.

2. Myers 1990, 173; Snedaker and Lugo 1971, 102.

3. Myers 1990, 167–172.

4. Burns 1992; Tebo 1988 (Florida's desert islands); Fitzpatrick 1992 (Vanishing Florida scrub).

5. Stap 1994.

6. Root grafting from Snedaker and Lugo 1971, 162.

7. Plant chemicals from Deyrup and Eisner 1993; rosemary competition from Stap 1994.

8. Eisner 1997.

9. Eisner 1997.

10. Deyrup 1989; Deyrup and Eisner 1993.

11. Deyrup and Eisner 1993.

12. Deyrup and Eisner 1996.

13. Deyrup 1994, 254–256.

14. Deyrup and Menges 1997.

15. Layne 1992.

16. Wolfe, Reidenauer, and Means 1988, 41, 51.

17. Snedaker and Lugo 1972, 101–102.

18. Fitzpatrick 1994.

Chapter 6—Temperate Hardwood Hammocks

1. Gap succession from Clewell 1981/1996, 193-194; scatter-hoarding from Platt and Hermann 1986.

2. Duffy and Meier 1992.

3. Will Whitcomb, conversation with D. Bruce Means, c. 1975.

4. Florida Biodiversity Task Force 1993, 2.

5. Mitchell 1963.

6. Carr 1994, 165.

7. Description of, and succession in, oak groves from Carr 1994, 170; size of oak from Canfield 1998; dimensions of oaks from Godfrey 1988, 313; and Laessle and Monk 1961.

8. Carr 1994, 178-179.

9. Carr 1994, 180.

10. Carr 1994, 181-182.

11. Begley 1995.

12. Foresters say that "Any simplification of a natural system [erodes] the system's capacity to resist and recover from disturbances." Perry and Amaranthus 1997, 32.

Chapter 7—Rocklands, Upland Glades, and Caves

1. Roger L. Hammer, note to Ellie Whitney, c. March 2003; Snyder, Herndon, and Robertson 1990, 248; Platt 1999.

2. Snyder, Herndon, and Robertson 1990.

3. Toops 1998, 53; Anon. 1990 (Wild Florida, vol. 2).

4. Hurchalla 1998.

5. Endemism from Snyder, Herndon, and Robertson 1990, 236; Anon 1998 (Key Largo Hammocks State Botanical Site); Sawicki 1997; Toops 1998, 56.

6. Snyder, Herndon, and Robertson 1990, 248.

7. Toops 1998, 57–59.

8. Sawicki 1997.

9. Cerulean 1992.

10. Huffstodt 1998.

11. Wisenbaker 1989.

12. Jamaican fruit bats were seen on Key West and Stock Island from 1872 to 1986, but are probably no longer present there.

13. Gore 1994, Wisenbaker 1991, Hartman 1992, and Beck 1996. Quantities bats eat from Tousignant 1995.

CHAPTER 8—THE PAST AND THE FUTURE

1. S. David Webb, letter to Ellie Whitney, 22 December 1998.

2. Patton 1969.

3. Webb 1990, 90, 95, 100.

4. Meylan 1984.

5. Pratt 1990.

6. S. David Webb, letter to Ellie Whitney, 22 December 1998.

7. Webb 1981; Meylan 1984.

8. Webb, MacFadden, and Baskin 1981; Hulbert 1982.

9. Webb and Crissinger 1983.

10. Ross 1996.

11. Turkey oak was probably already present at 18,000 BC. Andre C. Clewell, letter to Ellie Whitney, 10 July 2000.

12. Osborne and Tarling 1996; Wisenbaker 1988; Wisenbaker 1989.

13. Carr 1994, 19.

14. Hiaasen 1993.

15. Wilson 1983.

16. The value of nature's services was estimated by Daily, ed., 1997.

17. Yoon 1994.

18. Roush 1982; May 1993; Raven, Berg, and Johnson 1993, 344.

BIBLIOGRAPHY

Abrahamson, W. G., and D. C. Hartnett. 1990. Pine flatwoods and dry prairies. In Myers and Ewel 1990 (q.v.), 103-149.

Anon. 1990. Wild Florida, vol. 1: The Florida Scrub, a poster with text on back. Tallahassee: Florida Game and Fresh Water Fish Commission, Nongame Wildlife Education Section.

Anon. 1991. Longleaf pine communities vanishing. *Skimmer* 7:2 (Summer), 1, 7, 8.

Anon. 1991. Rainy rescue. *Tallahassee Democrat,* 12 January.

Anon. 1991. Survey unearths Eglin's past. *Tallahassee Democrat,* 25 August.

Anon. 1993. Some like it old. *Tallahassee Democrat,* 4 October.

Anon. c. 1994. *Fishing Lines.* Tallahassee: Department of Environmental Protection.

Anon. 1998. Key Largo Hammocks State Botanical Site. *Florida Living Magazine* (October): 62.

————. 1994. *Rare and Endangered Biota of Florida.* Vol. 4, *Invertebrates,* ed. M. Deyrup and R. Franz. Gainesville: University Press of Florida.

Ashton, R. E., and P. Ashton. 2004. *The Gopher Tortoise.* Sarasota: Pineapple Press.

Bailey 1998.

Ball, S. 1992. Florida—last stand for monarchs? *Florida Wildlife* 46 (January-February): 46.

Bates, S. K. 1986. Migratory butterflies flutter by Florida. *Skimmer* 2:2 (Summer), 1, 7.

Beck 1996

Begley, S. 1995. Why trees need birds. *National Wildlife* (August/September): 42-45.

Boyles-Sprenkel, C. 1991. Multiply your turkeys. *Florida Wildlife* 45 (January-February): 38-39.

Bridges, E. L., and S. L. Orzell. 1989. Longleaf pine communities of the west Gulf coastal plain. *Natural Areas Journal* 9: 246-263.

Brouillet, L., and R. D. Whetstone. 1993. Climate and physiography. In *Flora of North America, North of Mexico,* ed. Flora of North America Editorial Committee: 15-46. Oxford: Oxford University Press.

Brower, K. 1997. *Our National Forests.* Washington: National Geographic Society.

Brown, R. B., E. L. Stone, and V. W. Carlisle. 1990. Soils. In Myers and Ewel 1990 (q.v.), 35-69.

Burns, B. 1992. Partnership protects rare scrub. *Nature Conservancy Florida Chapter News* (Spring): 1.

Canfield, C. 1998. Highlands Hammock State Park. *Florida Living Magazine* (September): 66-67.

Carr, A. 1994. *A Naturalist in Florida.* New Haven, Conn.: Yale University Press.

Carr et al 2009a. Carr. S.M., K.M. Robertson, W.J. Platt, and W. Peet. 2009. A model of geographic, environmental, and regional variation in vegetation composition of pyrogenic pinelands of Florida. *Journal of Biogeography* 36: 1600–1612.

Carr et al 2009b. Carr, S.M., K.M. Robertson, and R.K. Peet. 2009. A vegetation classification of fire-dependent pinelands of Florida. *Castanea* 75: 153–189.

Cerulean, S. 1992. Delicate balance (Key Largo woodrat). *Florida Wildlife* 46 (May-June): 40.

————. 1994. Swallow-tailed kites. Florida Wildlife 48 (July-August): 7-9.

Clewell, A. F. 1971. The vegetation of the Apalachicola National Forest (unpublished manuscript). Prepared under contract number 38-2249, USDA Forest Service, Atlanta and submitted to the office of the Forest Supervisor, Tallahassee.

————. 1985. *Guide to the Vascular Plants of the Florida Panhandle.* Tallahassee: Florida State University Press.

————. 1981/1996. *Natural Setting and Vegetation of Panhandle Florida.* U.S. Army Corps of Engineers, Mobile District, Report No. COESAM/PDEI-86/001.

————. 2000. Restoring for natural authenticity. *Ecological Restoration* 18 (Winter): 216-217.

Collins, J. T., and T. W. Taggart. 2002. *Standard Common and Current Scientific Names for North American Amphibians, Turtles, Reptiles, & Crocodilians.* 5th ed. Hays, Kansas: Center for North American Herpetology.

Cox, J. 1988. The influence of forest size on transient and resident bird species occupying maritime hammocks of northeastern Florida. *Florida Field Naturalist* (May): 25-34.

Cressler, A. 1993. The caves of Dade County, Florida. *Florida Speleologist* 30 (Summer-Fall): 44-52.

Croker, T. C., Jr., and W. D. Boyer. 1975. *Regenerating Longleaf Pine Naturally*. Forestry Service, Research Paper SO-105. New Orleans, La.: USDA Southern Forestry Experiment Station.

Darwin, C. 1881. *The Formation of Vegetable Mould, through the Actions of Worms, with Observations on Their Habits.* London: Murray.

Derr, M. 1989. *Some Kind of Paradise.* New York: Morrow.

DeSelm, H., and N. Murdock. 1993. Grass-dominated communities. In *Biodiversity of the Southeastern United States: Upland Terrestrial Communities,* ed. W. Martin, S. Boyce, and A. Echternacht: 87-141. New York: Wiley.

Deyrup, M. 1989. Arthropods endemic to Florida scrub. *Florida Scientist* 52: 254-270.

————. 1994. Florida scrub millipede. In Ashton 1994 (q.v.), 254-256.

Deyrup, M., and T. Eisner. 1993. Last stand in the sand. *Natural History* (December): 42-47.

————. 1996. Photosynthesis beneath the sand in the land of the pygmy mole cricket. *Pacific Discovery* (Winter): 44-45.

Deyrup, M., and E. S. Menges. 1997. Pollination ecology of the rare scrub mint *Dicerandra frutescens* (Lamiaceae). Florida Scientist 60:3 (Summer).

Doren, R. F., W. J. Platt, and L. D. Whiteaker. 1993. Density and size structure of slash pine stands in the everglades region of south Florida. *Forest Ecology and Management* 59: 295-311.

Doyle, L. R., D. C. Sharma, A. C. Hine, O. H. Pilkey, Jr., W. J. Neal, and O. H. Pilkey, Sr. 1984. *Living with the West Florida Shore.* Durham, N.C.: Duke University Press.

Duffy, D. C., and A. J. Meier. 1992. Do Appalachian herbaceous understories ever recover from clearcutting? *Conservation Biology* (June): 196-201.

Dunne, P. 1995. The top ten birding spots. *Nature Conservancy* (May/June): 16-23.

Eisner, T. 1997. Tribute to a mint plant. *Wings* (Fall): 3-6.

Emmel, T. C. 2000. Fabulous Florida butterflies. *Florida Wildlife* 54 (May-June): 3-5.

Engstrom, R. T. 1982. In Thirty-fourth winter bird population study, ed. R. L. Boyd and C. L. Cink, 31. *American Birds* 36: 28-49.

Evered, D. S. 1993. Report from the field. *Barrier Island Trust Newsletter* (June): 1-4.

Ewel, K. C. 1990. Swamps. In Myers and Ewel 1990 (q.v.), 281-323.

Fernald, E. A., and D. J. Patton, eds. 1984. *Water Resources Atlas of Florida.* Tallahassee: Florida State University Institute of Science and Public Affairs.

FICUS. 2002. Ecosystem description: Pine flatwoods and dry prairies. http://www.ficus.-usf.edu/docs/fl_ecosystem/upland/up-flat.htm. 8 February.

Fitzpatrick, J. W. 1992. Vanishing Florida scrub. *Florida Naturalist* (Spring): 8-9.

————. 1994. Cited by D. Stap. 1994. Along a ridge in Florida. *Smithsonian* (September): 36-45.

Florida Biodiversity Task Force. 1993. Conserving Florida's biological diversity: A report to Governor Lawton Chiles. Tallahassee: State of Florida, Office of the Governor. Photocopy.

Fowells, H. A. 1965. *Silvics of Forest Trees of the United States.* USDA Forest Service Handbook #271. Washington: Government Printing Office.

Frank, N. L. 1982. Tropical storms and hurricanes. *ENFO* (September): 1-8.

Glitzenstein, J. S., D. R. Streng, and W. J. Platt. 1995. *Evaluating the Effects of Season of Burn on Vegetation in Longleaf Pine Savannas.* Tallahassee: Florida Game and Fresh Water Fish Commission.

Godfrey, R. K. 1988. *Trees, Shrubs, and Woody Vines of Northern Florida and Adjacent Georgia and Alabama.* Athens: University of Georgia Press.

Gore, J. 1994. The diversity of Florida's bats. *Skimmer* 10:2 (Summer), 1-2.

Gore, R. H. 1986. Barrier islands. Florida Wildlife 40 (January/February): 18-22.

————. 1992. The Gulf of Mexico. Sarasota, Fla.: Pineapple Press.

Guide 1990. *Guide to the Natural Communities of Florida.* 1990. Tallahassee: Florida Natural Areas Inventory and Department of Natural Resources.

Guide 2010. *Guide to the Natural Communities of Florida.* 1990. Tallahassee: Florida Natural Areas Inventory.

Hahn, D. A., and W. R. Tschinkel. 1997. Settlement and distribution of colony-founding queens of the arboreal ant, *Crematogaster ashmeadi,* in longleaf pine forest. *Insectes Sociaux* 44: 323-336.

Harris, L. D., and R. D. Wallace. 1984. Breeding bird species in Florida forest fragments. *Proceedings of the Annual Conference of Southeastern Associations of Fish and Wildlife Agencies* 38: 87-96.

Heath, R. C., and C. S. Conover. 1981. *Hydrologic Almanac of Florida.* Open-File Report 81-1107. Tallahassee: Florida Department of Environmental Regulation.

Hiaasen, C. 1993. The Miccosukee: The Seminoles and the Glades. *Tallahassee Democrat,* 4 April.

Hickman, C. P., L. S. Roberts, and F. M. Hickman. 1984. *Integrated Principles of Zoology.* 7th ed. St. Louis: Mosby.

Holzer, R. F. 1986. Ecological Communities of the Big Bend (an unpublished masters thesis). Tallahassee: Florida State University.

Hooper, R. G., A. F. Robinson, Jr., and J. A. Jackson. 1990. *The Red-Cockaded Woodpecker*. Atlanta: U.S. Department of Agriculture, Forest Service, Southeastern Area, State and Private Forestry.

Hulbert 1982. Hulbert, R.C. 1982. Population dynamics of the three-toed horse *Neohipparion* from the late Miocene of Florida. *Paleobiology* 8: 159–167.

———. 1998. Saving the Florida Keys. *Florida Wildlife* 52 (May-June): 16-19.

Hurchalla, M. 1998. Crossing the Everglades. *Palmetto* (Summer): 16-19.

Hutto, J. 1995. *Illumination in the Flatwoods*. New York: Lyons and Burford.

Johnson, A. F., and M. G. Barbour. 1990. Dunes and maritime forests. In Myers and Ewel 1990 (q.v.), 429-480.

Komarek, E. V. 1964. The natural history of lightning. *Proceedings of the Tall Timbers Fire Ecology Conference* 3: 139-183.

———. 1965. Fire ecology. *Proceedings of the Tall Timbers Fire Ecology Conference* 4: 169-220.

Laessle, A. M., and C. D. Monk. 1961. Some live oak forests of northeastern Florida. *Quarterly Journal of the Florida Academy of Sciences* 24(1): 39-55.

Layne, J. N. 1992. Florida mouse. In Ashton 1992 *(Mammals)* (q.v.), 250-264.

Leveton, D. 1995. Delicate balance (Fox squirrel). *Florida Wildlife* 49 (November/December): 15.

Livingston, E. H. 1989. Overview of stormwater management. *ENFO* (Feb): 1-6.

MacArthur, R., and J. MacArthur. 1961. On bird species diversity. *Ecology* 42: 594-598.

Margulis, L., and K. V. Schwartz. 1990. *Five Kingdoms*. New York, Freeman.

McCook, A. 2002. You snooze, you lose. *Scientific American*, April: 31.

McKibben, B. 1996. What good is a forest? *Audubon* 98 (May): 54-63.

Means, D. B. 1977. Aspects of the significance to terrestrial vertebrates of the Apalachicola River drainage basin. *Florida Marine Research Publication 26*, 37-67. Apalachicola: Florida Marine Research Institute.

———. 1985. The cotton rat. *ENFO* (February): 6-7.

———. 1991. Florida's steepheads. *Florida Wildlife* 45 (May-June): 25-28.

———. 1994. Longleaf pine forests. *Florida Wildlife* 48 (September-October): 2-6.

———. 1994. Temperate hardwood hammocks. *Florida Wildlife* 48 (November-December): 20-23.

———. 1996. Longleaf pine forest, going, going, . . . In *Eastern Old-Growth Forests*, ed. M. B. Davis, 210-229. Washington: Island Press.

Means, D. 2006. Chapter 6. Vertebrate faunal diversity in longleaf pine savannas. Pages 155–213 *in* S. Jose, E. Jokela, and D. miller, eds. *Longleaf Pine Ecosystems: Ecology, Management, and Restoration*. Spring, New Yorker. xii + 438pp.

Meylan, P. A. 1984. A history of fossil amphibians and reptiles in Florida. *Plaster Jacket* 44 (February): 5-29.

Minno, M., and M. Minno. 1993. Interdependence. *Palmetto* (Summer): 6-7.

Mitchell, R. S. 1963. Phytogeography and floristic survey of a relic area in the Marianna Lowlands. *American Midland Naturalist* 69: 328-366.

Muir, J. [1916.] *Thousand-Mile Walk to the Gulf*, reprinted 1981. Boston: Houghton Mifflin.

Muller et al 1989. Muller, J. W., E. D. Hardin, D. R. Jackson, S. E. Gatewood, and N. Claire. 1989. *Summary Report on the Vascular Plants, Animals and Plant Communities Endemic to Florida*. Technical Report No. 7 (June). Tallahassee: Florida Game and Fresh Water Fish Commission Nongame Wildlife Program.

Myers, R. L. 1990. Scrub and high pine. In Myers and Ewel 1990 (q.v.), 150-193.

National Oceanic and Atmospheric Administration (NOAA), http://www.noaa.gov/.

Norse, E. A. 1990. What good are ancient forests? *Amicus Journal* (Winter): 42-45.

Norton, B. G., ed. 1986. *The Preservation of* Species. Princeton, N.J.: Princeton University Press.

Osborne, R., and D. Tarling. 1996. Human origins and migration. *Historical Atlas of the Earth,* 156-157. New York: Holt.

Osorio, R. 1991. Three pine rock land shrubs. *Palmetto* (Fall): 8-9.

Page, L. M., B. M. Burr, E. C. Beckham, J. Sipiorski, and others. 2011. *Peterson Field Guide to Freshwater Fishes*. 2d ed. Peterson Field Guides.

Palumbi, S. 2000. Evolution, synthesized. *Harvard Magazine* (March-April): 26-30.

Patton, T. H. 1969. An Oligocene land vertebrate fauna from Florida. *Journal of Paleontology* 43:2 (March): 543-546.

Perry, D. A., and M. P. Amaranthus. 1987. Disturbance, recovery, and stability. In *Creating a Forestry for the 21st Century*, ed. K. A. Kohm and J. E. Franklin, 31-56. Washington, D.C.: Island Press.

Platt, W. J. 1999. Southeastern pine savannas. In *Savannas, Barrens, and Rock Outcrop Plant Communities of North America*, ed. R. C. Anderson, J. S. Fralish, and J. M. Baskin, 23-51. Cambridge, England: Cambridge University Press.

Platt, W. J., and S. M. Hermann. 1986. Relationships between dispersal syndrome and characteristics of populations of trees in a mixed-species forest. In *Frugivores and Seed Dispersal,* ed. A. Estrada, T. H. Fleming, C. Vasques-Yanes, and R. Dirzo, 309-321. The Hague, Netherlands: Junk (publisher).

Platt, W. J., and M. W. Schwartz. 1990. Temperate hardwood forests. In Myers and Ewel 1990 (q.v.), 194-229.

Puri, H. S., and R. O. Vernon. 1964. Summary of the geology of Florida and a guidebook to the classic exposures. *Florida Geological Survey Special Publication* No. 5.

Ray, P. S. 1992. The sunshine state's other claim to weather fame. *Tallahassee Democrat,* 1 December.

Reynolds, J. W. 1994. Earthworms of Florida. *Megadrilogica* 5(12): 125-141.

Robbins, C. S., B. Bruun, and H. S. Zim. *Birds of North America.* Rev. ed. New York: St. Martin's Press.

Ross, J. F. 1996. A few miles of land arose from the sea—and the world changed. *Smithsonian* (December): 112-121.

Rupert, F. R. 1998. Florida caves map (unpublished).

Sawicki, R. 1997. Tropical flyways and the white-crowned pigeons. *Florida Naturalist* (Summer): 6-7.

Schwartz, M. W., and S. M. Hermann. 1993. *The Population Ecology of Torreya Taxifolia.* Nongame Wildlife Program Project HG89-030. Tallahassee: Florida Game and Fresh Water Fish Commission.

Schwartz, M. W., and J. Travis. 1995. The distribution and character of natural habitats in pre-settlement northern Florida. *Public Land Survey Records Project Report* (December). Tallahassee: Florida Game and Fresh Water Fish Commission Nongame Wildlife Program.

Snedaker, S. C., and A. E. Lugo. 1972. Ecology of the Ocala National Forest. Ocala, Fla.: U.S. Forest Service (unpublished manuscript).

Snyder. J. R., A. Herndon, and W. B. Robertson, Jr. 1990. South Florida rockland. In Myers and Ewel 1990 (q.v.), 230-277.

Stap, D. 1994. Along a ridge in Florida. *Smithsonian* (September): 36-45.

Stevens, W. K. 1990. Monarchs' migration. *New York Times,* 4 December.

Stout, I. J., and W. R. Marion. 1993. Pine flatwoods and xeric pine forests of the southern (lower) coastal plain. In *Biodiversity of the Southeastern United States.* Vol. 1. *Lowland Terrestrial Communities,* ed. W. H. Martin, S. G. Boyce, and A. C. Echternacht, 373-446. New York: Wiley.

Stys, B. 1997. *Ecology of the Florida Sandhill Crane.* Nongame Wildlife Technical Report No. 15 (July). Tallahassee: Florida Game and Fresh Water Fish Commission.

Svingen, K. 1995. Group aims to rescue woodpecker. *Tallahassee Democrat,* 27 November.

Tebo, M. 1988. Florida's desert islands. *Skimmer* 4:1 (Winter), 1-2.

Toops, C. 1998. *The Florida Everglades.* Rev. ed. Stillwater, Minn.: Voyageur Press.

Tunstall, J. 1998. Tiny swamp, beach dwellers pack big bite. *Tallahassee Democrat,* 12 April.

U.S. Geological Survey Fact Sheet. 2010. Divisions of Geologic Time—Major Chronostratigraphic and Geochronologic Units.

Wahlenberg, W. G. 1946. *Longleaf Pine.* Washington: Charles Lathrop Pack Forestry Foundation.

Ware, S., C. Frost, and P. Doerr. 1993. Southern mixed hardwood forest: The former longleaf pine forest. In *Biodiversity of the Southeastern United States: Upland Terrestrial Communities,* ed. W. Martin, S. Boyce, and A. Echternacht: 447-493. New York: Wiley.

————.. 1988. Nature notes. *Florida Wildlife* 42 (September-October): 47.

Webb, S. D. 1981. The Thomas Farm fossil vertebrate site. *Plaster Jacket* 37 (July): 6-25.

————. 1990. Historical biogeography. In Myers and Ewel 1990 (q.v.), 70-100.

Webb, S. D., and D. B. Crissinger. 1983. Stratigraphy and vertebrate paleontology of the central and southern phosphate districts of Florida. Geology Society of America, Southeast Section Meeting, *Field Trip Guidebook:* 28-72.

Webb, S. D., B. J. MacFadden, and J. A. Baskin. 1981. Geology and paleontology of the Love Bone Bed from the late Miocene of Florida. *American Journal of Science* 281(5): (May), 513-544.

Weigl, P. D., M. A. Steele, L. J. Sherman, J. C. Ha, and T. L. Sharpe. 1989. Ecology of the fox squirrel *(Sciurus niger)* in North Carolina. *Bulletin of Tall Timbers Research Station* 24: i-91.

Wells, B. W., and I. V. Shunk. 1931. The vegetation and habitat factors of the coarser sands of the North Carolina coastal plain. *Ecological Monographs* 1: 465-520.

Winsberg, M. D. 1990. *Florida Weather.* Orlando, Fla.: University of Central Florida Press.

Wisenbaker, M. 1988. Florida's true natives. *Florida Naturalist* (Spring): 2-5.

————. 1989. Sinkholes. *Florida Naturalist* (Winter): 3-6.

————. 1991. Floridana. *Florida Wildlife* 45 (September-October): 49.

Wolfe, S. H., J. A. Reidenauer, and D. B. Means. 1988. *An Ecological Characterization of the Florida Panhandle.* Biological Report 88(12). Washington: U.S. Fish and Wildlife Service and New Orleans, La.: Minerals Management Service.

Wuerthner, G. 1995. Why healthy forests need dead trees. *Earth Island Journal* (Fall): 22.

Wunderlin, R. P., and B. F. Hanson. 2003. *Guide to the Vascular Plants of Florida.* 2d. ed. Gainesville: University Press of Florida.

APPENDIX

FLORIDA'S UPLAND ECOSYSTEMS

The left column of the table on the next page lists the terms chosen by the Florida Natural Areas Inventory (FNAI) for Florida's upland communities. The right column lists the alternative names used in this book, showing in what chapters they are described, mentioned, or depicted. Other authorities use other schemes. No one scheme is perfect. The diversity of classification systems reflects the diversity of the communities themselves.

APPENDIX REFERENCE NOTES

[a] Among the temperate hardwood hammocks and hardwood forests treated in Chapter 6 are the Beech-magnolia forest, Mesic hammock, Xeric oak hammock, and Steephead ravine forest.

[b] Among the High pine grasslands treated in Chapter 2 is the Longleaf pine-wiregrass community.

[c] Among the scrub communities treated in Chapter 5 are Oak scrub, Rosemary scrub, Sand pine scrub, and Slash pine scrub.

[d] What was once known as the "Upland mixed forest" is now understood to consist of two distinct types of forest, "Upland mixed woodland," which contains conifers and hardwoods, and "Upland hardwood forest," which contains just hardwoods. This book treats the latter in Chapter 6.

[e] This was once known as "Upland pine forest," but is now called simply "Upland pine," so as not to imply that it has a closed canopy.

FNAI TERMS (2010)	TERMS USED IN THIS BOOK
Hardwood forested uplands	Temperate hardwood hammock—Ch 6[a]
	Hardwood forest—Ch 6
Mesic hammock	Beech-magnolia forest—Ch 6
	Mesic hammock—Ch 6
Rockland hammock	Keys hammock—Ch 7
	Rockland hammock—Ch 7
	Tropical hardwood hammock—Ch 7
	Xeric oak hammock—Ch 6
Slope forest	Steephead ravine forest—Ch 6
	Highlands hammock—Ch 6

High pine and scrub

Sandhill	High pine grassland—Ch 2[b]
	Longleaf pine-wiregrass—Ch 2[b]
	Pine savanna—Ch 2[b]
	Sandhill—Ch 2[b]
Scrub	Florida scrub—Ch 5[c]
Upland mixed woodland	Upland hardwood forest—Ch 6[d]
Upland pine	Upland pine—Ch 2[e]

Coastal uplands

Beach dune	Beach-dune; Oak scrub—Ch4
Coastal berm	Coastal berm—Ch 4
Coastal grassland	Coastal grassland; Overwash plain—Ch 4
Coastal strand	Coastal strand—Ch 4
Maritime hammock	Maritime hammock—Ch 4
Shell mound	Shell mound—Ch 4

Sinkholes and outcrop communities

Keys cactus barren	Keys cactus barren—Ch 4
Limestone outcrop	
Sinkhole	Sinkhole—Ch 7
Terrestrial cave	Terrestrial cave—Ch 7
Upland glade	Upland glade—Ch 7

PHOTOGRAPHY CREDITS

ALA = Alabama Cooperative Fish and Wildlife
 Research Unit

BC = Bruce Colin Photography

BM = Barry Mansell

BP = Bill Petty, Amateur Mycologist,
 Crawfordville, Fla.

CC/NOAA = C. Clark for NOAA (q.v.)

DA = Doug Alderson

DB/FPS = Dana Bryan for FPS (q.v.)

DBM = D. Bruce Means, Coastal Plains Institute
 and Land Conservancy

FFWCC = Florida Fish and Wildlife Conservation
 Commission

FHF = Finley-Holiday Film Corporation,
 www.finley-holiday.com

FKNMS = Florida Keys National Marine Sanctuary

FLAUSA = Visit Florida

FMNH = Florida Museum of Natural History,
 Exhibits and Public Programs Department

FPS = Florida Park Service,
 www.FloridaStateParks.org

GB = Giff Beaton, www.giffbeaton.com

GN = Gil Nelson, Ph.D., Botanist/Author/
 Photographer

IAW/FPS = Ivy Aletheia Wilson for FPS (q.v.)

JR = Jeff Ripple, Photographer, PO Box 142613,
 Gainesville, FL 32614

JT = Jerry Turner, 28 Pebble Pointe, Thomasville,
 GA 31792

JV = James Valentine, Photographer

KME = Kevin M. Enge

KWM/USFWS = Kenneth W. McCain for
 USFWS (q.v.)

LB = Larry Busby, Ranger, Waccasassa Bay
 State Preserve

LF = Lois Fletcher, Executive Director, Gilchrist
 County Chamber

MW = Michael Wisenbaker, Outdoor Photographer,
 Tallahassee

NOAA = National Oceanographic and
 Atmospheric Administration

PEM = Paul E. Moler, FFWCC (q.v.)

PG/FKNMS = Paige Gill for FKNMS (q.v.)

PKS = Pam Sikes, Photographer, P.O. Box 997,
 Folkston, GA, stpsikes@alltel.net

PS = Peter Stiling

REA = Ray E. Ashton, Jr., Ashton Biodiversity
 Research and Preservation Institute, Inc.

RLH = Roger L. Hammer

RPP = Rick Poley Photography, 12410 Green Oak
 Lane, Dade City, FL 33525

RW = Russ Whitney

SC = Stephen Coleman, Nature Photographer,
 sdcme1@juno.com

SFWMD = South Florida Water Management
 District

TCH = Terrence Hitt, Nature Coast Expeditions,
 P.O. Box 218, Cedar Key, FL 32625

TE = Thomas Eisner, Naturalist, Ithaca, New York

USFWS = United States Fish and Wildlife Service

WBSP = Waccasassa Bay State Preserve

WCM = William C. Maxey

WRT = Walter R. Tschinkel

INDEX TO SPECIES

The several hundred plants, animals, and other living things that appear in this book's photos and lists are indexed here by their common names, followed by their scientific names. Photos are indicated by bold italics (e.g., **60**).

Finding species by their common names is often difficult, because, although there are standards for common names, names in popular use do vary and also change over time. Should it be difficult to locate a species by a familiar name such as "Magnolia," try prefacing the name with "American," "Common," "Eastern," "Florida," "Northern," "Southeastern," or "Southern." The common name of the familiar magnolia, for example, is "Southern magnolia."

Most scientific names are italicized two-word phrases. The first word refers to the genus (a category that includes several or many closely-related species). The second word identifies the species. The genus name is capitalized and the species name is always lower case even if it is a country or a person's last name. Thus the Acadian flycatcher is identified as "Acadian flycatcher, *Empidonax virescens*."

In some instances, species are divided into several varieties. Variety names follow species names thus: "White basswood, *Tilia americana,* var. *heterophylla*."

Species that are Florida endemics are identified as such. Some species have been broken down to subspecies, and one or more of these may be endemic. An example is: "Bluetail mole skink, *Eumeces egregius lividus* (endemic)."

In some instances, an organism is identified only down to the genus level. In that case, the entry reads like this: "Barbara's buttons, *Marshallia* species."

All listings are of native species unless identified as "alien." For example, a listing of the bark anole reads: "Bark anole, *Anolis distichus* (alien)."

The authorities used here for common and scientific names are listed in the Reference Notes for Chapter 1 (note 4).

Feay's palafox, *Palafoxia feayi* (endemic), **87**

Fetterbush, *Lyonia lucida,* 40, 77

Fewflower milkweed, *Asclepias lanceolata,* **65**

Firewheel, *Gaillardia pulchella,* **56**

Fish crow, *Corvus ossifragus,* 33

Fivepetal leafflower, *Phyllanthus pentaphyllus* (endemic), 110

Flatwoods salamander, *Ambystoma cingulatum,* **43**

Flaxleaf aster, *Ionactis linarifolia,* 24

Florida atala, *Eumaeus atala,* **111**, 116

Florida beargrass, *Nolina atopocarpa* (endemic), **35**

Florida black bear, *Ursus americanus,* 85

Florida bluestem, *Andropogon floridanus,* 110

Florida butterfly orchid, *Encyclia tampensis,* **109**

Florida calamint, *Calamintha dentata,* 24

Florida clover ash, *Tetrazygia bicolor,* 110

Florida dropseed, *Sporobolus floridanus,* 24

Florida flame azalea, *Rhododendron austrinum,* **vi,** 102, **144**

Florida greeneyes, *Berlandiera subacaulis* (endemic), 24

Florida Key deer, *Odocoileus virginianus clavium* (endemic), 116, 117

Florida Keys blackbead, *Pithecellobium keyense,* 60

Florida Keys indigo, *Indigofera mucronata var. keyensis,* 61

Florida Keys mole skink, *Eumeces egregius egregius* (endemic), 117

Florida Keys noseburn, *Tragia saxicola,* 110

Florida leafwing, *Anaea floridalis,* 116

Florida leatherleaf, *Veronicella floridana,* **81**

Florida maple, *Acer saccharum floridanum,* 91

Florida mouse, *Podomys floridanus (endemic),* **31**, 80

Florida panther, *Felis concolor coryi* (endemic), 116

Florida poisontree, *Metopium toxiferum,* 110, 114

Florida purplewing, *Eunica tatila* (endemic), **118**

Florida rosemary, *Ceratiola ericoides,* 77, **78**

Florida royal palm, *Roystonea regia,* **113**

Florida sandhill crane, *Grus canadensis pratensis,* **44**

Florida scrub lizard, *Sceloporus woodi* (endemic), 80, **83**

Florida scrub millipede, *Floridobolus penneri* (endemic), **81**

Florida scrub oak, *Quercus inopina* (endemic), 71

Florida scrub-jay, *Aphelocoma coerulescens* (endemic), 80, **83**

Florida tree snail, *Liguus fasciatus,* 116, **117**

Florida worm lizard, *Rhineura floridana* (endemic), 80, **83**

Flowering dogwood, *Cornus florida,* 91, 106, **126**

Flyr's nemesis, *Brickellia cordifolia,* 102

Fox squirrel, *Sciurus niger,* **28**

G

Gallberry, *Ilex glabra,* 40

Gayfeather, *Liatris* species, 24

Ghost crab, *Ocypode quadrata,* **8,** 62

Goat's rue, *Tephrosia virginiana,* 24

Golden silk spider, *Nephila clavipes,* **v**

Golden stars, *Bloomeria crocea,* 102

Gopher frog, *Lithobates capito,* **31,** 32, 85.

Gopher tortoise, *Gopherus polyphemus,* **31,** 32, 62, 80

Gopherwood, *Torreya taxifolia* (near-endemic), **100**

Gray bat, *Myotis grisescens,* 125

Gray fox, *Urocyon cinereoargenteus,* 85, 116

Gray kingbird, *Tyrannus dominicensis,* 116, 117

Gray rat snake, *Pantherophis spiloides,* **22,** 32, 62

Gray squirrel, *Sciurus carolinensis,* 62

Great crested flycatcher, *Myiarchus crinitus,* 33, 64, 94, 116

Great horned owl, *Bubo virginianus,* 33, 94, **96**

Greater Florida spurge, *Euphorbia floridana,* 102

Green anole, *Anolis carolinensis,* **vii,** 116, 117

Green antelopehorn, *Asclepias viridis,* **65**

Green ash, *Fraxinus pennsylvanica,* 91

Green hawthorn, *Crataegus viridis,* 106

Green heron, *Butorides virescens,* 64

Green sprangletop, *Leptochloa dubia,* 61

Green treefrog, *Hyla cinerea,* 117

Greendragon, *Arisaema dragontium,* 106

Greenhouse frog, *Eleutherodactylus planirostris* (alien), 117

Ground lichens, *Cladonia leporina, C. prostata, Cladina subtenuis, C. evansii,* 76, 77. *See also* Lichens

Ground skink, *Scincella lateralis,* 32, 116

Gulf fritillary, *Agraulis vanillae,* **49**

Gull-billed tern, *Sterna nilotica,* 61

Gumbo limbo, *Bursera simaruba,* 60, 61, 114

H

Hairawn muhly, *Muhlenbergia capillaris*, **41**

Hairsedges, *Bulbostylis* species, 77

Hairy woodpecker, *Picoides villosus*, 33, 94

Hammock velvetseed, *Guettarda elliptica*, 110

Hawthorn, *Crataegis* species, 91. *See also* Dwarf, Green, *and* Parsley hawthorn

Henslow's sparrow, *Ammodramus henslowii*, 43

Hickory, *Carya* species, 91.

Hispid cotton rat, *Sigmodon hispidus*, **45**, 62, 80, 117

Hoary bat, *Lasiurus cinereus*, 125

Hog plum, *Ximenia americana*, 60

Holywood lignumvitae, *Guajacum sanctum*, **vii**

Honeycombhead, *Balduina* species, 24

Hooded warbler, *Wilsonia citrina*, 94

House wren, *Troglodytes aedon*, 33

I

Indiana bat, *Myotis sodalis*, 125

Indigo bunting, *Passerina cyanea*, 94

J

Jack-in-the-pulpit, *Arisaema triphyllum*, 102

Jamaican capertree, *Capparus cynophallophora*, 114

Jamaican dogwood, *Piscidia piscipula*, 114

Joewood, *Jacquinia keyensis*, 50, 60, 77, 114

Jointweeds, *Polygonella* species, 77

K

Keen's myotis, *Myotis keeni*, 125

Key Largo cotton mouse, *Peromyscus gossypinus allapaticola* (endemic), 117, **118**

Key Largo woodrat, *Neotoma floridana smalli* (endemic), 117, **118**

Key thatch palm, *Thrinax morrisii*, 110

Key tree cactus, *Pilosocereus polygonus*, **112**, 114

Keys short-winged conehead, *Belocephalus sleighti*, 116, 117

Knight anole, *Anolis equestris*, 117

L

Lady lupine, *Lupinus villosus*, **15**

Lake Placid funnel wolf spider, *Sosippus placidus* (endemic), **82**

Lakecress, *Neobeckia aquatica*, 102

Laughing gull, *Larus atricilla*, 61

Laurel oak, *Quercus hemisphaerica*, **9,** 91

Leafy beaked ladiestresses, *Sacoila lanceolata* var. *paludicola* (endemic), **107**

Least tern, *Sterna antillarum*, 61

Leavenworth's tickseed, *Coreopsis leavenworthii* (endemic), **40**

Lespedeza, *Lespedeza* species

Lichens (with no common names), Cladonia perforata, *Cladonia evansii*, **76**

 See also Ground lichens

Little brown bat, *Myotis lucifugus*, 125

Live oak, *Quercus virginiana*, 91, **102**

Loblolly pine, *Pinus taeda*, 91

Loggerhead shrike, *Lanius ludovicianus*, 33, 85

Long Key locustberry, *Byrsonima lucida*, 110

Longleaf pine, *Pinus palustris*, 14-**23, 15**

Long-tailed skipper, *Urbanus proteus*, **68**

Louisiana waterthrush, *Seiurus motacilla*, 94, **105**

Lyreleaf sage, *Salvia lyrata*, **6**

M

Mammoth, *Mammuthus colombi* (extinct), **137**

Mangrove cuckoo, *Coccyzus minor*, 117

Marlberry, *Ardisia escallonioides*, 110, 114

Mayapple, *Podophyllum peltatum*, 102

Meadowparsnip, *Thaspium* species, 102

Merlin, *Falco columbarius*, 117

Milkbark, *Drypetes diversifolia*, 60, 114

Milkpea, *Galactia* species, 24

Mississippi kite, *Ictinia mississippiensis*, 94

Mock pennyroyal, *Stachydeoma graveolens* (endemic), **34,** 41

Mohr's threeawn, *Aristida mohrii*, 24

Mole salamander, *Ambystoma talpoideum*, 85

Mole skink, *Eumeces egregius* (endemic), 32. *See also* Bluetail *and* Florida Keys mole skink

Monarch butterfly, *Danaus plexippus*, **66**

Moth (no common name), *Shinia gloriosa*, **87**

Mountain spurge, *Pachysandra procumbens*, 102

Mourning dove, *Zenaida macroura*, 33, 94

Mule-ear oncidium, *Trichocentrum undulatum,* **115**

Myrsine, *Rapanea punctata,* 110

Myrtle oak, *Quercus myrtifolia,* 77

N

Narrowleaf blue-eyed grass, *Sisyrinchium angustifolium,* **40**

Narrowleaf yellowtops, *Flaveria linearis,* **56**

Narrowmouth toad (eastern), *Gastrophryne carolinensis,* 32

New Jersey tea, *Ceanothus americanus,* 102

Northern bobwhite, *Colinus virginianus,* 33, **34,** 43, 85, 94, 116

Northern cardinal, *Cardinalis cardinalis,* 43, 85, 94, 117

Northern flicker, *Colaptes auratus,* 33, 94

Northern mockingbird, *Mimus polyglottos,* **89,** 94

Northern parula, *Parula americana,* 94

O

Oak toad, *Bufo quercicus,* 32, 85, 116

Oakleaf hydrangea, *Hydrangea quercifolia,* **101**

Oblongleaf twinflower, *Dyschoriste oblongifolia,* 110

Onion-stalk lepiota, *Lepiota cepaestipes,* **94**

Ornate chorus frog, *Pseudacris ornata,* 32, **43**

P

Painted bunting, *Passerina ciris,* **9**

Palamedes swallowtail, *Papilio palamedes,* **68**

Palm warbler, *Dendroica palmarum,* 33, 85

Parsley hawthorn, *Crataegus marshallii,* 106

Partridge pea, *Chamaecrista fasciculata,* 24

Patent leather beetle. *Passalus cornutus,* **95**

Pawpaw, *Asimina* species, **39**

Peninsula crowned snake, *Tantilla relicta relicta* (endemic), 80

Peninsula ribbon snake, *Thamnophis sauritus sackeni,* 116

Peppervine, *Ampelopsis arborea,* 106

Perdido Key beach mouse, *Peromyscus polionotus trisyllepsis,* **62, 142**

Perfumed spiderlily, *Hymenocallis latifolia,* 60

Pigeon plum, *Coccoloba diversifolia,* 114

Pigeonwings, *Clitoria* species, 25

Pileated woodpecker, *Dryocopus pileatus,* 33, 94

Pine bark borer, *Tyloserina nodosa,* **25**

Pine warbler, *Dendroica pinus,* 33, 43, 116, 117

Pine woods treefrog, *Hyla femoralis,* 32

Pineland passionflower, *Passiflora pallens,* **113**

Pineland spurge, *Poinsettia pinetorum* (endemic), 110

Pinelandcress, *Warea species,* 25

Pineywoods dropseed, *Sporobolus junceus,* 25

Pinweeds, *Lechea* species, 77

Piping plover, *Charadrius melodus,* 64

Pocket gopher, *Geomys pinetus,* **84**

Poisonwood, *Metopium toxiferum,* 60

Prairie warbler, *Dendroica discolor,* 117

Pricklypear, *Opuntia* species, 114

Puffball, *Lycoperdon* species, **94**

Pyramid magnolia, *Magnolia pyramidata,* 100

Q

Queensdelight, *Stillingia sylvatica,* 25

R

Raccoon, *Procyon lotor,* 62, 85, 116, 117

Rafinesque's big-eared bat, *Plecotus rafinesquei,* 125

Railroad vine, *Ipomoea pes-caprae,* **55**

Red buckeye, *Aesculus pavia,* 91

Red mangrove, *Rhizophora mangle,* 60

Red maple, *Acer rubrum,* 91, **141**

Red-cockaded woodpecker, *Picoides borealis,* **29,** 33, 43

Red-eyed vireo, *Vireo olivaceus,* 94, **105**

Red mulberry, *Morus rubra,* 91, 102

Red widow spider, *Latrodectus bishopi,* 80

Red-bellied woodpecker, *Melanerpes carolinus,* 33, 43, 94, 116, 117

Red-breasted nuthatch, *Sitta canadensis,* 33

Red-headed woodpecker, *Melanerpes erythrocephalus,* 33

Red-shouldered hawk, *Buteo lineatus,* 43, 94, 116

Red-tailed hawk, *Buteo jamaicensis,* 43, 94, 116

Red-winged blackbird, *Agelaius phoeniceus,* 33, 62

Reef gecko, *Sphaerodactylus notatus,* 117

Resurrection fern, *Pleopeltis polypodioides* var. *michauxiana,* 103

Rim rock crowned snake, *Tantilla oolitica,* 117

Ringneck snake, *Diodophis punctatus,* 62

Rosebud orchid, *Pogonia divaricata,* **37**

Splitbeard bluestem, *Andropogon ternarius,* 25

Spotted skunk, *Spilogale putorius,* 62, 85

Spruce pine, *Pinus glabra,* 91

Spurred butterfly pea, *Centrosema virginianum,* **17**

Squirrel treefrog, *Hyla squirella,* 62

Starry rosinweed, *Silphium asteriscus,* **129**

Strangler fig, *Ficus aurea,* 114, **116**

Striped newt, *Notophthalmus perstriatus,* 32, 85

Striped skunk, *Mephitis mephitis,* 85

Strongbark, *Bourreria* species, 114

Sugarberry, *Celtis laevigata,* 91

Summer farewell, *Dalea pinnata,* 25

Summer tanager, *Piranga rubra,* 33, 94, 116

Swainson's warbler, *Limnothlypis swainsonii,* 94

Swamp bay, *Persea palustris,* 110

Swamp chestnut oak, *Quercus michauxii,* 91

Swamp dogwood, *Cornus foemina,* 106

Swamp sparrow, *Melospiza georgiana,* 33

Sweetbay magnolia, *Magnolia virginiana,* 98, 101,

Sweet goldenrod, *Solidago odora,* 25

Sweetgum, *Liquidambar styraciflua,* 91

Sweet pinxter azalea, *Rhododendron canescens,* **130**

T

Tall thistle, *Cirsium altissimum,* 102

Tamarind, *Tamarindus indicus* (alien), 114

Tarflower, *Bejaria racemosa,* 40

Tennessee leafcup, *Polymnia laevigata,* 102

Threeawns, *Aristida* species, 77

Three-spined pricklypear, *Opuntia triacantha,* 61

Ticktrefoil, *Desmodium* species, 25

Tiger salamander (eastern), *Ambystoma tigrinum,* 32

Tiger swallowtail, *Papilio (Pterouras) glaucus,* **47, 68**

Triangle cactus, *Acanthocereus tetragonus,* 114

Tufted titmouse, *Baeolophus bicolor,* 33, 94

Tuberous grasspink, *Calopogon tuberosus,* 40

Tuliptree, *Liriodendron tulipifera,* 91

Turkey oak, *Quercus laevis,* 20

Turkey-tail mushroom, *Trametes versicolor,* 13

Turkey vulture, *Cathartes aura,* 43, 85

V

Velvetseed, *Guettarda* species, 114

Viceroy, *Limenitis archippus,* **65**

Vinegaroon, *Mastigoproctus giganteus,* 80

Virginia creeper, *Parthenocissus quinquefolia,* 106

Virginia opossum, *Didelphis virginiana,* 85, 116, 117, **131**

W

Wagner's mastiff bat, *Eumops glaucinus,* 125

Wakerobin, *Trillium* species, 102

Walking stick (order *Phasmatodea*), **42,** 116

Water oak, *Quercus nigra,* 91

Wax myrtle, *Myrica cerifera,* 40, 91, 110

West Indian mahogany, *Swietenia mahagoni,* 114

White basswood, *Tilia americana,* var. *heterophylla,* 102

White birds-in-a-nest, *Macbridea alba* (endemic), **40**

White indigoberry, *Randia aculeata,* 60, 102, 114

White mangrove, *Laguncularia racemosa,* 60

White oak, *Quercus alba,* 91

White peacock, *Anartia jatrophae,* **47**

White stopper, *Eugenia axillaris,* 114

White-tailed deer, *Odocoileus virginianus,* 80, 85, **143**

White thoroughwort, *Eupatorium album,* 25

White-breasted nuthatch, *Sitta carolinensis,* 33, 94

White-crowned pigeon, *Columba leucocephala,* 117

White-eyed vireo, *Vireo griseus,* 94

Whitetop aster, *Seriocarpus* species, 25

Wicky, *Kalmia hirsuta,* 40

Wild blue phlox, *Phlox divaricata,* 102

Wild coffee, *Psychotria* species, 114

Wild columbine, *Aquilegia canadensis,* **101,** 102

Wild dilly, *Manicara jalmiqui,* 60

Wild ginger, *Asarum arifolium,* **100**

Wild olive, *Osmanthus americanus,* 91

Wild turkey, *Meleagris gallopavo,* 43, **45,** 94, 116

Willet, *Catoptrophorus semipalmatus,* 61, 64

Willow bustic, *Sideroxylon salicifolium,* 110, 114

Wilson's plover, *Charadrius wilsonia,* 61

Y

Z

GENERAL INDEX

OTHER TITLES FROM PINEAPPLE PRESS
Here are some other books from Pineapple Press on related topics.

For a complete catalog, write to Pineapple Press, P.O. Box 3889, Sarasota, Florida 34230-3889, or call (800) 746-3275. Or visit our website at www.pineapplepress.com.

The other two in this series of Florida's Natural Ecosystems and Native Species:

Florida's Wetlands by Ellie Whitney and D. Bruce Means and Anne Rudloe.
Covers the ecosystems and species of Florida's seepage wetlands, interior marshes, interior swamps, coastal intertidal zones, and mangrove swamps.

Florida's Waters by Ellie Whitney, D. Bruce Means and Anne Rudloe.
Covers the ecosystems and species of Florida's lakes and ponds; alluvial, backwater, and seepage streams; aquatic caves, sinks, springs, and spring runs; coastal estuaries and seafloors; submarine meadows; sponge, rock, and reef communities; and the gulf and ocean.

Florida's Magnificent Coast by James Valentine and D. Bruce Means.
Stunning photography by James Valentine of the coasts from the Georgia border on the Atlantic around the peninsula and through the Keys along the Gulf of Mexico to the Alabama border in the panhandle. Text on the magnificent ecology of Florida's coasts by D. Bruce Means.

Florida's Magnificent Land by James Valentine and D. Bruce Means.
Stunning photography of the wild areas of the state's panhandle and peninsula by James Valentine. Text on the magnificent ecology of Florida's land by D. Bruce Means.

Florida's Magnificent Water by James Valentine and D. Bruce Means.
Stunning photography by James Valentine, both above and below the many forms of the state's waters, and the wild creatures that live in and near them. Text on the magnificent ecology of Florida's waters by D. Bruce Means.

Florida's Living Beaches: A Guide for the Curious Beachcomber by Blair and Dawn Witherington.
Comprehensive accounts of over 800 species, with photos for each, found on 700 miles of Florida's sandy beaches.

Everglades: River of Grass, 60th Anniversary Edition by Marjory Stoneman Douglas with an update by Michael Grunwald.
Before 1947, when Marjory Stoneman Douglas named the Everglades a "river of grass," most people considered the area worthless. She brought the world's attention to the need to preserve the Everglades. In the Afterword, Michael Grunwald tells us what has happened to them since then.

Florida's Rivers by Charles R. Boning.
An overview of Florida's waterways and detailed information on 60 of Florida's rivers, covering each from its source to the end. From the Blackwater River in the western panhandle to the Miami River in the southern peninsula.

Florida's Birds, 2nd Edition by David S. Maehr and Herbert W. Kale II. Illustrated by Karl Karalus.
This new edition is a major event for Florida birders. Each section of the book is updated, and 30 new species are added. Also added are range maps and color-coded guides to months when the bird is present and/or breeding in Florida. Color throughout.

Nature's Steward by Nick Penniman.
Chronicles the development of southwest Florida using the modern-day Conservancy of Southwest Florida as the lens through which to examine environmental history.

Myakka by Paula Benshoff.
Discover the story of the land of Myakka. This book takes you into shady hammocks of twisted oaks and up into aerial gardens, down the wild and scenic river, and across a variegated canvas of prairies, piney woods, and wetlands—all located in Myakka River State Park, the largest state park in Florida. Each adventure tells the story of a unique facet of this wilderness area and takes you into secret places it would take years to discover on your own.

The Trees of Florida, 2nd Edition, by Gil Nelson.
The only comprehensive guide to Florida's amazing variety of tree species, this book serves as both a reference and a field guide.

The Springs of Florida, 2nd Edition, by Doug Stamm.
Take a guided tour of Florida's fascinating springs in this beautiful book featuring detailed descriptions, maps, and rare underwater photography. Learn how to enjoy these natural wonders while swimming, diving, canoeing, and tubing.

St. Johns River Guidebook by Kevin M. McCarthy.
From any point of view—historical, commercial, or recreational—the St. Johns River is the most important river in Florida. This guide describes the history, major towns and cities along the way, wildlife, and personages associated with the river.

Suwannee River Guidebook by Kevin M. McCarthy.
A leisurely trip down one of the best-known and most beloved rivers in the country, from the Okefenokee Swamp in Georgia to the Gulf of Mexico in Florida.

Exploring Wild South Florida by Susan D. Jewell. Explore from West Palm Beach to Fort Myers and south through the Everglades and the Keys. For hikers, paddlers, bicyclists, bird and wildlife watchers, and campers.

Easygoing Guide to Natural Florida, Volume 1: South Florida by Douglas Waitley.
Easygoing Guide to Natural Florida, Volume 2: Central Florida by Douglas Waitley.
If you love nature but want to enjoy it with minimum effort, these are the books for you. To be an easygoing nature site, it must be beautiful and easy to reach, not cost much, and require little effort.

CPSIA information can be obtained
at www.ICGtesting.com
Printed in the USA
BVOW07s0833180717
489547BV00002B/6/P

9 781561 646852